D1596418

GUNFIGHTS & SITES IN TEXAS RANGER HISTORY

MIKE COX

THE
History
PRESS

Published by The History Press
Charleston, SC 29403
www.historypress.net

Front cover, top right: Colonel Homer Garrison Jr. helped shape the
twentieth-century Rangers. *Author's collection.*

First published 2015

Manufactured in the United States

ISBN 978.1.62619.971.2

Library of Congress Control Number: 2015944408

Notice: The information in this book is true and complete to the best of our
knowledge. It is offered without guarantee on the part of the author or The
History Press. The author and The History Press disclaim all liability in
connection with the use of this book.

Scientists say even a bronze statue theoretically will only last 100,000 years, but monuments still endure longer than human memory, hence their vital importance to our culture. This book owes a debt to a man I never met, but whose sole literary work—self-published in 1958—had a lasting influence on a junior high school kid who one day would become a writer. The man is William Moses Jones (1876–1973). His long out of print book, to which this book is dedicated, is Texas History Carved in Stone. *So far as I know, Jones produced the first book-length travel guide to historical markers and monuments related to the rich history of the Lone Star State. His book definitely led to this book.*

And a Special Note of Thanks…

To Beverly Waak, who, as the old Ranger expression goes, "would do to ride the river with." She cheerfully assisted with research, helped scan photographs, did the driving so I could work on my laptop, gave the book its first edit, prepared the index, put up with my twelve-hour workdays and, on top of all that, provided support and encouragement. Thanks, too, to friend and fellow history devotee Sloan Rodgers, who also gave the manuscript a helpful read. To list all the others who helped with this project would take more space than my editor at The History Press allowed, so I'll just have to tip my figurative Stetson and empty my six-shooter in the air in your honor. Thanks to all.

CONTENTS

Document considered the "Magna Carta" of the Texas Rangers. *Photo courtesy Ralph Elder.*

"MAGNA CARTA" OF THE TEXAS RANGERS

On August 5, 1823, likely while staying at the log cabin of Sylvanus Castleman on the Colorado River above present La Grange in what is now Fayette County, the young empresario Stephen F. Austin penned 177 words—the "Magna Carta" of the Texas Rangers:

> *I have determined to augment at my own private expense the company of men which was raised by order of the late Governor Trespalacios for the defense of the Colony against hostile Indians. I therefore by these presents give public notice that I will employ ten men in addition to those employed by the late Governor to act as rangers for the common defense. The said ten men will form a part of Lieut. Moses Morrison's Company and the whole will be subject to my orders.*

This document, written in ink on the back of a roughly eleven- by fourteen-inch proclamation by the Baron de Bastrop, marked the first use in Texas of the word "ranger" to describe the irregular force that would evolve into the Texas Rangers. Clearly, judging by strikethroughs and insertions, Austin gave the matter careful thought. While some historians have argued that this single piece of paper should not be seen as important as is generally asserted, it nevertheless demonstrates Austin's mindset and essentially codifies the early Ranger concept. It is the traditionally accepted seminal Ranger document.

Bibliographically listed as "Austin's Address to Colonists," it is part of the extensive archive of Austin papers held by the Briscoe Center for American

PROLOGUE

History at the University of Texas–Austin. In a protective sleeve, it rests among other Austin papers in Box 2A150, safely stored in a secure, climate-controlled facility in the heart of the city that honors its author's name.

Austin expressed his idea concisely, but the story of the Texas Rangers is epic.

TRAILING THE RANGERS

AN INTRODUCTION

E arning their reputation as one of the world's most storied and unique criminal justice agencies, the Texas Rangers left deep boot prints in the history of the Lone Star State. Some of those figurative heel marks have been filled by the sands of time, but Texas is covered with reminders of the trials and trails of these legendary lawmen.

This book is the first of its kind, a guide to historic sites across the state with a Ranger connection—places where battles with Indians, Mexican soldiers or bandits took place or where gunfights with outlaws (and at least once with another ranger) went down, as well as surviving structures, even some still-visible bullet holes. In addition, this book locates gravestones, monuments, statuary, other forms of public art and historical markers connected to the Rangers. Even some historic trees.

Arranged by region and county, *Gunfights and Sites in Texas Ranger History* locates nearly six hundred Ranger-related features dating from the early 1820s up into the 1930s. A fair number of the sites are graves, but this book only focuses on the tombstones of noted rangers or those with particularly interesting stories. Indeed, with more than twelve thousand individuals having served as rangers over the years, it would be impossible to include every grave location (assuming the whereabouts of all ranger graves were known, which isn't the case). Nor could all places with some association with the Rangers be included, though this book covers a lot.

Much work remains for future historians, archaeologists and genealogists. Some battle sites and burial places are yet to be located, if they can ever be

found. Since for most of their history, rangers stayed constantly on the move, traveling from one trouble spot to another, likely some campsites and other features with a ranger tie-in have been lost to time. Sadly, many homes and buildings with a Ranger connection have been lost in another way—fire or the wrecking ball. Other structures or sites are endangered, badly in need of preservation or mitigation efforts.

Fortunately, organizations such as the Former Texas Rangers Association (FTRA) continue to locate and mark ranger graves and other sites. So far, the FTRA has placed more than 650 metal Ranger crosses at burial sites across the state. In addition, members of the Wild West History Association, which traces its roots to two former entities—the National Association for Outlaw and Lawman History (NOLA) and the Western Outlaw and Lawman Association (WOLA)—are ever searching for lost graves and other tangible traces of the wild and woolly days of Texas and the Old West.

The dead obviously can no longer speak for themselves, but added to many of the entries are snippets either written or spoken during their lifetime by some of the rangers mentioned in this book, or those who knew them.

Most entries also list the nearest museum or museums. Texas has more than 660 museums, and many hold exhibits and artifacts dealing with the Rangers, including two devoted exclusively to the Rangers—the Texas Ranger Hall of Fame and Museum in Waco (in 2015, the Newsmax website ranked the museum tenth among fifty places in the United States every patriotic American should visit) and the FTRA's Texas Ranger Museum at the historic Buckhorn Saloon in downtown San Antonio.

Phase one of another major Ranger-related destination, the FTRA's Texas Ranger Heritage Center adjacent to old Fort Martin Scott in Fredericksburg opened in 2015. Hill Country tourism officials expect it to become a major attraction, right up there with Fredericksburg's Museum of the Pacific War, a worldwide draw.

Rather than listing plot, row and section numbers for ranger graves, this book simply notes what cemetery they are in. Since many rangers lie in small cemeteries, and often are marked with Ranger crosses, finding them should be easy enough—and maybe an adventure. Most of the larger cemeteries have caretakers who are usually more than happy to direct a visitor to a historic grave. If that doesn't work, most local genealogical societies know the cemeteries in their area well.

For those of us enthralled by the past, cemeteries—especially the lonely country graveyards scattered across the state—are compelling places to visit. But you have to be careful. The hostile Indians and bandits who put some

early-day rangers and others in their graves are long gone, but fire ants, ticks, wasps, bees, venomous snakes and other critters that can cause problems are sometimes found among the tombstones or at other historic sites. Don't wear flip-flops or sandals, and never go far in Texas without water.

Many of the sites described in this book are on private property. Just because a publicly funded historical marker stands nearby does not mean the place is accessible to the public. Going through a gate or climbing a barbed wire fence without permission is illegal—and risky. It also is illegal to collect any artifacts on public property or to collect any on private property without the landowner's permission. All that said, Texans are friendly folks. Most of the time, if you ask politely and have a legitimate reason to see a particular site, you'll get invited to visit.

Well, as an old ranger might say, you're burning daylight. Tuck this book in your saddlebag and start tracking the lawmen who helped tame Texas.

MIKE COX
Austin, Texas

EAST TEXAS

ANDERSON COUNTY
Frankston
MILLER-GARRISON HOUSE

More interested in finding a home for his young wife than Texas history, farmer Homer Garrison probably didn't give much thought to the fact that the house he rented had been around since before the Civil War. Garrison and Mattie moved into the old place in 1900. A year later, the couple had a son, whom they named Homer Milam Garrison Jr.

Later, the family moved to Lufkin, where young Garrison grew up and began his long law enforcement career as an Angelina County deputy sheriff. In 1930, he took a job with the Texas Highway Patrol, organized in 1927 as part of the Texas Highway Department.

The Texas legislature merged the highway patrol and the Texas Rangers, which had been part of the adjutant general's department, to create the Department of Public Safety (DPS) in 1935.

In 1938, Garrison became director of the DPS, and he remained the state's top cop until his death in 1968. No subsequent director has served as long. As director of the state law enforcement agency, he had a major role in shaping the modern Texas Rangers.

A historical marker tracing the house's history and Garrison's influence on Texas law enforcement was placed on the property in 1999.

Birthplace of future Department of Public Safety director and Texas Ranger Chief Colonel Homer Garrison Jr. *Photo by Mike Cox.*

> *They are men who cannot be stampeded.*
> —*DPS Colonel Homer Garrison Jr. on the Texas Rangers*

Visit: Three miles south of Frankston off Farm to Market 19. House and marker on private property. A historical marker honoring Colonel Garrison stands adjacent to the Anderson County Courthouse Annex portico, 703 Mallard Street, Palestine.

Palestine

Fort Houston

A ghost story is all that survives of Fort Houston, a stockade-surrounded log blockhouse built in April 1836 in present Anderson County to protect a new settlement named Houston in honor of General Sam Houston. A month later, survivors of the Fort Parker massacre straggled into the fort for protection.

After the fort's abandonment around 1842, the town of Houston began being referred to as Fort Houston. When Palestine became the county seat in 1846, the settlement faded away and the fort fell to ruin. John H. Reagan, future postmaster general of the Confederate States of America, bought six hundred acres in 1857 that included the site of the old fort and built a house there.

On January 28, 1837, six rangers rode from the fort in search of missing hogs. Instead, they found thirty hostile Indians. The warriors killed three of the rangers; one of the victim's bodies was never found. That incident led to a legend that the cries of the grieving widows can sometimes still be heard where the old fort stood.

The Daughters of the Republic of Texas planted a cedar in the center of the site in 1932, and four years later, the state placed a granite historical marker on the property.

Visit: The 1936 marker stands two miles west of Palestine off Farm Road 1990. A cemetery dating from the time of the Ranger fort is nearby. The unmarked graves of slain rangers Anderson C. Columbus and David Faulkenberry likely are there. Museum of East Texas Culture, 405 South Micheaux, Palestine.

DANIEL PARKER (1781–1844)

The Reverend Daniel Parker came to Texas with his father, Elder John Parker, his brothers and other family members in 1833 to organize what became its first non-Catholic church. He and his extended family and followers first settled at Elkhart in what became Anderson County. Some stayed, but others moved to future Limestone County and established a log stockade called Fort Parker. In October 1835, while serving as a representative of the provisional Texas government, Daniel Parker introduced a measure to create a corps of Texas Rangers.

Delegates attending the meeting at San Felipe de Austin approved the resolution, and Daniel's brother Silas was named as one of three superintendents—each in command of a ranging company—"whose business shall be to range and guard the frontiers between the Brazos and Trinity rivers." Later, brother James Wilson Parker also headed a ranger company.

Following Daniel's death at sixty-three in 1844, he was buried in the cemetery adjacent to the church he founded, Pilgrim Primitive Baptist. A granite historical marker placed near Daniel's grave in 1936 explains his importance in the settling of this part of Texas and his role in the development of the Rangers.

A line of rangers has been established on the frontiers to protect the inhabitants from the savage scalping knife.
—Daniel Parker, Journal of the Permanent Council

Visit: Drive west from Elkhart on State Highway 294, turning left on Farm to Market Road 319. Take that road to Farm to Market 861, turn left and travel two and a half miles to the cemetery.

CYNTHIA ANN PARKER'S FIRST GRAVE

Cynthia Ann Parker—captured by Comanches in 1836 and rescued by rangers in 1860—died in Palestine in the fall of 1870, though the exact date has never been pinned down. Her family buried her in the Foster Cemetery near the community of Brushy Creek, and there she remained until 1910, when her son Chief Quanah Parker had her remains exhumed and reinterred at Cache, Oklahoma. A historical marker placed in 1969 marks the former grave site.

Visit: Six miles north of Brushy Creek off Farm to Market 315 at Millnar Road.

AUSTIN COUNTY

San Felipe

STEPHEN F. AUSTIN AND SAN FELIPE

In the fall of 1823, Stephen F. Austin laid out a town site near the Brazos River and named it San Felipe. For the next thirteen years, the log cabin village served as the capital of his colony as well as the social, economic and political hub of Anglo settlement in the Mexican province of Coahuila and Texas.

While Austin had been the first to conceive of a Ranger-like force, and armed men did fulfill that function throughout the 1820s, not until 1835 did the ranging concept become more or less formalized in Texas. And that happened at San Felipe.

As Anglo Texas began to disenfranchise itself from Mexican rule, an independence-minded body calling itself the Permanent Council realized it faced two major problems—a growingly dictatorial centralist government in Mexico City and the more imminent threat of hostile Indians. Meeting at San Felipe in October 1835, delegates spent the fall wrestling with both issues.

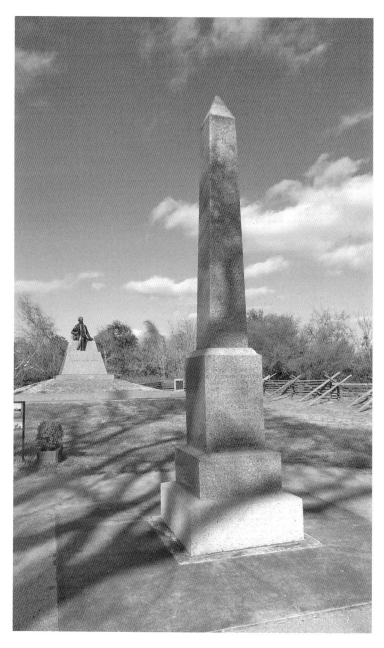

Monument at San Felipe honoring Stephen F. Austin, considered the father of Texas and the Rangers. *Photo by Mike Cox.*

A resolution offered by Daniel Parker on October 17 proposed a three-company, seventy-man ranger force. By November, a larger group of delegates referring to themselves as a "Consultation" further developed Parker's proposal, but not until November 24 did they pass an "Ordinance Establishing a Provisional Government." That document included twenty-nine articles and an appendage labeled "Of the Military." Article 9 of that provided for a "corps of rangers."

The Rangers had for the first time become a government force, but in the eyes of Mexican officials, what had taken place at San Felipe amounted to piracy, not the formulation of law. The words written by the delegates in ink would have to be purchased with blood.

San Felipe's chance of remaining one of the most important cities in Texas ended in the revolution that soon followed. After the fall of the Alamo in March 1836, residents of San Felipe torched the town and fled east with General Antonio Lopez de Santa Anna not far behind, bent on violently subduing Anglo Texas.

The town never regained its prewar significance, but given all that happened there, it is considered one of the most historically important sites in the state, the true birthplace of the Texas Rangers.

> *There shall be a corps of rangers under the command of a major.*
> *—Ordinance Establishing a Provisional Government,*
> *"Of the Military," Article 9*

Visit: San Felipe State Historic Site is six miles east of Sealy and forty-five miles west of Houston at 15945 Farm to Market 1458, north of Interstate 10. The site is on the left, just past Park Road 38 on the Brazos River.

BRAZORIA COUNTY
Angleton
STEPHEN F. AUSTIN STATUE

Considered the Father of Texas, colonizer Stephen F. Austin stands as a giant figure in Texas history. And since 2009, a concrete and steel statue of him holding a fifty-two-foot-long rifle has stood nearly eight stories tall (seventy-six feet) to remind passing motorists and visitors of his

significance to the state. Not only did he bring Anglo settlement to Texas in 1821, two years later, he proposed hiring ten rangers "for the common defense" of his fledgling colony—the traditionally accepted origin of the Texas Rangers.

Visit: U.S. 288 just south of State Highway 35. A visitors' center has interpretive exhibits. Brazoria County Historical Museum, 200 East Cedar Street.

BRAZOS COUNTY
College Station
SUL ROSS STATUE

Since its dediction on May 4, 1919, the bronze statue of former Texas Ranger Lawrence Sullivan Ross has stood watch in front of the copper-domed administration building overlooking the Academic Plaza on the campus of Texas A&M University. Designed by world-famous Italian sculptor Pompeo Coppini, the statue stands eight feet tall on a Texas granite base. Known by students as "Sully," Ross rode as a ranger captain before the Civil War and served as governor before becoming president of what was then Texas Agricultural and Mechanical College in 1891. Much revered by students and faculty, he held the post until his death in 1898. The old ranger likely saved the institution from closure due to financial problems. Ross also is credited as being the driving force behind the storied A&M spirit, one that stresses core values like leadership. For decades, students hoping for good luck on their exams have left a penny on the base of the statue.

Visit: A&M's visitors' center offers guided, self-guided and virtual tours of the sprawling campus, including one of its historic sites and statuary. For more information, see http://visit.tamu.edu/visitor-center/.

CHAMBERS COUNTY
Anahuac
THREE-LEGGED WILLIE

His parents named him Robert McAlpin Williamson, but in Texas lore, he is far better known simply as Three-Legged Willie.

He came by that handle due to a childhood disease that left his lower right leg permanently bent back at the knee. The wooden leg he wore made it look like he had an extra lower limb. While that was how he got his nickname, the thirty-one-year-old Georgian who came to Texas in 1826 to practice law (he also published several newspapers) earned his reputation as a hard-drinking fighter, jurist and lawmaker. He also played an important part in the development of the Rangers.

In the fall of 1835, the San Felipe–based General Council, Texas's revolution-minded quasi-government, elected Williamson as major in charge of the newly created "corps of rangers." This formalized the Rangers as an arm of Texas government, though at that point, Texas remained a rebellious Mexican state.

At the coastal town of Anahuac in 1832, Williamson became a strong independence advocate following a contentious dispute with the commander of the Mexican garrison there, Fort Anahuac. After the revolution, Williamson served in East Texas as a district judge (which made him a member of the republic's supreme court) and lawmaker during the days of the republic and early statehood.

During Williamson's time as a judge, an annoyed petitioner approached the bench with bowie knife drawn. "This is the law in Shelby County," the man said. The former ranger pulled a long-barreled pistol. "And this is the constitution that overrides your law," he ruled.

Williamson died in 1859 and was buried in Wharton. In 1930, his remains were relocated to the State Cemetery in Austin.

Visit: A historical marker chronicling Williamson's life stands at Fort Anahuac Park, 1704 South Main Street. A granite historical marker placed in 1936 briefly summarizes the history of the old fort and its role in the looming Texas Revolution. Wallisville Heritage Park, Exit 807 on Interstate 10, Wallisville.

EAST TEXAS

FORT BEND COUNTY
Richmond
ERASTUS "DEAF" SMITH (1787–1837)

In capturing a Mexican courier with dispatches that gave Sam Houston insight into General Santa Anna's movements, New Yorker turned Texan Deaf Smith's efforts clearly helped the fight go Texas's way at the Battle of San Jacinto.

In addition to the intelligence he gathered, Smith and his fellow scouts destroyed the Vince's Bayou Bridge to prevent the Mexican army from retreating. His actions earned him Houston's praise and a lasting place in Texas history, but not until the early twenty-first century did historians understand that Smith should be considered a Texas Ranger, not simply a skilled military scout.

Once Texas's independence had been ensured, Smith resigned from the army. But in the winter of 1836, when the newly created Texas Congress called for a mounted force to protect the republic's southwestern frontier, Smith organized a ranger company at San Antonio. One of the twenty-two men he recruited, a young surveyor originally from Tennessee, would become the most famous of the early Rangers—John Coffee Hays.

On February 21, 1837, Smith got orders to move his company toward Laredo. Though the old border city lay on the north side of the Rio Grande, for all practical purposes, it had remained in Mexican control. Their mission: Assert Texas's sovereignty.

Four days later, Smith's rangers joined cavalrymen under Lieutenant Colonel Juan Seguin to assist in providing a military funeral for the slain Alamo defenders, whose bone fragments and ashes had been collected and placed in a black coffin.

Leaving San Antonio on the first anniversary of the fall of the Alamo, the rangers rode south for ten days before encountering a small party of Mexicans. When the riders saw the rangers, they wheeled their horses and galloped to Laredo to report the approaching Texans. The following day, March 17, the rangers and a contingent of Mexican cavalry fought a pitched battle seven miles east of town. With ten Mexican soldiers killed and an equal number wounded, the rest of the cavalrymen retreated. Only two rangers sustained wounds in the fight.

Realizing Laredo held too many Mexican troops for his company to venture farther, Smith led his men back to San Antonio. That summer, he

resigned his ranger commission and moved to Richmond. He died there at fifty on November 30.

Visit: Smith is buried in Morton Cemetery, Richmond. A monument erected by the state in 1931 stands at the corner of Houston and Sixth Streets.

JAYBIRD-WOODPECKER FEUD

The bird sitting atop the high stone obelisk appears real at first glance. But a closer look reveals that the avian form is just as lifeless as the men whose names are carved on the base of what stands not so much as a monument to bravery but as one to political passion, misplaced southern pride and just plain orneriness.

Contrary to the "one ranger, one riot" myth, rangers did not always succeed in preventing violence. But sometimes they got shot up trying. Sent to Richmond in the summer of 1889 to avert bloodshed, in the end, the state lawmen could only dodge bullets and wire for help as near anarchy broke out one hot, humid evening.

What's known as the Jaybird-Woodpecker feud essentially reflected the enmity between two political factions and the pre–Civil War belief that African Americans could still be excluded from participating in democracy. White Democrats called themselves Jaybirds; the Republicans, many of them African American, were known as the Woodpeckers.

Politics had first turned bloody with the August 2, 1888 murder of Jaybird leader J.M. Shamblin. Matters worsened with the fatal shooting of Jaybird Ned Gibson by Woodpecker tax assessor Kyle Terry in nearby Wharton County on June 21, 1889. Not only had two Jaybirds been killed, the Woodpecker faction also won the election and continuing political control of Fort Bend County.

Adjutant General Wilbur King dispatched seven rangers under Captain Frank Jones to Richmond on June 28. As rangers had done before, Jones met with both sides to urge restraint. Satisfied he had succeeded in preventing further trouble, the captain left on July 10. But just in case, he left behind Sergeant Ira Aten and three men.

Aten and his men began regularly patrolling the town, assuming the state's show of force would defuse the situation. The peace held until shortly before 6:00 p.m. on August 16, when Aten heard gunshots. Quickly mounting his horse, he galloped downtown.

Gunmen fired from the upstairs windows of the Isaac McFarlane House in Richmond during the climactic battle of the Jaybird-Woodpecker feud in 1889. *Library of Congress.*

The sergeant approached the leader of each side fruitlessly exhorting them to stop shooting, but the twenty-seven-year-old sergeant knew better than to resort to force. Outgunned, Aten raced out of the line of fire along with two other rangers.

The battle raged for twenty minutes, an eternity in gunplay. Afterward, an innocent young African American girl lay dead from a stray bullet. Also dead were Woodpeckers Jake Blakely and Sheriff J.T. Garvey. Jaybird boss and saloon owner Henry "Red Hot" Frost suffered a grave wound and later died.

Another casualty was Ranger Frank Schmidt. An inert rifle round had unsaddled him, and a second slug traveling at full velocity tore into his leg. He never fully recovered and died of complications on June 17, 1893.

The human toll took most of the momentum out of the feud, but the killing did not end until January 21, 1890, when Kyle Terry, facing trial for Ned Gibson's murder, was gunned down by Ned's brother Volney Gibson inside the Galveston County Courthouse.

I said, "Boys, this is not our fight, save yourselves!"…I just run my horse right across the street, the only opening there was, made him jump that

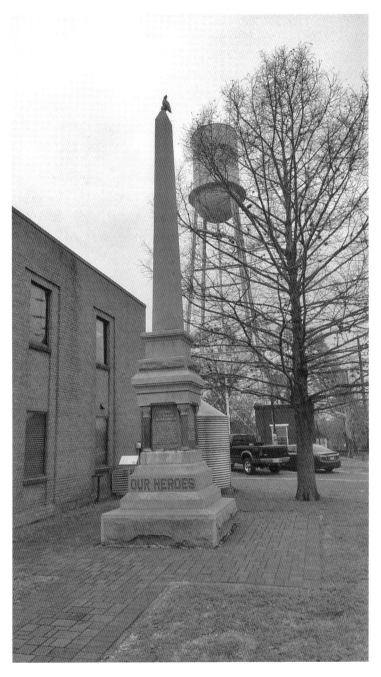

Jaybird monument erected in Richmond in 1896 to commemorate the bloody Jaybird-Woodpecker feud that claimed one ranger's life. *Photo by Mike Cox.*

EAST TEXAS

sidewalk, getting out of the shooting line. When I got there, I looked behind and [Schmidt]…*was shot down in the street.*

—*Ranger Sergeant Ira Aten*

Visit: The Isaac McFarlane House, from which several Jaybirds on the second floor fired numerous shots, still stands at 410 Jackson Street. A historical marker erected in 1985 gives its history. The courthouse the Woodpeckers defended stood at Third and Morton. It was razed in 1908 and a new courthouse built several blocks away. The square remained a park until 1940, when the Richmond City Hall covered part of it. Adjacent to city hall is the Jaybird monument, dedicated on March 18, 1896. Fort Bend County Museum, 500 Houston Street, Richmond.

GALVESTON COUNTY
Galveston
HARMONY HALL

Not everything that transpired at Harmony Hall could be called harmonious. Inside the hall on February 25, 1901, African American boxer Jack Jackson faced older, more experienced (and white) Joe Choynski, who knocked him out in the third round. But prize fighting was illegal in Texas, and rangers promptly arrested both pugilists. In jail, Choynski taught Jackson a few moves. A grand jury declined to indict the two boxers, but both received not-so-cordial invitations to leave the island immediately. The young dockworker, son of former slaves, went on to become heavyweight champion of the world and the most noted African American boxer prior to Muhammad Ali (Cassius Clay).

Visit: The hall, built in 1880, was destroyed by fire in 1928 and replaced the following year with Harmony Hall Masonic Lodge, 2128 Church Street.

LABOR TROUBLE AND VICE CRACKDOWN

When a dockworkers' strike that started in March 1920 threatened to seriously disrupt commerce, Governor William P. Hobby declared martial

law on the Galveston waterfront and sent in one thousand National Guard troops to prevent violence.

Realizing that the ready availability of alcohol (no matter national Prohibition law) aggravated the situation, on July 15, the governor expanded his martial law order, suspending the police chief and all his officers. At the same time, the general commanding the state troops announced that "all gambling and immoral houses must be closed, and the illegal manufacture, sale and importation of intoxicating liquor must be stopped."

In mid-September, after meeting with Galveston officials and civic leaders not pleased with the ongoing military control of their city, the governor agreed to end martial law and let rangers handle local law enforcement. Soon, ranger captain Joe B. Brooks became the acting police chief, and two dozen mounted rangers patrolled the streets.

By December, with the strike broken and considerable progress made in at least temporarily shutting down all the attractions that had always made the island city popular with seamen and visiting conventioneers, the rangers returned to their regular stations. The state lawmen made more than 1,500 arrests, but as soon as they left, Galveston's bars, brothels and gambling casinos resumed operation as the island city enjoyed its heyday as Texas's flat Monte Carlo.

Visit: Galveston's four-story Italian Palazzo–style city hall, built in 1914–16 at 823 Twenty-fifth Street, remains in use. In 1920, rangers headquartered at the police department there. The jail used then has long since been razed. Galveston County Museum, Galveston County Courthouse, Galveston County Historical Museum, Shearn Moody Plaza Building, Twenty-fifth and Strand, Suite 4157.

GREGG COUNTY

Gladewater

KILLING OF RANGER DAN L. McDUFFIE

Ranger Dan L. McDuffie happened to be at the police station on the night of July 7, 1931, when a report came in about a man staggering around downtown firing a rifle. McDuffie rode along with police chief W.A. Dial, saying he believed he could talk the man into giving up his gun. With the

Trying to help a law enforcement colleague, Ranger Dan McDuffie was gunned down in booming Gladewater in 1931. *Photo by Mike Cox.*

forty-eight-year-old ranger riding shotgun and two policemen in the back seat, the officers sped to the scene. As they drove up, the man fired a .30-30 at Dial. Missing Dial, the round shattered the windshield, hit the car's steering column and ricocheted into the ranger's leg, piercing his femoral artery. At that, the chief leaned from the car and emptied his .30-30 into the shooter, a former jailer he had fired for improper treatment of female prisoners and chronic drunkenness. Dial rushed the wounded ranger toward the hospital in Longview, but he exsanguinated before they got there.

McDuffie would be the last ranger to die at the hands of a gunman for the next forty-seven years.

> *It must be remembered with pride that Ranger Dan McDuffie lost his life because he did not want to kill his adversary, which he could have easily done without being injured himself...This is in direct refutation of the charge that enemies of the Texas Rangers...make in saying that the Rangers will kill at the slightest provocation.*
> *–Adjutant General W.W. "Bill" Sterling, Annual Report, 1931*

Visit: On July 7, 1967, the thirty-sixth anniversary of McDuffie's murder, a historical marker was unveiled at his grave in Reed Hill Cemetery in New Boston. A red granite memorial honoring the slain ranger was dedicated in Gladewater in the summer of 1998 outside Gladewater's East Texas Museum, 116 West Pacific Avenue.

Longview

DALTON GANG ROBS AGAIN

While no rangers were in town when outlaw Bill Dalton and his gang hit the First National Bank on May 23, 1894, Captain Bill McDonald and some of his men later stood guard to discourage the openly discussed lynching of one of the perpetrators.

Dalton and his associates "withdrew" $2,000 from the bank, but before they could make their getaway, lead started flying. In a twenty-minute exchange of gunfire with numerous townspeople, gang member Jim Wallace died along with two citizens. The rest of the outlaws made it out of town. The killing of two innocent men and the wounding of two others, not to mention the uninsured loss from the bank, so outraged the

populace that just for good measure they strung the dead outlaw from a telephone pole. Two weeks later, in Ardmore, Oklahoma, someone recognized a bank note Dalton tried to pass. A posse went after him, and he died in a gunfight.

Three years passed before anyone faced prosecution for the robbery. Arrested in Kimble County for cattle theft after a shootout with county lawmen, Jim Nite stood trial in Longview in 1897 for his part in the caper. That's when rangers had to make sure no one tried to adjudicate the case extralegally before the defendant made it to the courthouse. With the state lawmen present, no one interfered and justice ran its course, such as it was. Nite got twenty years, but Governor Oscar B. Colquitt later pardoned him. Still not rehabilitated, he later died in a gunfight in Tulsa, Oklahoma.

> *Defendant says that the citizens of Gregg County are so eager to have him tried here that he cannot get any compurgators to sign an application for a change of venue with him, and he here now makes oath to the foregoing and asks this Court to change the venue of this case of its own motion.*
> *—From motion filed by Jim Nite, December 27, 1897. Motion denied.*

Visit: The bank stood at 200 North Fredonia Street. A historical marker on the Fredonia Street side of Citizens National Bank marks the site. The courthouse where Nite saw trial was razed in the early 1930s to make room for the current building. The jail the rangers guarded is also gone. Gregg County Museum, 214 North Fredonia Street, Longview.

Kilgore

THE BLACK GIANT

The discovery of the wildly prolific East Texas oil field—called the Black Giant—temporarily suspended the Great Depression in this part of the state in 1931. Rangers converged on the derrick-studded boomtown of Kilgore to tame crime and later to enforce oil production conservation measures.

Ranger Manuel T. "Lone Wolf" Gonzaullas spent two weeks pretending to be an oil field denizen to learn who was who in the town's underworld. Then he reappeared in his customary cowboy hat, well-starched clothes and shiny boots—and matching pistols on each hip—to lead other rangers in arresting three hundred criminals of various stripes.

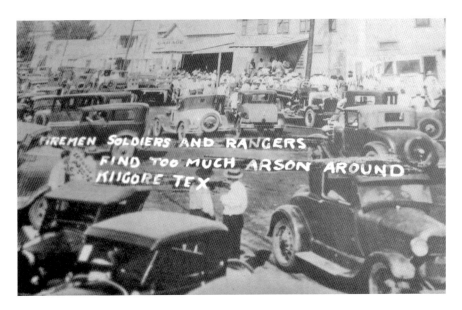

The East Texas oil boom kept rangers busy in Kilgore. *Author's collection.*

Kilgore not yet having a jail, the rangers chained their prisoners inside a recently vacated Baptist church. Absent any other evidence, rangers identified crooks, at least to their satisfaction, by inspecting their hands. Rough, greasy hands generally belong to a hardworking man. Smooth hands with neatly trimmed nails usually indicated a bootlegger, pimp, gambler or thief who didn't know the difference between a rod iron and a rotary table.

> *We put men on one end* [inside Kilgore's church-jail] *with chains around their necks and we put the women on the opposite end…And we never lost any prisoners.*
>
> *—"Lone Wolf" Gonzaullas*

Visit: East Texas Oil Museum, 1100 Broadway Boulevard, Kilgore.

KILGORE JUNIOR COLLEGE RANGERETTES

The Texas Rangers did not have any female rangers until 1993, but Kilgore Junior College has had its Rangerettes since before World War II.

Long before the state started commissioning female rangers, Texas had its Kilgore Junior College Rangerettes. *Author's collection.*

Under the direction of Miss Gussie Nell Davis, the world-famous precision drill team made its first white-booted high kicks in 1940, the "brainchildren" of then college president Dr. B.E. Masters. He wanted to attract more female students and come up with something that would keep his male students from leaving the stands to drink during football game halftimes. With the Rangerettes marching and dancing beneath white cowgirl hats in red blouses and short blue skirts, he accomplished both goals. Still kicking after all these years, the Rangerettes enjoy the distinction of being the world's first precision drill team.

Visit: Rangerette Showcase and Museum, Kilgore Junior College Campus in the Physical Education (PE) Complex, Broadway and Ross Streets, one block west of U.S. Highway 259.

GRIMES COUNTY

Navasota

JEFF MILTON (1861–1947)

When young Jeff Milton came to Texas from Florida in 1877, he stayed for a time with his sister, Fannie Milton Yarborough, in Navasota. Her husband, James Quincy Yarborough, along with two partners, operated a flourishing mercantile business there. Milton clerked at the store for a while, but when the firm's two bookkeepers left to take up cattle ranching in West Texas, he decided to throw in with them. With a new .44-40 Winchester he rode west. Milton later joined the Rangers, living an action-filled life that writer-historian J. Evetts Haley chronicled in his book, *Jeff Milton: Good Man with a Gun.*

Visit: The two-story redbrick building where the future ranger worked stands at 100 West Washington Avenue in Navasota. A historical marker was placed on the former store in 1980.

FRANK HAMER STATUE

Getting a finger shot off after just a week on the job, Marshal W.B. Loftin saw it as an omen and notified the Navasota city council that he would be turning in his badge.

For a small town of three thousand, lawlessness had reached big city proportions. Democrats and Republicans exchanged invective, and while that was nothing new, the political war of words had escalated into periodic gunplay. Meanwhile, bigoted, brutal white men terrorized the local black population. To cap all that, saloons and gambling halls ran wide open.

In desperation, the mayor asked for rangers. Soon, two state lawmen arrived, Company C Sergeant John Dibbrell and a young private, Frank Hamer. The presence of the rangers had the hoped-for calming effect, but when the state officers left, conditions reverted to the way they had been.

With Marshal Loftin gone, the city needed a new marshal. The mayor wired Dibbrell to offer him the position. He said no thanks but recommended Hamer.

The twenty-three-year-old Hamer agreed to take the job, resigned from the Rangers and on December 3, 1908, set about dealing with the sociopolitical issues at hand. A few shin kicks and face slaps—Hamer trademarks—and a couple of killings later, peace reigned in Navasota. On April 20, 1911,

A life-size bronze of Ranger Frank Hamer stands perpetual guard outside Navasota's city hall. *Photo courtesy Russell Cushman.*

Hamer resigned and moved on to a special investigator job in Houston before rejoining the Rangers in 1915.

The impact Hamer had on conditions in Navasota became part of local folklore. In 2012, expressing its appreciation long after the fact, the city council commissioned artist Russell Cushman to do a life-size bronze statue of Hamer. Dedicated in 2013, it stands in front of City Hall.

Visit: 202 East Washington Avenue.

THE BURIED BADGE

Not long after taking on the marshal's job, Hamer hired another ranger as his deputy, Marvin E. Bailey.

Hamer had joined the Rangers in April 1906, eight months after Bailey and only a month before R.M. "Duke" Hudson enlisted in Company C. All reported to Captain John H. Rogers in Alpine.

A few years after Hamer left Navasota, his friend Bailey (who in the spring of 1910 had been appointed captain of Company B) hired on as marshal. He later worked as a Grimes County sheriff's deputy under former ranger Hudson, sheriff from 1924 to 1928. Bailey remained in Navasota through at least 1940, when he was chief deputy under Sheriff Earl Harris. Known in Navasota as "Cap" Bailey, he died in Houston on August 8, 1953, and is buried in San Antonio's San Fernando Cemetery Number 3.

In the spring of 1999, nearly ninety years after Bailey's Ranger service ended, a man digging in his garden in one of Navasota's older neighborhoods hit something metallic about ten inches deep. Wiping the dirt off the object, he saw it was an old Texas Ranger badge. Not only that, stamped on it was "Captain M.E. Bailey/Company B/Texas Rangers." Turns out, the person who found the badge owned the house where Bailey had lived. Knowledgeable folks who examined the copper badge pronounced it authentic.

Visit: The former ranger's house is at 415 Church Street. The old Grimes County Jail where former Ranger Hudson lived with his family stood at the county seat in Anderson until razed in 1956.

HARRIS COUNTY
Houston
RANGERS IN THE BATTLE OF SAN JACINTO

Even some serious history buffs don't know that nearly 10 percent of the Texans who participated in the pivotal Battle of San Jacinto—the brief but bloody engagement that bought Texas's independence from Mexico—were either former or current Texas Rangers.

The battle began about 4:00 p.m. on April 21, 1836, six weeks after General Antonio Lopez de Santa Anna's troops stormed the Alamo in San Antonio de Bexar and killed all its defenders. At a point in present Harris County where Buffalo Bayou flows into the San Jacinto River, some 930 Texans under General Sam Houston defeated more than 1,300 Mexican soldiers, killing 630 and capturing 730. Only 9 Texans died outright or suffered mortal wounds.

In one eighteen-minute battle, the course of the Texas Revolution (international historians refer to the period as the Federalist War of 1835–

1836) had changed. Now considered one of the more significant military encounters in world history, had Mexico prevailed that spring afternoon, the United States likely would have been a much smaller nation—one without Texas, New Mexico, Arizona and California and some additional territory to boot.

While every Texas public school student learns this story in state-required Texas history classes in the fifth and seventh grades, the role of the rangers in the battle is poorly understood. More than eighty men in the Texas ranks had served as rangers either engaged in combat that day or detailed to protect the Texas army's supplies behind their lines at Harrisburg. Contemporary accounts are clear that those left at the rear considered it less than a plum assignment and did so only because they had orders to stay. Of the thirty-six rangers who did fight, four are well known: Robert "Three-Legged Willie" Williamson, John J. Tumlinson Jr., Isaac Watts Burton and Ben McCulloch.

Any armed confrontation is rich in irony. One of the Mexicans who survived the vicious fighting, which degraded into mass slaughter before Houston reined in his men, was First Sergeant Francisco Becerra. Wounded before his capture by the Texans, after the battle he stayed in Texas. Not only that, by March 1839, he rode as a Texas Ranger.

Visit: The San Jacinto Battleground State Historical Park is off State Highway 225 East, twenty-two miles from downtown Houston at One Monument Circle, La Porte. San Jacinto Museum of History is in the San Jacinto Monument at the San Jacinto Battleground State Historical Park.

JAMES WILSON HENDERSON (1817–1880)

When former Texas Ranger Peter H. Bell resigned as governor on November 23, 1853, Lieutenant Governor Henderson was sworn in as his replacement the same day. A native of Tennessee, Henderson had ridden as a ranger under Captain Jack Hays, earning the nickname "Smokey." Henderson served as the state's chief executive for only twenty-eight days before a duly elected governor took office. He served again in the legislature in 1857 and as a captain in the Confederate army during the Civil War. He died in Houston on August 30, 1880.

Visit: Glenwood Cemetery, 2525 Washington Avenue.

JEFFERSON COUNTY
Beaumont

When the Spindletop well blew in on January 10, 1901, Texas and the rest of the nation entered the modern age. Nearby Beaumont boomed, with tens of thousands rushing to Jefferson County from across the nation to capitalize on the new oil play.

By 1903, the Spindletop field had already begun to wane. But a new play developed north of the small Hardin County town of Batson, and it, too, soon mushroomed. By January 1904, crime there had grown out of hand, and Governor Samuel W.T. Lanham dispatched ranger captain J.A. Brooks. When Brooks returned to Austin to report that conditions were indeed bad, the governor sent him back on February 7 with three rangers. This marked the first time Texas Rangers were used to tame a lawless oil boomtown, but it would not be the last.

> *Before his* [Brooks's] *arrival the town was in a constant turmoil, while now everything is peace and quiet. The bad man full of whiskey with his six-shooter has taken to the woods.*
> —*"Card of Thanks" from the citizens of Batson,* Houston Post

Visit: Off State Highway 105, thirty-seven miles northwest of Beaumont. Spindletop–Gladys City Boomtown Museum, 5550 Jimmy Simmons Boulevard, Beaumont. Museum of Hardin County History, 830 South Maple Street, Kountze.

LIMESTONE COUNTY
Groesbeck
FORT PARKER

The sturdy split cedar-log stockade and twin blockhouses built in 1833–34 by the family and followers of Elder John Parker would figure in one of the classic dramas of American frontier history: the capture and subsequent rescue of Cynthia Ann Parker. Much less known is that before that happened

the fort served as the rendezvous point for the first ever government-authorized Texas Ranger force.

On July 31, 1835, four volunteer ranger companies arrived at the fort on the Navasota River to join with a fifth company commanded by Captain Robert M. Coleman, who had strongly advocated creation of a tax-funded ranger force to protect settlers from hostile Indians. This body constituted the first ranger battalion organized as an arm of Texas government, even though Mexico saw that government as illegal.

The rangers bought beef, corn and bacon from the Parkers and, after reorganizing into four companies and electing John M. Moore as their commander, left the fort in August on an Indian expedition. Moore's rangers had a few skirmishes, killing a handful of Indians while losing one of their own, but the battalion was mustered out of service at Bastrop in mid-September, its results far from spectacular.

Had it been possible to maintain a ranger presence at or near Fort Parker, what happened in the late spring of 1836 might have been averted. But by then, even though Texas forces had finally prevailed in freeing the former province from Mexico, frontier protection amounted to only one of many issues awaiting the attention of the nascent Texas republic.

The Parker family built this log fort near present Groesbeck and played a major role in the development of the Rangers. *Author's collection.*

On the morning of May 19 that year, several hundred Comanche and Kiowa warriors approached the fort. Most who lived in and around the stockade were working their fields at the time. The Indians killed five men, including family patriarch John Parker and two of his sons, Benjamin and Silas, and kidnapped five women and children, including Rachel Plummer and little Cynthia Ann Parker. The others managed to escape.

The saga of Cynthia Ann did not end here, but this historic spot is where it had its beginning—along with the Texas Rangers as an arm of government.

> *I was vain enough to try to save myself,* [but] *they soon headed me* [off], *and one large sulky looking Indian picked up a hoe and knocked me down. I well recollect their tearing my little James Pratt out of my arms, but whether they hit me any…more I know not, for I swooned away.*
> —*Rachel Plummer's narrative*

Visit: Reconstructed in 1936 by the Civilian Conservation Corps, old Fort Parker was part of Fort Parker State Park when it opened in 1941. By 1965, the fort badly needed renovation, which the state funded and oversaw. In 1992, the Texas Parks and Wildlife Department deeded the reconstructed fort to the city of Groesbeck, which continues to operate it. The state park remains as a separate attraction.

FORT PARKER MEMORIAL PARK

A year to the day after the attack, James Parker (who had been a ranger for a time) led an armed group to the abandoned fort and collected the animal-gnawed bones of the victims. They buried five sets of remains in a common grave, the beginning of a cemetery first called Union Burial Ground, then Lewisville Cemetery, then Glenwood Cemetery and, finally, Fort Parker Memorial Park. A concrete slab marks the grave. A large monument was dedicated at the site in 1932.

Visit: Off Farm to Market Road 1245, on State Park Road 35, at Fort Parker Historical Park, north of Groesbeck. The Fort Parker site has exhibits and signage on the massacre and its aftermath.

EAST TEXAS

Mexia

RANGER CRACKDOWN

As had happened elsewhere, and would unfold again in other places, the discovery of a large oil field in Limestone County in 1920 led to the rapid growth of a once small town. Seemingly overnight, Mexia's population exploded from four thousand to fifty thousand. Unfortunately for the rule of law, some of those people made their living illegally.

On January 7, 1922, Adjutant General Thomas Barton led two ranger companies on raids of the two worst gambling and boozing hot spots in the county. Four miles east of Mexia on the Teague road (present U.S. 84), one company converged on a joint called the Winter Garden, quick-freezing illegal activity with numerous arrests. At the same time, north of town near the community of Wortham, the second ranger company hit a dive called the Chicken Farm.

Armed with shotguns and some just-introduced Thompson Model 1921 .45-caliber submachine guns, rangers confiscated gambling paraphernalia and ample quantities of bootleg booze.

Four days later, still concerned about crime and vice in the community only forty-one miles from his hometown of Waco, Governor (and future Baylor University president) Pat Neff declared martial law in portions of both Limestone and adjacent Freestone Counties and sent in state troops. An estimated three thousand residents suddenly found it expedient to leave.

The cleanup saw two firsts in Ranger history: prisoners got photographed and fingerprinted, the forensic expertise courtesy of the Houston Police Department. Also for the first time, the state used an airplane for law enforcement purposes. The flights revealed illegal moonshine stills hidden in the sticks along the Trinity River bottom in adjacent Freestone County. Thanks to aerial photographs of the stills, prosecution proved easier.

> *Courageous and impersonal in the performance of duty, they exemplified on every occasion the highest ideals and the best traditions of the Ranger Force that constitutes so great a part of the glorious history of Texas.*
> —Adjutant General's Department Annual Report, 1921–1922

Visit: A historical marker placed in 1967 just south of Mexia on State Highway 14 tells the story of the Mexia boom.

NAVARRO COUNTY
Corsicana
THOMAS INGLES SMITH (1800-1848)

Born in Virginia, Smith got his first taste of combat during the War of 1812 when only a boy. He came to Texas in 1836, enlisting in the Republic of Texas army. After the revolution, he served again in the Battle of Salado on September 18, 1842. Three months later, with Eli Chandler, he co-commanded a small detachment of rangers with a sensitive assignment: remove the young republic's government records from the congressionally selected capital of Austin to Washington-on-the-Brazos as ordered by President Sam Houston.

When Smith and his men showed up with three wagons and began loading them with documents, the people of Austin took serious umbrage. If another town became capital, which possession of the government records would certainly foster, Austin—no metropolis even as it was—would become a ghost town. Following a show of force that included the firing of a howitzer in the general direction of the rangers, Smith's men hastily left with what they had been able to load so far.

A vigilante group led by a former ranger chased the wagons to Brushy Creek in present Williamson County, fired a few shots and recovered the papers.

Smith continued to serve periodically as a ranger and Indian scout throughout the life of the republic. Appointed as a commissioner to negotiate with Indians, he was a signatory to the last treaty between the republic and Indians.

Owning land with two partners in what would become Navarro County, he donated the town site for Corsicana and served on the commission that selected it as the county seat in 1848. A historical marker commemorating Smith was erected in Corsicana in 1986.

Visit: Navarro County Courthouse, 601 North Thirteenth Street, Corsicana.

JONES RANCHO

In 1869, Colonel Henry Jones, father of future Frontier Battalion commander Major John B. Jones, moved to 2,500 acres he owned in western Navarro County. The colonel raised horses on the land. That June, the elder Jones conveyed 500-plus acres and half his herd to his son. Though the younger

Jones lived in Austin during his seven-plus years of state service and traveled widely across the state, he returned to Corsicana and his "rancho"—clearly a place of mental refuge for him—as often as he could. The property remained in Jones's family after his death but was later sold.

Jones was active in the Masonic order, eventually becoming the state's grand master. While commanding the Frontier Battalion, he periodically attended lodge meetings in Corsicana. At the time, his lodge met upstairs in the S.B. Pace Building.

Visit: The Jones ranch lay seven miles west of the old town of Dresden, or twenty miles west of Corsicana. A historical marker detailing Dresden's history stands in the community cemetery, all that remains of the settlement. Take State Highway 55 south from Blooming Grove for five miles, then turn west onto Farm to Market Road 744 and drive a half mile to the cemetery. Built in 1875, the two-story brick Pace Building is located on the northeast corner of South Beaton Street and West Sixth Avenue.

RANGER IRA ATEN REPORTS

Corsicana wasn't really a cow town, but following the invention and spread of barbed wire, Navarro County landowners using the new product to fence their land experienced serious resistance from those opposing the partitioning of range country by means of a flesh-ripping wire.

Sergeant Ira Aten, Frontier Battalion Company D, got orders to spend time in the county working undercover to stop the fence cutting. Threatening to affix what he called "dynamite booms" designed to explode when someone snipped a strand of barbed wire, the ranger used a little psychology to end the problem. The only tangible evidence of the ranger's efforts, his bravado-filled reports to headquarters, are filed away at the Texas State Library and Archives in Austin.

> *Nothing will do any good here but a first class Killing* [sic] *& I am the little boy that will give it to them if they don't let the fence alone.*
> —Sergeant Aten to Captain Lamartine Sieker, August 31, 1888

Visit: Vicinity of the Richland community, twelve miles south of Corsicana. Pioneer Village, 912 West Park Avenue; Pearce Museum, Navarro Junior College, 3100 West Collin Street, Coriscana.

ORANGE COUNTY
Orange
No Close Shave for Ranger Fuller

Oscar Poole, the county judge's son, apparently never heard the old admonition against taking a knife to a gunfight. Struggling to arrest the knife-wielding Poole, Ranger T.L. Fuller shot him to death in Orange on December 21, 1899. City police arrested the ranger, but soon cut him loose, the shooting clearly a justified homicide.

After Fuller moved on to another trouble spot in the state, he learned that he and fellow ranger A.L. Saxon had been indicted in Orange County for false imprisonment. Their captain, Bill McDonald, warned that was only an attempt to get Fuller back in Orange for retribution, but the adjutant general overruled McDonald and ordered recently promoted Lieutenant Fuller and Private Saxon to return to southeast Texas to deal with the legal issue.

On October 15, 1900, during a break in his trial, Fuller and Saxon walked to a nearby barbershop for shaves. About 5:30 p.m., as Fuller leaned over a sink to wash his face, a man walked into the barbershop with a Winchester and shot the ranger in the head. The gunman ran to a butcher shop next door, where local officers arrested him. He turned out to be Thomas Poole, the brother of the man Fuller had killed the year before.

A clearly partisan jury acquitted Poole in the murder of the ranger, but in March 1902, Poole lost a gunfight with Orange city marshal James A. Jett. Not willing to let bygones be bygones, less than two months later, George, Claude and Grover Poole shot and killed Marshal Jett.

Visit: The last Frontier Battalion ranger killed in the line of duty before the service was formally renamed as the Texas Rangers, Fuller died inside Adam's Barbershop, which occupied rental space on the ground floor of the two-story Custom House Saloon building on Front Avenue (contemporary newspapers did not give the numerical address) in downtown Orange. The building was destroyed by fire on December 22, 1911. Fuller is believed to be buried near Fulshear in Fort Bend County, but his grave has not been located.

EAST TEXAS

SABINE COUNTY
Hemphill
Four Rangers Down

Willis Conner didn't start out as an outlaw. He was just a Georgia-born Confederate vet who believed in handling his own business. For instance, if a body stole some of the hogs that ran on his land, especially after being warned to tend his own stock, Conner saw no need in troubling the sheriff over the matter.

When concerned friends found the missing Kit Smith and Eli Low shot to death in Holly Bottom on December 5, 1883, the Sabine County sheriff's office started looking into Conner's whereabouts on the day of the killings. Everyone knew bad blood existed between the Conners and the Smiths and the Lows, and now some of that blood had been spilled.

On February 16, 1884, a grand jury indicted Conner and four of his five sons for the killings. For their safety, the sheriff transferred the Conners to the Nacogdoches County Jail pending trial. That proceeding took place in San Augustine County, where a jury found three of the boys guilty. Willis Conner would be tried separately, and charges against the other son had been dropped.

In early 1885, an armed party sprang the Conners from jail, and they lit out for the tall pines they knew so well. Word spread, as one lawman recalled, that the Conners had made it plain they intended if necessary "to die right there with their shoes on, looking their enemies…in the face." The truth is they crossed into Louisiana until things cooled off a bit.

When local authorities got word that the Conners had finally slipped back into Sabine County, they requested assistance in getting the Conner clan back in jail and on their way to prison. Rangers under Captain William Scott arrived on March 29, 1887, and soon learned the Conners' hiding place.

At daybreak on April 1, the rangers moved in. Alerted by their hunting dogs, the Conners came out shooting. When the gun smoke dissipated, Ranger James H. Moore lay dead, a bullet in his head. The rangers had killed one of Conner's sons—the only son they did not have a warrant for—but his innocence had ended when he started shooting at the lawmen. Captain Scott had been gravely wounded, and Rangers J.A. Brooks and John Rogers had significant though nonfatal wounds. But the elder Conner and the rest of his boys had escaped.

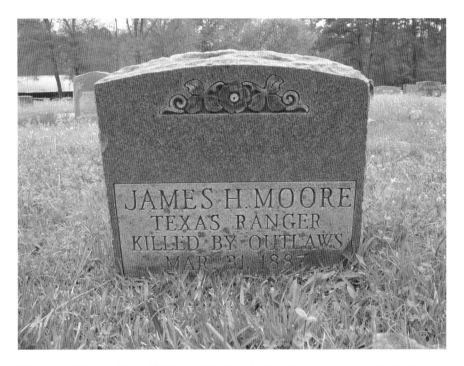

The grave of Ranger James H. Moore, killed in a Sabine County shootout with the Conner family. *Photo courtesy Weldon McDaniel.*

A posse found one of the convicted Conners the following October and killed him in a gunfight. In November, Willis Conner and his eight-year-old grandson died at the hands of another posse. Folks said they killed the young boy just to end the Conner bloodline.

> *A terrible fight occurred* [yesterday] *morning, ten miles below Hemphill, in Sabine County Texas, between Captain Scott and his little company of State rangers on the one side and old Willis Conner and his sons on the other.*
>
> —Salt Lake Herald, *April 2, 1887*

Visit: Ranger Moore is buried in the Hemphill Cemetery, one-tenth of a mile south of the courthouse on South Texas Street. When word of the shootout reached Moore's brother, Kerr County sheriff Frank M. Moore, he went to East Texas to bring his brother's body home for burial. But by the time he got to Sabine County, Moore had been buried, and his brother decided to leave him be. He did claim the dead ranger's horse, however. The two-

story, redbrick jail the Conners escaped from, built in 1883 and used until 1919, still stands in San Augustine. Sabine County Historical Commission Museum and Library, 201 Main Street, Hemphill.

SAN AUGUSTINE COUNTY
San Augustine
SAN AUGUSTINE CLEANUP

Four days before Christmas in 1934, a fistfight escalated into a shootout in front of the W.R. Thomas hardware store in downtown San Augustine. When it was over, two men lay dead and two others were mortally wounded. Responding to the county sheriff's request for help, on January 5, 1935, the state dispatched a ranger captain and three privates to San Augustine. But they had no success in getting to the root of the problem, which had to do with two well-established criminal factions involved in everything from hog theft to robbery and murder. One thing both gangs had in common were their victims: black sharecroppers and their families.

After newly elected Governor James Allred took office later that month, he appointed an old friend, former Wichita Falls police chief James W. McCormick as a ranger captain. In addition to his municipal law enforcement experience, McCormick had spent eight years in the Rangers. His specialty, well honed as an oil boomtown cop, was town taming.

McCormick arrived with three rangers. Walking the streets with a pistol on each hip, a third in a shoulder holster and one tucked discretely in his boot just in case, the captain assured the townspeople they had nothing to fear in coming forward to testify before the grand jury. Statements rangers took and evidence they gathered led to one hundred indictments and forty prison sentences.

Only two months after the rangers came, conditions had improved so much that grateful residents hosted a street dance in the rangers' honor.

Visit: Still a hardware store (but with a different name and owners), the building where the shootout occurred stands at 134 West Columbia. The grand jury testimony and court proceedings that broke up the criminal factions occurred in the 1927-vintage San Augustine County Courthouse, Main and Broadway. Prisoners arrested by the rangers were

held in a two-story brick jail built in 1919 that continued in use until the first decade of this century. The San Augustine County Historical Commission and two other organizations were raising money in 2015 to restore the old lockup.

SMITH COUNTY
Tyler
BRYAN MARSH (1833-1901)

Bryan Marsh, an Alabamian who came to Tyler in 1854, lost his right arm fighting for the South during the Civil War, but that didn't hamper a long career in law enforcement. He served as Smith County sheriff from June 25, 1866, to November 1, 1867, when ousted during the federal military occupation of Texas following the Civil War. Marsh later completed a second term as sheriff from 1876 to 1878.

In 1880, he received command of Company A, Frontier Battalion, and served until his company disbanded due to budget constraints in 1881. During his captaincy, he successfully defused a racially charged situation in San Angelo and helped preserve some semblance of law and order in a succession of frenetic railroad towns as the Texas and Pacific Railroad laid the first tracks across West Texas.

Back in the piney woods, Marsh served again as Smith County sheriff from 1886 to 1892. As a lawman, he never wore a gun. The story goes that whenever someone asked why he went unarmed, the former ranger would reply, "What would a one-armed man do with a gun anyway?" Marsh otherwise made a living as a planter and merchant.

> [H]*e would drink right smart and scrap right smart. He was an old Confederate war colonel with one arm shot off at the shoulder, and the other hand almost gone. But he would fight his shadow; wa'n't afraid of anything.*
> *—Former ranger Jeff Milton*

Visit: Marsh is buried in Tyler's Oakwood Cemetery. Tyler's first elementary school, opened in 1886 in the 700 block of North Bois d'Arc Street and rebuilt on the same site in 1917, bore the former ranger's name. A historical marker commemorating Marsh was placed on the building in 1963. Seven

years later, U.S. district judge William Wayne Justice ordered the old school closed as part of a school desegregation plan. Marsh spent time in the two-story brick, 1881 Smith County jail during his last three terms as sheriff. Various accused felons arrested by rangers cooled their heels in this lockup, which continued in use until 1916. A former jailer purchased the facility at 309 East Erwin Street and converted the old Cross Bar hotel into a real hotel, which flourished during the East Texas oil boom. Listed on the National Register of Historic Places, the former jail has been restored to its original appearance and now serves as a law office. Smith County Historical Museum, 125 South College Avenue.

WALKER COUNTY
Huntsville
SAMUEL H. WALKER (1810–1847)

In a quirky instance of place name selection, Walker County had been Walker County for seventeen years when the Texas legislature decided to "rename" it Walker County in honor of noted Republic of Texas–era ranger Samuel H. Walker. When created in 1846, the county was named for Robert James Walker (1801–1869), a Mississippian who had strongly supported the annexation of Texas into the United States. But in 1863, state lawmakers realized Walker County officials wouldn't have to change any stationery or signage if they renamed the county for the former ranger who fell in the Battle of Monterrey during the Mexican War.

Visit: A 1936 granite historical marker 1.4 miles northwest of Huntsville reveals the story behind the county's name. Walker County Museum, 1228 Eleventh Street, Huntsville.

THE WALLS

The long, colorful history of the state prison system is entirely separate from that of the Texas Rangers, but beginning with the rangers' transition from Indian fighters to state lawmen, the rangers have placed many a convict behind its bars.

During the days of the Republic of Texas, individual counties took care of housing convicted felons, but after statehood in 1845, the legislature established a state prison in 1848. Governor George T. Wood appointed a three-member committee to select a location, and the group picked Huntsville. Exactly why the small town on the edge of the piney woods got selected has never been determined, but one of the decision makers hailed from Walker County, and Sam Houston lived in Huntsville. To be fair, the community had agreed to donate construction material to the state to lower costs.

The committee soon purchased 4.8 acres (total cost: $22) for the prison, plus an additional 94.0 acres ($470) to give room for future use.

In 1849, with construction of a brick facility under way, a temporary lockup built of heavy logs went up to house any prisoners who arrived before completion of the more secure facility. That October, the man who got the dubious honor of being the first state prison inmate was a convicted horse thief from Fayette County.

The Rangers were our best customer.
—James Estell, Texas Department of Criminal Justice director, 1972–82

Visit: The Texas Prison Museum, 491 Highway 75 North.

SAM HOUSTON (1793–1863)

Sam Houston had many ties to the Texas Rangers, beginning with his use of rangers during the Texas Revolution and continuing during his two nonconsecutive terms as president of the Republic of Texas. As a U.S. senator, he fought for federal funding for the Rangers and once again commanded them as state governor, his last public office. While governor, he ran the Rangers like they were his private army. In fact, he briefly fantasized about using the rangers to conquer Mexico, a scenario in which he envisioned himself as leader. Some historians have speculated Houston was only trying to divert secessionists from joining the Confederacy.

The general spent the last years of his life in Huntsville, where he died on July 26, 1863, during the Civil War he had warned strongly against.

Give me a few Rangers and I will get it done.
—Sam Houston

Visit: Houston Monument. Dedicated on October 22, 1994, a towering sixty-seven-foot statue of Houston standing on a ten-foot base. Take exit 109 or 112 off Interstate 45 to 7600 State Highway 75 South in Huntsville. Visitor's center. Houston is buried in Oakwood Cemetery, Nineth Street and Avenue J. Sam Houston Memorial Museum, 1836 Sam Houston Memorial Drive, Huntsville.

WASHINGTON COUNTY
Burton
Leander Harvey McNelly (1844–1877)

A slight, tubercular southerner whose appearance belied the stereotypical image of the tall, brawny state lawman, Leander H. McNelly helped forge the Ranger reputation.

Born on March 12, 1844, in Virginia, he lived briefly with his brother Peter's family in Missouri, eventually returning to the Old Dominion. When Peter McNelly moved to Texas, buying land in Washington County, his younger brother came along. As a teenager already afflicted with debilitating lung disease, McNelly herded sheep for Travis J. Burton, namesake of the Burton community.

No matter his undependable health, when the Civil War began, McNelly enlisted as a private in the Fifth Texas Cavalry. Having seen action in New Mexico and Louisiana as well as in Galveston, McNelly had risen to captain by war's end.

In 1865, McNelly returned to Washington County and took up farming. But McNelly liked the feel of horseflesh between his legs and evidently did not mind the smell of gunpowder. When the legislature created a uniformed state police force in 1870, McNelly gained a commission as one of its four captains. Wounded once in the line of duty, he served until the legislature abolished the agency in 1873.

When the legislature formed the Washington County Volunteers in 1874, McNelly became its captain. The Special Force, as it was more commonly known, was distinct from the newly created Frontier Battalion of rangers—but only in nomenclature. In form and function, McNelly and the men he recruited were rangers.

The grave of Captain Leander McNelly at Burton lies beneath an ornate monument placed by the owner of the King Ranch. *Photo by Mike Cox.*

McNelly's Rangers, as they tended to call themselves, worked to suppress violence in the bloody Sutton-Taylor feud and in the Nueces Strip, a virtual no-man's land between the Nueces River and the Rio Grande. McNelly did not always abide by the rules, but he helped build the Rangers' reputation for effective, no-nonsense law enforcement.

The captain and his men faced feudists, outlaws and Mexican raiders, but McNelly's most dangerous foe was the persistent bacterium that continued to flourish in his lungs. Forced to resign due to his health, he died on September 4, 1877.

Richard King, founder of the legendary South Texas ranch that bears his name, thought so highly of McNelly that he placed a sixteen-foot, $3,000 granite monument over the captain's grave.

Visit: Mount Zion Cemetery, three miles north of Burton at State Highway 390 and FM 1948. Texas Cotton Gin Museum, 307 North Main Street, Burton.

MATSON-McNELLY HOUSE

When McNelly recruited his soon-to-be-famous ranger company, he; his wife, Carey Cheek Matson; and their two children lived in a two-story

McNelly and Carrie Matson got married in this house in 1865, and the captain died here in 1877. *Photo courtesy Larry Lessard.*

antebellum frame house on 1,100 acres four miles from Burton. Carey's father died in the Civil War, and her mother followed him in death on January 1, 1865, leaving the sixteen-year-old girl sole owner of the property. Back from the war, McNelly began seeing Carey, and they married in the house on October 17, 1865. Only thirty-three, the captain died in the house in the late summer of 1877. By the 1980s, the old house had been cut in two sections and was being used for grain and hay storage. Sue Rowan Pittman purchased the two halves, had the disjointed structure moved to her rural property about a mile from Burton and restored the 1850s house to its former splendor.

Visit: Painted period peach pink with green awnings, the house stands on private property at 9902 Farm to Market 390, about one thousand feet off the roadway. It changed hands twice following its restoration, but the current owners have had the house since 1996.

Washington

WASHINGTON-ON-THE-BRAZOS

A delegation of worried if gutsy Texans (though only two had actually been born in Texas) gathered at Washington-on-the-Brazos on March 1, 1836, to formalize what had already begun—a rebellion against Mexico.

By then, the Republic of Mexico had decided what to do about its Texas problem: kill anyone involved in what the Mexican government viewed as treasonous actions. As the delegates convened in Washington-on-the-Brazos, soldiers under General Antonio Lopez de Santa Anna had already surrounded the Alamo. In barely five days, they would storm it and kill every male combatant inside.

Meeting in a drafty frame building, the delegates adopted a declaration of independence on March 2. Three of the fifty-nine signers were rangers or had been, Matthew "Old Paint" Caldwell, Robert M. Coleman and Sterling C. Robertson.

Visit: Washington-on-the-Brazos State Park. Star of the Republic Museum. 23200 Park Road 12, Washington, Texas.

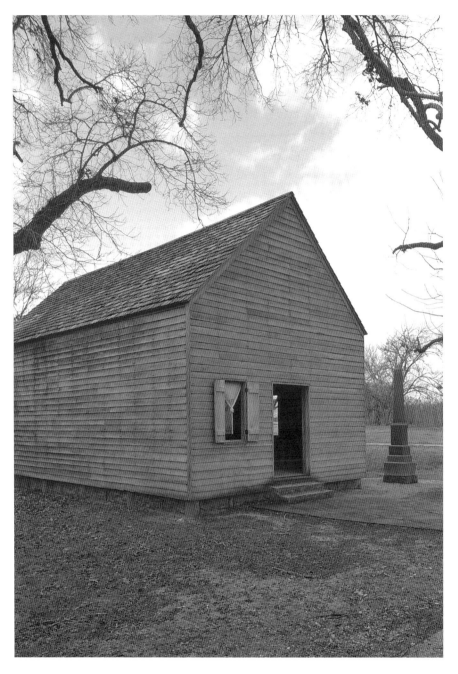

A replica of the wooden building at Washington-on-the-Brazos where fifty-nine men (including two rangers) signed Texas's Declaration of Independence in 1836. *Photo by Mike Cox.*

WOOD COUNTY
Mineola
WILLIAM JESSE MCDONALD (1852-1918)

Even as a young man, Bill McDonald exhibited an assertiveness that would both cause him trouble and make him one of the most noted ranger captains of the late nineteenth and early twentieth centuries.

McDonald came with his mother and sister to Rusk County from Mississippi in 1866. Too young to have fought in the Civil War, he made up for that in a confrontation with federal Reconstruction authorities that led to a charge of treason. Acquitted, he left Texas to attend a commercial college in New Orleans.

Former ranger captain Bill McDonald wearing a decidedly un-ranger-like hat. *Library of Congress.*

Back in East Texas, he taught penmanship for a while in Henderson and briefly ran a store in Gregg County. He soon relocated to the new—and booming—railroad town of Mineola, where he opened a general store, W.J. McDonald and Company. While in Wood County, he became friends with James Stephen Hogg, an attorney and newspaper editor. Hogg introduced him to Rhoda Carter, whom he married in 1876.

McDonald may have been an up-and-coming young businessman, but that didn't shield him from the law. Arrested for unlawfully carrying a weapon, the person who prosecuted the case was his friend Hogg, by then Wood County attorney. The gritty southerner's rationalization for toting a pistol was Mineola's growing level of violence.

Changing career directions, he took a job as a sheriff's deputy and soon gained a reputation for effectiveness.

In 1883, McDonald and his wife decided to start ranching and moved to Wichita County. That marked the end of the future ranger's East Texas days, but his progression to fame would continue in West Texas.

Visit: A 1999 historical marker summarizing McDonald's life stands at 116 Newsome Street. Mineola Historical Museum, 114 North Pacific, Mineola.

VAN ZANDT COUNTY

The Battle of the Neches

Four ranger companies participated in one of the darker episodes of the Republic of Texas era, the so-called Cherokee War.

Its instigator was Republic of Texas president Mirabeau B. Lamar, a man who did not like Indians. Fearing Mexico would succeed in allying with the Cherokees in an attempt to regain Texas, Lamar declared that unless the tribe "consent at once to receive a fair compensation for their improvements and other property and remove out of this country, nothing short of the entire destruction of all their tribe will appease the indignation of the white people against them."

Eighty-three-year-old Chief John Bowles, leader of the Cherokees in Texas and a friend of former president Sam Houston, believed his people had a right to be where they had been since 1819, which was the East Texas timberland. The chief did not want war, but the younger members of his tribe vowed to fight. When negotiations between a commission appointed by Lamar and the tribe broke down, Brigadier General Kelsey Douglass received orders to drive the Indians from Texas.

The young republic fielded more than 1,000 fighting men for the campaign, a combination of regular soldiers, volunteers and 208 rangers.

The first clash happened on July 15, 1839, in present Henderson County. The heated skirmish resulted in light casualties, but in retreating under cover of darkness, the Indians lost a substantial number of horses and cattle, along with corn, ample lead and five kegs of gunpowder.

The decisive battle came the next day. Douglass had deployed about half of his force elsewhere, but roughly five hundred men engaged Bowles and

his six hundred to eight hundred warriors near the Neches River in current Van Zandt County. Indians from numerous other smaller East Texas tribes joined the Cherokees.

A hard fight, in which even the Texans admitted Chief Bowles distinguished himself before being killed, resulted in at least one hundred Indian deaths. The Texans lost eight men and around thirty wounded.

In the days that followed, the Cherokees left Texas for what is now Oklahoma. The battle, the largest ever fought between rangers and Indians, effectively ended any Indian presence in East Texas.

> *Some rude chaps scalped the poor chief* [Bowles] *after his death.*
> –Houston Telegraph and Texas Register, *September 1, 1841*

Visit: The main battle site is on private property, about fifteen miles southeast of a historical marker placed in 1968 at a roadside park on State Highway 20, five miles east of Colfax. In 1936, the state placed a granite historical marker where Chief Bowles is believed to have been killed. From Canton, take State Highway 64 about nineteen miles southeast to County Road 4923, follow signs north about two and a half miles to the marker. In 2009, a group of metal detector enthusiasts, working with representatives of the Texas Cherokees, found an assortment of lead bullets, including numerous .69-caliber rounds, at the battle site. A framed collection of the relics was presented to the Cherokee Nation, with another set going to the Texas Ranger Hall of Fame and Museum in Waco.

The sword taken from Chief Bowles's body, a gift from Sam Houston (who was an honorary member of the Cherokee Tribe) is on display at the Masonic Hall in Tahlequah, Oklahoma.

CENTRAL TEXAS

BANDERA COUNTY
Bandera
BATTLE OF BANDERA PASS

The Battle of Bandera Pass, an oft written about fight between rangers under Captain Jack Hays and a much larger Comanche war party, probably never happened. A historical marker says it did, but historians have never found official documentation.

The legend is that in the spring of 1841, while scouting in the Guadalupe Valley, Hays and thirty-plus rangers made camp for the night near present Bandera. The next morning, the rangers rode into Bandera Pass, a geologic feature about 500 yards long and 125 feet across.

Unknown to the Texans, a large Comanche war party sat waiting for the approaching rangers. The ambush worked, catching the rangers by surprise.

Hays rallied his men, ordered them off their pitching horses and began a defensive action that soon degenerated into hand-to-hand fighting. Ranger Kit Acklen shot the Comanche chief with his pistol, but the Indian still had enough fight in him to draw his knife and charge the ranger. Acklen unsheathed his knife and, in a vicious struggle, prevailed. When the other warriors saw their leader fall, they withdrew.

Five rangers supposedly died in the battle with six others wounded.

In the legend's defense, many Republic of Texas documents burned when the state adjutant general's department caught on fire in 1857. Other documents of Hays's day were likely lost in the 1881 capitol fire.

Visit: A marker detailing the history of Bandera Pass itself stands ten miles north of Bandera on Farm to Market 689.

Old Texas Ranger Trail

The Battle of Bandera Pass may or may not have occurred, but rangers did operate in this area during the Republic of Texas era. The reason was the Pinta Trail, a road extending from San Antonio northwest to the old Spanish mission on the San Saba River in present Menard County. A historical marker placed in 1968 is titled the "Old Texas Ranger Trail," but it refers to the Pinta Trail.

Visit: Across from Bandera County Courthouse at Main and Pecan Streets, Bandera. Frontier Times Museum, 510 Thirteenth Street, Bandera. Built of native stone, fossils and petrified rock, the museum is historic in its own right. J. Marvin Hunter (1880–1957) opened it in 1933. He had founded *Frontier Times* magazine ten years earlier, and until he sold it in 1953, he published many hundreds of pages full of grass-roots history that might otherwise have been lost, including numerous articles on the early Rangers. During Hunter's lifetime, old rangers periodically dropped by the museum for a visit.

Bastrop County
Bastrop
Fairview Cemetery

Bastrop's oldest cemetery, dating to the early 1830s, holds fifteen Texas Ranger graves, the earliest burial in 1855. For a list of the burials, visit bastropcountyhistoricalsociety.com.

Visit: Hill overlooking town, 1100 State Highway 95.

CENTRAL TEXAS

ROBERT COLEMAN HOME

Before Robert Coleman could face court martial over the death of a drunk ranger at Fort Coleman, in 1837, he accidentally drowned while bathing in the Brazos River. He left behind wife Elizabeth and two sons, who lived in a cabin between Bastrop and Austin. On February 18, 1839, Comanches attacked the Coleman home and killed Mrs. Coleman and one of her boys. The Indians took the other son captive. A historical marker placed at the home site in 1936 is the only vestige of what happened there.

Visit: The marker stands seventeen miles north of Bastrop off Farm to Market Road 969. Bastrop County Museum, 904 Main Street, Bastrop.

BELL COUNTY
Belton
BIRD CREEK FIGHT

The Comanches did not relinquish their hunting grounds without fierce resistance.

On May 25, 1839, thirty-five rangers under Captain John Bird encountered a Comanche buffalo hunting party and charged. The Indians fled, but they did not go far.

The next morning, a group of Indians stampeded a herd of buffalo through the rangers' camp. Again, the rangers chased the Indians, but the Comanches succeeded in staying just out of shooting range. When the rangers gave up and returned to camp, a party of roughly forty Indians waiting in ambush surrounded the Texans and let loose with a withering barrage of arrows.

Bird ordered his men to fall back to a nearby ravine and take cover. From there, the rangers looked toward a hill and saw an estimated 250 warriors lined up to attack. When the Indians rode down on them, the rangers held their fire until they could make their bullets count. Several warriors fell, and they pulled back, only to charge again.

As often happened in Indian fights, when a ranger killed their chief, the Comanches withdrew. But five rangers lay dead, including Captain Bird.

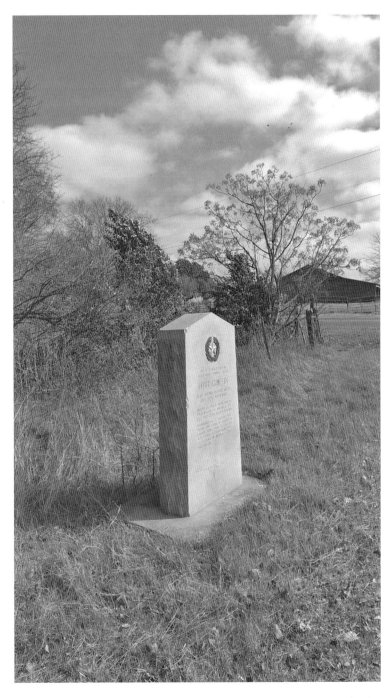

Five rangers died in an Indian fight not far from this 1936 historical marker in Bell County. *Photo by Mike Cox.*

> *After drawing up their lines, the war-whoop from one end of their line to the other was heard, which shrieked in the ears of our gallant little band, which was soon followed by a desperate charge from every point; but our boys gave them such a warm reception they were handsomely repulsed.*
> —*battle survivor Nathan Brookshire*

Visit: The battle happened in present Bell County near a creek later named in Bird's honor. A 1936 granite historical marker commemorating the fight stands at Adams and Interstate 35 in Temple. Another marker, this one recognizing Captain Bird and the other slain rangers, is in the 2000 block of Nugent, west of Interstate 35 and just east of Bird Creek. A third marker, placed in 2002, indicates the approximate site of the buffalo stampede. Take State Highway 36 6.0 miles northwest of Temple, then go north 6.8 miles on State Highway 317, turning west 2.9 miles to the marker. The rangers lie buried in a common grave on the bank of the Little Leon River, the exact location unknown.

PETER HANSBROUGH BELL (1812–1898)

One of three former rangers to become governor, the namesake of Bell County fought in the Battle of San Jacinto and served as both assistant inspector general and inspector general for the Texas army from 1837 to 1839. Bell rode as a Texas Ranger and held the rank of colonel of Texas volunteers in the Mexican War. Elected governor in 1849, he served until 1853 when he entered the U.S. Congress, representing his district until 1857.

In 1936, during the Texas Centennial, a bronze statue of the former ranger was placed on the courthouse square in Belton.

Visit: 101 West Central Avenue. Bell is buried in the State Cemetery. Bell County Museum, 201 North Main, Belton.

Temple

RAILROAD STRIKE

As organized labor began to grow in power in the late nineteenth century, the state occasionally dispatched Texas Rangers to prevent violence during strikes. When a nationwide railroad work stoppage in 1894 triggered

bloodshed and sabotage—paralyzing transportation and the mail—Captains J.A. Brooks and John R. Hughes took sixteen rangers to Temple, a division point on the Atchison, Topeka and Santa Fe Railroad.

Not only did the presence of the state lawmen preserve the peace, someone took a photograph of them standing with Winchesters in hand in front of a Santa Fe boxcar. Extensively published over the years, the image likely was taken near the Santa Fe depot downtown.

Visit: The old Santa Fe depot was replaced by an impressive two-story station house opened in 1911 at 315 Avenue B. Closed in 1989, the City of Temple bought the property in 1995. The restored depot continues to serve as the city's Amtrak station. The Temple Santa Fe Depot Railroad and Heritage Museum is also in the depot.

BLANCO COUNTY

Blanco

SCOTT COOLEY (1845-1876)

Exactly how Scott Cooley died, either of natural causes or by intentional poisoning, has never been determined. But the real mystery is why he did not catch a Comanche arrow and lose his scalp in the fierce Indian fighting he took part in as a ranger, or why someone didn't just back-shoot him as recompense for his role in the Mason County Hoo-Doo War. However it happened, Cooley died in Blanco in June 1876 and lies in Miller Creek Cemetery under a concrete slab that simply says, "Scott Cooley/Texas Ranger."

Visit: East 2.1 miles from intersection of U.S. 281 and U.S. 290, 5.3 miles north of Blanco.

Johnson City

RUFUS CICERO PERRY (1823-1898)

Alabama-born Cicero Rufus "Old Rufe" Perry first served in a ranger company under Captain William Hill in 1836 when only fourteen. Later, he

rode under Captain John Coffee Hays. Perry also fought as a ranger in the Mexican War.

When the legislature created the Frontier Battalion in 1874, Perry gained appointment as the first captain of Company D. The veteran Indian fighter, along with numerous other rangers, had to be laid off in December 1874 due to a state budget shortfall. Perry ran cattle on property he owned along the Pedernales River in Blanco County until he grew infirm. He died in the small community of Hye, between Johnson City and Fredericksburg. In reporting the old ranger's death, the *Beeville Bee* newspaper said Perry had been wounded by Indian arrows twenty-one times and shot seven times.

Visit: Masonic Cemetery, North Nugent Street (Spur 356). Johnson City. The former ranger's restored log cabin, 404 U.S. 290.

BURNET COUNTY

DEER CREEK INDIAN FIGHT

The roughly twenty-minute battle that took place along Deer Creek in Burnet County in mid-August 1873 did not involve the rangers, but it likely led to the enlistment a year later of a young man who would become one of the force's more famous captains—Daniel Webster Roberts. Viewed another way, the engagement came close to killing him.

Near the wagon road from Austin to Fredericksburg, the future ranger leader; his father, George Roberts; and seven other Texans rode up on a party of twenty-five to thirty-five Comanches cooking four stolen beeves.

In a pitched battle, George Roberts, his son and another man suffered wounds along with two of their horses. With three men already wounded, the outnumbered Texans backed off, and the Indians opted not to follow. The Indians lost two to four warriors and a couple horses.

> *Knowing what I now do, I do not see how a man of us escaped alive, for the Indians were well armed and shot well.*
> —James Ingram, *letter published in the* Austin Tri-Weekly State Gazette, *August 23, 1873*

Visit: No historical marker commemorates this fight, and the exact location is unknown. Deer Creek, which empties into the Colorado River, extends only a few miles. State Highway 71 (the old road to Fredericksburg) crosses the creek, and the battle likely occurred in this vicinity.

Holland Springs

After the Mexican War, with Texas's status as the twenty-eighth state no longer contested, the U.S. military intended to establish a string of forts across the western frontier to keep hostile Indians in check. But until federal troops returned from Mexico, only the rangers stood between Texas and its enemies.

Ranger captain Henry Eustace McCulloch, newly returned from service in Mexico under Jack Hays, established a camp near a spring on Hamilton Creek in December 1847 about three miles south of present Burnet. The rangers built twenty log cabins, each housing six rangers. Known as McCulloch's Station, the camp also had six cabins for men with families.

Samuel Holland, who happened to visit the camp and decided the area would be a fine place to settle, bought the land in 1848. The rangers moved on in early 1849 when the federal troops arrived, but Holland stayed, the first settler of future Burnet County. U.S. dragoons briefly occupied the old ranger camp, but the garrison soon moved north to a more favorable location on Hamilton Creek which soon became Fort Croghan.

Visit: Fort Croghan Museum, 703 Buchanan Drive (State Highway 29) in Burnet. A historical marker placed in 1936 tells the story of the old army post. Several restored fort buildings are located behind the museum. Another marker dating from 1968 stands near the old ranger campsite at the intersection of County Road 340 and an unpaved road, three miles south of Burnet.

Longhorn Cavern

Discovered in the mid-1850s, Longhorn Cavern has a cultural history as rich as its geology and prehistory.

Supposedly, Indians used the cave's largest chamber as a council room. During the Civil War, miners collected bat guano from the cave for use in making gunpowder. Later, Texas Rangers checking the cave are said to have

found a young girl held captive by Indians. The 1878 ranger shootout with outlaw Sam Bass in Round Rock gave rise to a story that before his death Bass stashed some of his loot in the cave. None of the ranger-related stories have been substantiated, but since the temperature inside is a constant sixty-five degrees, visiting the cave has always been a fun way to beat the summer heat or winter cold. During the Depression, Civilian Conservation Corps workers removed sediment from the cave, strung electric lights and made other improvements before it opened as Longhorn Cavern State Park in 1938.

Visit: Twelve miles southwest of Burnet on U.S. 281, take Park Road 4 to the park.

CALDWELL COUNTY
Lockhart
BATTLE OF PLUM CREEK

Some six hundred Comanches raided deep into Texas in the summer of 1840, cutting a bloody swath all the way to the coastal village of Linnville on Lavaca Bay. Killing twenty-three Texans in the August 8 raid, the Indians destroyed the town so thoroughly no one ever felt inclined to rebuild it.

Three days later, a hastily organized force of two hundred men under General Felix Huston—regular soldiers and rangers—found the Comanches near Plum Creek in present Caldwell County, thirty miles southeast of the new capital at Austin. With their captives and plunder, the Indians rode northwest to their home range—Comancheria. Realizing they outnumbered the Texans, the Comanches arrayed themselves in a long line and prepared to attack. Content to await the charge, Huston ordered his men to dismount—an old-school military tactic.

But ranger captain Matthew "Old Paint" Caldwell, an experienced Indian fighter, knew better. Men afoot had little chance against horsemen, especially Comanches. Then the Indians started picking off the horses of Huston's dismounted regulars, also wounding some of the men. The skirmishing continued roughly a half-hour before a Texas rifle bullet dropped a chief from his horse.

"Now, General, is your time to charge them!" Caldwell implored. "They are whipped!"

Not waiting for permission, Caldwell and his rangers spurred their horses and galloped toward the Comanches "howling like wolves," as Ranger Robert Hall remembered. Holding their fire until they closed with the Indians, the rangers shot at least fifteen warriors from their ponies, putting the others to flight. In a running battle covering fifteen miles, eighty Indians died. The Texans lost only two men.

> *Old Paint Caldwell was equal to a thousand men. As soon as the bullets began to whistle he seemed to grow taller and look grander.*
> *—Ranger Robert Hall, participant*

Visit: No firm fix on the location is known. Lockhart State Park is believed to lie within the battle area, but archaeological surveys have produced no conclusive evidence. A historical marker in Lion's Park, 403 South Colorado Street just off U.S. 183 in Lockhart, commemorates the incident. Caldwell County Museum, 314 East Market Street.

COLORADO COUNTY

Columbus

STEPHEN F. AUSTIN'S RANGERS

In 1906, ranger captain Bill McDonald went to Colorado County to calm down one of Texas's many blood feuds. Eight decades later, a modern Texas Ranger captain adroitly extricated himself from the middle of another kind of feud: historians arguing over where to place a historical marker outlining the origin of the Rangers.

The war of words began in the spring of 1986 when James G. and Mary E. Hopkins of Colorado County put together the research and footed the bill for an aluminum marker to be placed on the courthouse square in Columbus.

After the Texas Historical Commission approved the marker, folks in nearby Austin County took umbrage. The way they saw it, the new marker gave the impression that the Rangers had originated in Colorado County. They believed it rightfully should stand at San Felipe, twenty-five miles from Columbus. No matter page-one newspaper coverage of the brief controversy, Columbus kept the marker.

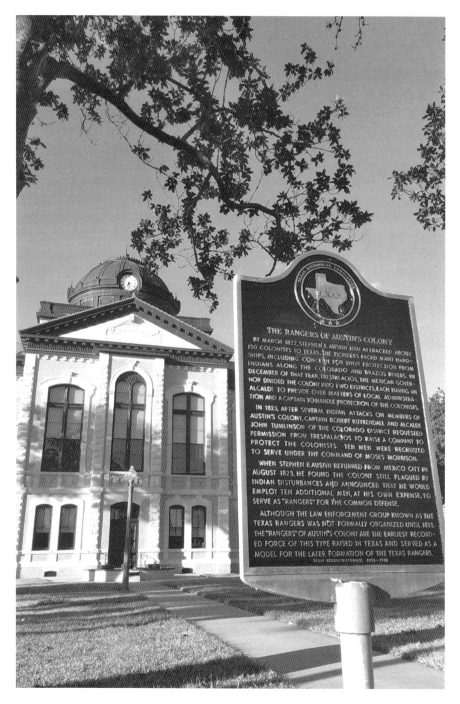

Where to put this historical marker on the origin of the Rangers sparked a modern-day battle…Columbus won. *Photo by Mike Cox.*

I dare say you can make a case for both towns. Don't get the Rangers in the middle of it, because we don't know.
　　　　　—Company A captain Dan North, in the Houston Chronicle

Visit: Courthouse square, 400 Spring Street.

TUMLINSON FAMILY

A photograph of Joseph Tumlinson (1811–1874) shows a full-faced, balding man with a bushy black mustache. His light eyes appear somewhat astigmatic, but that uncorrected condition did not impact his shooting abilities.

Tumlinson came to Texas from Tennessee with his parents and siblings to live in Stephen F. Austin's new colony in present Colorado County. When Indians killed his father, John Jackson Tumlinson, on July 6, 1823, in present Guadalupe County, twelve-year-old Tumlinson and his elder brother John J. Tumlinson Jr. joined the rangers who tracked down and killed the warriors responsible.

In the fall of 1835, Joseph signed on to serve with ranger captain Robert M. Coleman. He later participated in the Battle of San Jacinto and rode with several other ranger companies. His brothers John and Peter also were rangers. During Reconstruction, Joseph spent ten months in the uniformed Texas State Police. Despite his law enforcement job, Tumlinson became a leader of the William Sutton faction in the violent Sutton-Taylor feud. He died in 1874 and was buried on his ranch near Yorktown in DeWitt County.

Fourteen other Tumlinson family members, related either by blood or marriage, served as rangers from 1859 to 1921.

A marker commemorating the long connection of the Tumlinsons to the Texas Rangers was erected in Columbus in 1999.

Visit: South side of courthouse. Alley Log Cabin Museum, 1224 Spring Street. Built in 1836 by Abraham Alley, one of Austin's original colonists and an acquaintance of the Tumlinsons.

JAMES WILLIAM GUYNN (1840–1882)

The flat granite stone over Guynn's grave only preserves his name and dates of birth and death, but there is more to his story. He fought for the South

during the Civil War and served in the summer of 1875 as a ranger lieutenant under Captain Leander McNelly. In addition to his law enforcement duties, he wrote a letter to the *Colorado Citizen*, his hometown newspaper, describing McNelly's activities. Following his state service, he had two run-ins with the law, one for stabbing someone. Years before conservation laws made it illegal to hunt whitetail during in the summer, he was accidentally shot while deer hunting with friends on June 27, 1882, and died five days later.

> *We are expecting to have a fight with raiders soon, or as soon as they set foot on Texas soil.*
> —*Guynn to* Colorado Citizen, *July 25, 1875*

Visit: Odd Fellows Rest Cemetery, Columbus.

COMAL COUNTY
New Braunfels
A RANGER LENDS A HAND

Sixty-six days crowded below deck in a ship bound from Germany to the Republic of Texas had been hard enough and their trek inland from Galveston arduous, but in the spring of 1844, a group of European immigrants found themselves stranded in San Antonio—many of them sick, all hungry and desperate.

The men, women and children awaited the man who had arranged their journey to a new life, Frenchman Henri Castro. Few spoke English; none had money for food and shelter. Though paid to protect the frontier from Indians or invading Mexicans, seeing this, Ranger Johann Jacob Rahm took it upon himself to deal with a humanitarian crisis.

The Swiss-born ranger convinced Captain Jack Hays to arrange for food, medical care and other assistance for the immigrants until Castro arrived to escort them to their colony on the Medina River. Rahm even kicked in some money himself and found jobs for some of the immigrants.

That kindness impressed another newly arrived European, Prince Carl of Solms-Braunfels, who had recently come to Texas to oversee a German immigration enterprise. The prince presented both rangers engraved weapons (a combination rifle-shotgun for Hays and a shotgun for Rahm) in appreciation.

Rahm had immigrated to Texas from Europe around 1834. He fought in the revolution and later joined the 1841 Santa Fe Expedition, an ill-conceived military action that landed him and most of the participants in a Mexican prison. After his release, the thirty-seven-year-old enlisted in Hays's San Antonio–based ranger company. Serving variously from 1843 to 1844, he took part in the famous Battle of Walker Creek, the first time rangers used Colt revolvers against Comanches.

As a ranger, Rahm first saw a series of seven prolific springs known as Los Fantanos—the fountains—on the Comal River. In 1845, when Rahm described the springs and the lush area around them to Prince Carl, the German nobleman purchased sight unseen 1,265 acres that became New Braunfels. The former ranger led the prince and several others to the area, helping cut a four-mile trail to the springs.

Again beholden, the prince deeded four and a half acres to Rahm, who opened Rahm's Butchery between what are now San Antonio and Coll Streets. Likely Rahm would have enjoyed a long and prosperous life had he not been overly fond of distilled spirits.

In October 1845, drunk and argumentative, Rahm fired a couple pistol shots at one of the German settlers. Whether he intended to harm the man or merely make a point is unknown, but the man took the shooting as a threat and killed Rahm.

> *Those who survive owe their recovery solely to the untiring care of a soldier in Colonel Hays's company.*
> —*Prince Solm*, A New Land Beckoned

Visit: Rahm's burial place is not known, though likely in Comal or Bexar County. Sophienburg Museum and Archives, 401 Coll Street, New Braunfels.

FALLS COUNTY

THE SEARCH FOR JAMES CORYELL

In the spring of 1837, two ranger companies operated out of a post called Fort Milam, a log stockade near the Falls of the Brazos. Either on May 11 or 27 (records are unclear), Ranger James Coryell and four colleagues came across a beehive near Perry's Creek in present Falls County. Stopping to enjoy

a sweet bit of nature's bounty, the rangers raided the hive. As they enjoyed their snack and talked, a dozen hostile Caddo slipped up.

For some reason, only three of the rangers had taken their rifles with them, and one was unloaded. Coryell grabbed one of the loaded firearms and got a shot off at the Indians about the time three of them fired at him. As he fell gravely wounded, two of the outnumbered, out-gunned rangers fled for their lives. A third stood his ground and raised one of the other rifles, but it misfired. Meanwhile, the Indians fell on Coryell and scalped him. Seeing that, the last ranger made his escape.

The forty-year-old Coryell, who had survived an earlier Indian fight in present McCulloch County along with future Alamo hero James Bowie, was buried in the vicinity. Over time, the location was forgotten.

In February 2011, after reviewing an oral history concerning a one-time slave community in Falls County, Texas Historical Commission archaeologists and a team from the Smithsonian Institution exhumed remains from a solitary, rock-covered grave near Bull Hill Cemetery not far from where the Indian attack is believed to have occurred. An assortment of human bones went to a laboratory in Pennsylvania for DNA sample extraction. At the same time, a descendant of Coryell living in Missouri provided a DNA sample for comparison. Test results proved inconclusive, but circumstantial evidence indicates the remains are those of the long lost ranger.

> *When* [Ranger Ezra] *Webb ran in* [at the quarters of ranger captain Barron] *with great haste and fright, and breathless…he fell…past speaking…After a little time, he was able to whisper,* "Indians! Poor Coryell!"

Visit: Bull Hill Cemetery is near the small community of Rosebud in Falls County. The committee that determines Texas State Cemetery burial eligibility has approved the reinterment of Coryell's remains there, though in mid-2015, the ranger's bones remained in the custody of the Texas State Historic Commission Archeology Division in Austin.

FAYETTE COUNTY
La Grange
JOHN HENRY MOORE (1800–1880)

Young John Henry Moore had no use for Latin. Rather than continue his studies of that oldest of the Romantic languages, at eighteen, Moore ran away from college in his native Tennessee and struck out for the Spanish province of Texas.

That happened in 1818, three years before Stephen F. Austin began his colonization efforts just as Mexico wrested control of the province from the Crown. By that time, Moore had returned to Tennessee. But the young man who disliked Latin liked what he had seen on his first trip, and when Austin founded his colony in 1821, Moore came back to Texas. This time he stayed, one of what came to be called the Old Three Hundred.

Moore did not get the publicity that propelled his younger fellow Tennessean Jack Hays to fame, but few early rangers (like many of these men, he was not always referred to as a ranger) spent as much time pursuing and fighting Indians as Moore. He did not prevail in every engagement, but he never hesitated to saddle up for Texas.

Settling in what would become Fayette County, in 1828, Moore built a twin blockhouse. Soon known as Moore's Fort, it was the beginning of La Grange, which was founded in 1831.

Like most of Austin's colonists, Moore farmed and started a family, but from 1834 to 1842, he took part in five different Indian campaigns. In addition, he led militia-like companies in actions against Mexico four times.

SITE OF TWIN BLOCKHOUSE

The state placed a historical marker at the site of Moore's fortified home during the Texas Centennial in 1936. The structure, the oldest in Fayette County, was later moved to Round Top.

Visit: The marker stands at 385 North Main in La Grange. The restored Moore's Fort is at Village Green, a collection of historic Fayette County structures between Bauer Rummel Road and West Wantke Street in Round Top off State Highway 237, sixteen miles northeast of La Grange. Moore's 1838 house stood until 2011, when it was burned in a drought-enhanced wildfire. A historical

This fortified residence built by ranger leader John H. Moore was the first structure in La Grange. *Photo courtesy Gary McKee.*

marker placed in 1936 still stands at the site. A granite historical marker placed near Moore's final resting place in 1936 incorrectly has his date of death as 1877. Take U.S. Highway 77 from La Grange one mile northwest to Farm to Market Road 2145, turn right and continue five miles to the Oak Meadow Ranch. The cemetery is in a field 200 yards north of the Moore house site.

WARREN FRENCH LYONS (1825–1870)

Comanches attacked the Fayette County homestead of New York-born James Lyons early on October 15, 1835. They killed him and kidnapped his youngest son, twelve-year-old Warren French Lyons. For the next decade, Lyons lived with the Indians and, as often happened, adapted to their culture.

Several Fayette County men who knew the Lyons family happened to be in Fredericksburg in 1847 when they recognized Warren among a group of Indians who had come to town to trade with the German settlers. The men talked Lyons into returning to La Grange with them. The young man had a hard time readjusting, but he married in the summer of 1848 and settled into family life. Still, he only slept on his porch, never inside.

Three years later, he volunteered to serve as a guide and Comanche interpreter for the Texas Rangers. He rode with Lieutenant Edward Burleson, son of the man who served as vice-president under Republic of Texas president Mirabeau B. Lamar. On January 27, 1851, the rangers tangled with Indians on the San Antonio–Laredo Road just south of the Nueces River. Though outnumbered, Burleson's men killed four Comanches and wounded most of the others. In the process, the Indians killed one ranger and left another with a wound that proved fatal. Only Lyons escaped unscathed.

Lyons and his wife later moved to Johnson County, where he died on August 11, 1870. Mrs. Lyons remained in the county and died there a year later. Neither grave has ever been located. Other members of the Lyons family, however, are buried in the Lyons family plot in the Schulenburg City Cemetery. One of the graves is that of Indian victim James Lyons, though a tombstone placed over it in 1931 incorrectly says its Warren's grave.

Visit: Lyons family plot, Schulenberg City Cemetery. From North Main Street, go north on Schultz Avenue. Cemetery is west of intersection of Schultz and Russek Streets. Fayette County Heritage Museum and Archives, 855 South Jefferson Street, La Grange.

GUADALUPE COUNTY

Seguin

RANGER OAKS

Seguin owes its existence to the rangers who, prior to and after the Texas Revolution, periodically camped under a stand of walnut, pecan and oak trees near the bank of Walnut Branch, a spring-fed creek running through what is now downtown Seguin. The large trees, still standing, came to be called the Ranger Oaks.

Demonstrating that they had business sense as well as Indian fighting skills, in 1838 Matthew "Old Paint" Caldwell and two other rangers—James Campbell and Arthur Swift—formed a company to develop a town on half of a three-hundred-acre land grant belonging to Joseph Martin. That land included their former campsite. Thirty-three men—most, if not all,

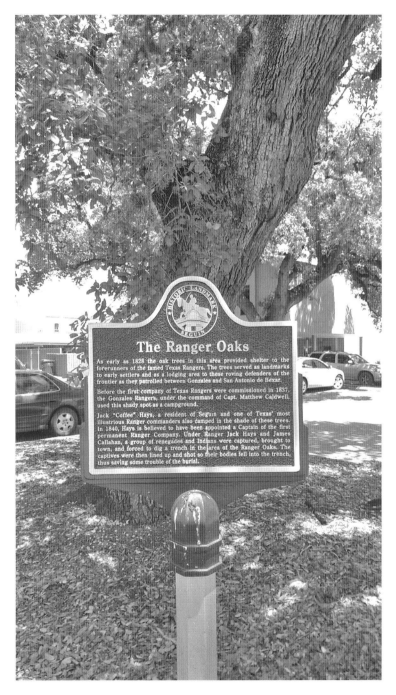

Republic of Texas rangers camped under these trees along Walnut Brand in what is now downtown Seguin. *Photo by Mike Cox.*

rangers—bought shares in the townsite venture, and Seguin soon grew into a thriving community.

The city's mayor unveiled a locally funded metal historical marker at the site in 2011. According to the marker, near there in 1840, ranger captains Jack Hays and James Callahan forced captive "renegades and Indians" to dig their own mass grave before the rangers executed them. Ranger historians say this never happened, merely one of several legends concerning Hays.

Visit: Southeast corner, Gonzales and Travis Streets, Seguin. The trees stand in the parking lot of the Seguin Chamber of Commerce. Seguin-Guadalupe County Heritage Museum, 114 North River Street.

SEGUIN RANGER STATION

Local tradition has it that rangers built an adobe structure near Walnut Branch and used it as a base when scouting in the vicinity. As a 1977 archaeological report put it, "There may be some truth to [that]." Certainly, an adobe and stone house dating from 1838 to 1839, later known as Seguin Ranger Station, stood at the site until bulldozed in the last third of the twentieth century. Though often described as the home of Ranger James Milford Day (1815–1894), the likely builder was M.P. Woodhouse. Day did live nearby, hence the confusion.

Visit: The structure, with later frame additions, stood at the southeast corner of Court and Guadalupe Streets.

JUAN NEPOMUNCEO SEGUIN (1806–1890)

The son of one of San Antonio's first settlers and leading citizens, Seguin likely would have died at the Alamo fighting for Texas independence, but Colonel William B. Travis dispatched him as a messenger and the garrison fell before he returned. He went on to take part in the Battle of San Jacinto and later was the only Tejano (Mexican Texan) to serve in the congress of the Republic of Texas. He also was mayor of San Antonio for a time. Far less known is that Seguin also served as a Texas Ranger in 1839, elected as captain of a company of roughly fifty-five Tejanos. In the 1860s, he left Texas for

Nuevo Laredo, Mexico, where he remained until his death. Seguin's remains were exhumed at Nuevo Laredo in 1974 and ceremoniously reburied in his namesake city on July 4, 1976.

Visit: Seguin's grave lies on the side of a hill beneath a flat granite tombstone at 789 South Saunders Street. A larger-than-life bronze statue depitcting Seguin astride a horse at the Battle of San Jacinto, his saber raised, was placed in the city's Central Park in 2000. The park is bounded by Austin, Nolte, South River and Donegan Streets. A 1970-vintage historical marker outlining the high points of Seguin's life stands outside city hall at 205 North River Street.

Battleground Prairie

Whether envisioning a handsome reward, or simply because he thought it the right thing to do, Vicente Cordova had been conspiring to help Mexico regain its former province of Texas. Because of that, the Republic of Texas government viewed the Nacogdoches man and his followers as traitors.

When two Texas scouts saw signs that a large party of horsemen had moved through what later became Austin, they suspected Indians. Edward Burleson organized a company of volunteers and rangers and took up the trail to identify the riders.

As it turned out, they were Cordova and some seventy-five of his followers—Mexicans, Cherokees and a few African Americans. (Slavery was illegal in Mexico, hence their interest in Cordova's cause.) On March 29, 1839, along Mill Creek in present Guadalupe County, Burleson's command encountered the band. Not losing a man, the Texans killed eighteen of the conspirators, who had been on their way to Matamoras, Mexico. Cordova escaped, but he would not die naturally of old age. Before Cordova left the area, he and his men skirmished with a smaller party of rangers. During that fight, Seguin settler James M. Day suffered a wound that permanently impaired his walking ability.

A 1936 historical marker commemorates the fight.

Visit: Five miles east of Seguin on U.S. 90A.

MAGNOLIA HOTEL

DeWitt colonist James Campbell (circa 1806-1840) built a log dogtrot cabin—two rooms separated by a breezeway—in the new settlement circa 1838–1840. While serving under Ranger Captain Caldwell as a lieutenant, Campbell was waylaid, killed and scalped on June 18, 1840 by two Comanches one mile east of San Antonio. Buried on the spot, his grave site is unknown.

But the cabin he built in Seguin still stands, the architectural anchor of one of Texas's more historic buildings. After Campbell's death, his cabin became a stagecoach stop. With additions, by 1844, it was the two-story frame Magnolia Hotel. On April 29, 1847, Captain Jack Hays got married there to Susan Calvert, daughter of the hostelry's owner. Expanded in 1853 with some use of the limecrete first produced in Seguin, the building continued as a hotel into the 1930s. Listed as one of the state's most threatened historic structures in 2012, it was purchased and underwent extensive restoration in 2015. Included in the Historic American Buildings Survey in 1934, it was added to the National Register of Historic Places in 1983.

Visit: 203 South Crockett Street.

One of Seguin's oldest structures, the now-restored Magnolia Hotel hosted Captain Jack Hays's wedding in 1847. *Photo by Mike Cox.*

CENTRAL TEXAS

ROBERT HALL HOUSE

Ranger Robert Hall (1814–1899) built this frame house for his family shortly after Seguin's founding. He served as a ranger under fellow Seguin resident Ben McCulloch and in 1840 participated in the Battle of Plum Creek. One of the oldest houses in Seguin, it is listed on the National Register of Historic Places.

The old ranger spent the last years of his life living in Cotulla with one of his thirteen children. In 1898, with help from Robert Miller, Hall published a gripping memoir, *Life of Robert Hall: Indian Fighter and Veteran of Three Great Wars*.

Visit: Northwest corner of Travis and Nolte Streets. Privately owned.

HENRY EUSTACE McCULLOCH (1816–1895)

Brother often rode with brother in the Texas Rangers. Henry McCulloch's older brother Benjamin (1811–1862) served in the Rangers under Captain Jack Hays from 1839 to 1842 and as a federalized ranger captain from 1847 to 1848 during the Mexican-American War. Afterward, he was elected to the legislature, where he held a House seat from 1853 to 1859. Next he served as a deputy U.S. marshal. When the Civil War began, he fought for the South along with his brother, who died in the Battle of Pea Ridge in Arkansas. Later, Henry McCulloch was superintendent of the Texas State School for the Deaf in Austin. A historical marker was placed near his grave in 1962.

Visit: Geronimo Cemetery, one and a half miles east of Seguin on U.S. 90A. The marker is at the cemetery's fourth entrance, on the east side of the pavement. Los Nogales, 415 North River Street, is a stuccoed adobe structure with a cypress roof built in 1849. A historical marker placed in 1989 erroneously says that Ben McCulloch briefly owned the property in 1870. Since Ben had been dead for eight years by then, either the 1870 date is incorrect or brother Henry was the short-term landowner.

McCULLOCH HOUSE

Rangers Ben and Henry McCulloch built a stone house near Mill Creek in 1841 and lived there off and on through the early 1850s. After they left, Nathaniel Benton (1814–1872), who served as a ranger in 1858, made the

house his family's residence. A final famous occupant, Elijah V. Dale, rode as a ranger in 1871. All four men fought in the Texas Revolution. Restored in 1972, the old house went on the National Register of Historic Places in 2011. It is one of twenty-three surviving structures in and around Seguin containing limecrete, an early concrete-like building material first developed in Seguin around 1850.

Visit: The old house is eight miles from Seguin. Take U.S. 90 three miles west from Seguin, turn left on Tschoppe Road and continue two miles to 1936 historical marker at 1806 Tschoppe Road. Private property. Benton is buried in Vaughan Cemetery, Seguin. From U.S. 90A, go north on Prexy Drive about half a mile to cemetery.

A.J. SOWELL (1815-1883)

A Tennessean who came via Missouri to Gonzales in 1829, Andrew Jackson Sowell farmed until the beginning of the war for independence, when he took up arms for Texas. He participated in the Battles of Gonzales and Concepción and the Grass Fight. When the Alamo siege began, Sowell stood as one of the defenders, but he left with several others with orders to acquire more supplies. While buying cattle in Gonzales, he learned the mission had fallen. After the war, Sowell rode as a ranger and fought in the Mexican War and in the Civil War.

Sowell's grave was lost for generations, but 130 years after his death, the noted Texan's great-great-great-grandson Gary Humphreys of Del Rio started looking for it. After finding an old newspaper article mentioning that a cedar had been planted at the head of Sowell's grave in Mofield-Sowell Cemetery soon after his burial, Humphrey searched the cemetery from above using Google Earth. To his amazement, he saw that the cedar still stood. Going to that spot, he located the grave and has since placed two granite stones to permanently mark the pioneer ranger's final resting place.

Visit: Mofield-Sowell Cemetery is nine miles east of Seguin off Cross Road on private property. A historical marker is at the Geronimo Cemetery (directions in previous section).

CENTRAL TEXAS

"STAGECOACH ROAD" MURAL

Flanked by Frontier Battalion rangers Captain John R. Hughes and Private Joe Sitters, a formally dressed Captain Jack Hays stands larger than life at the center of "Stagecoach Road," a ninety- by twenty-six-foot acrylic mural by artist Brent McCarthy. The large work of public art, painted on the south side of a brick building, was dedicated in 2008.

Visit: 114 South Austin Street, southwest corner of Donegan and Austin Streets.

GILLESPIE COUNTY

Fredericksburg

BATTLE OF ENCHANTED ROCK

Thousands of hikers make their way to the top of Enchanted Rock annually, but in the nineteenth century, the climb offered more than an impressive view. In the fall of 1841, ranger captain Jack Hays left his men in their camp on Crabapple Creek in present Gillespie County intending to scale the giant granite uplift to look for Indians.

Before he got there, Hays ran into three Comanches. The young captain kicked his horse into a gallop and easily outdistanced the

Ranger Joaquin Jackson atop Enchanted Rock, a landmark where one of his famous predecessors held off a party of Comanches wanting his scalp. *Photo by Mike Cox.*

Indians, but more warriors joined the chase. His horse tiring, Hays made it to the rock, picked a defensible spot and prepared to hold off his pursuers until his men heard the shooting and came to his assistance. Firing only when he had a dead shot, the captain kept the Comanches at bay for several hours.

Finally, his ammunition running low and the number of Indians increasing, Hays heard yelling and gunfire as his men rode to his rescue and the Comanches fled.

Two men who had known Hays, writer Samuel Reid and former ranger John Caperton, later penned accounts of this incident, but no official record of it or any contemporary newspaper coverage has ever been found. Whether the standoff ever occurred may never be known.

Visit: Enchanted Rock State Natural Area is eighteen miles north of Fredericksburg on Farm to Market Road 965.

BRAEUTIGAM MURDER

In 1876, pioneer Fredericksburg resident John Wolfgang Braeutigam and nearly eighty other Gillespie and Blanco County citizens signed a petition requesting rangers to protect the area from Indians. The adjutant general's department had too much pressing business for its rangers elsewhere and did not act on the plea, but eight years later, rangers would come to Fredericksburg to help local authorities track down the men who murdered Braeutigam.

On September 3, 1884, four strangers entered the biergarten on the San Antonio Road a couple miles out of town that Braeutigam and his family operated at the site of old Fort Martin Scott, east of Fredericksburg. After knocking down the beers they'd ordered, one of the men pulled a six-shooter and told the proprietor they would also have his cash. Instead of handing over what little money lay in the till, Braeutigam reached for a rifle. That proved a fatal mistake, and the gunman killed the fifty-year-old man.

Rangers followed the killers' tracks and soon rounded up three of the four, placing them in San Antonio's new, supposedly escape-proof jail to prevent mob action in Fredericksburg. But to the embarrassment of Bexar County officials, the four suspects dug their way out and hit the brush.

Again, rangers took up the trail. This time they booked the first suspect they caught into the Gillespie County jail, a place thought to be sturdy

enough to prevent another escape. But the facility wasn't fireproof. Just the killer's luck, that very night, the jail happened to burn down with him the only occupant. The late Mr. Braeutigam had been very well thought of, and the county needed a new lockup anyway. Rangers recaptured the second suspect and lodged him in the Mason County jail. When cornered in a ranch house six miles east of the small community of Leander on May 26, 1886, the third accused murderer died suddenly of circulatory failure from Ranger Ira Aten's bullet in his heart. The fourth suspect, a man known only as Fannin, never was heard from again.

In locating the man he had been forced to kill, Aten had help from Williamson County rancher John R. Hughes. The two men became friends, and in 1887, at Aten's urging, Hughes enlisted in the rangers. That began the law enforcement career of one of the most famous captains in Ranger history.

Visit: The Braeutigam house stood just south of the old guardhouse on the northern side of the old fort, two miles east of Fredericksburg on U.S. 290. The biergarten, long since razed, stood between what is now U.S. 290 and a well on the fort site about sixty feet off the roadway. Pioneer Museum, 325 West Main Street, Fredericksburg.

FORMER TEXAS RANGERS ASSOCIATION HERITAGE CENTER

In 1897, aging former Texas Ranger John S. "Rip" Ford, who, as a newspaper editor, Indian fighter, soldier and politician made his share of Texas history, began to realize that if a society is to learn from the past, it must know what that past involved. In addition to writing a memoir and helping organize the Texas State Historical Association, he formed the forerunner of the Former Texas Rangers Association. (They named Bigfoot Wallace as their secretary, but he could hardly write due to palsy.)

More than a century later, under the leadership of then newly retired ranger Joe B. Davis, the nonprofit Former Texas Rangers Foundation began raising funds to build a heritage center dedicated not only to Ranger history and all the many rangers who have died in the line of duty since 1823 but also as a place where the character traits that helped the lawmen build their legend could be instilled in young people.

Following a groundbreaking ceremony in September 2013, the $3.8 million first phase of the Texas Ranger Heritage Center opened in the summer of 2015. Situated on twelve acres adjacent to old Fort Martin

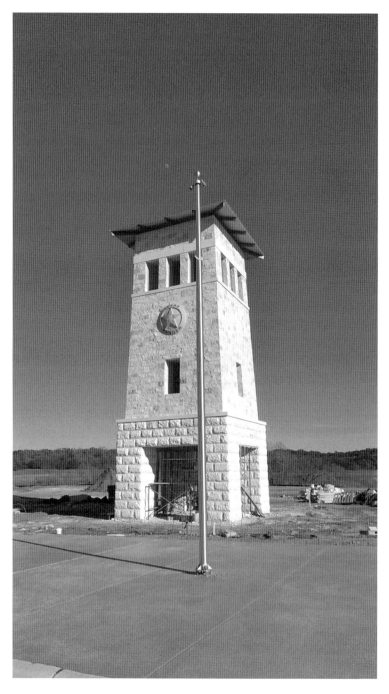

A fifty-foot bell tower at Texas Ranger Heritage Center in Fredericksburg. *Photo by Mike Cox.*

An artist's sketch of a large Ranger statue planned for the Texas Ranger Heritage Center. *Photo by Mike Cox.*

Scott, the complex includes a 50-foot limestone campanili bathed in blue light at night, a Ranger Ring of Honor built around a twenty-ton, five-point concrete replica of a Ranger badge thirty feet in diameter, an outdoor pavilion, an amphitheater and a historical reenactment area. The heritage center's second phase will include a 7,600-square-foot building with five galleries for interactive museum displays, a Ranger library and archive, a gift shop and administrative offices.

A bronze statue (two-thirds size) by artist Richard O. Cook of a ranger leading a pack mule, dedicated on May 1, 1983, in front of the old Pioneer Memorial Hall (opened in 1936 as part of San Antonio's historic Witte Museum) was refurbished by the FTRA and moved to the Buckhorn in 2011. In 2015, the statue was moved a final time to the heritage center, outside the pavilion.

Also standing near the pavilion is a two-thirds-size bronze of an 1850s ranger holding a Sharps rifle. Done by Boerne artist Erik Christianson, the

statue was underwritten by John Starkie of Houston and donated to the heritage center.

The Ranger Ring of Honor features plaques listing the names of all known ranger line-of-duty deaths. Carved along the circumference of the badge are five ranger-defining character traits: Courage, Determination, Dedication, Respect and Integrity.

Visit: Just east of the Fort Martin Scott site on U.S. 290. The facility is open during daylight hours, and the pavilion is available for private events such as weddings and family reunions. The FTRA offices are located at 103 Industrial Loop, Suite 700, in Fredericksburg. For a list of 650-plus ranger graves marked by the association with metal Ranger crosses, see formertexasrangers.org.

HAYS COUNTY
San Marcos
JACK HAYS RIDES FOREVER

Astride a rearing horse, his unholstered revolver pointing upward, Captain Jack Hays stands cast in bronze, perpetually ready for action.

When the Texas legislature took land from southwestern Travis County to create a new political subdivision in 1848, they named it for Hays (1817–1883). A larger-than-life bronze statue for this larger-than-life ranger was dedicated on the courthouse square in San Marcos 153 years later. Authorized by the San Marcos Arts Commission and designed by artist Jason Skull, the 2001 statue stands fourteen feet high on a limestone base. A plaque on the base gives a brief summary of Hay's life.

The private life of Colonel Hays was pure; his honesty unimpeachable; he was charitable, and his personal courage and gallantry in battle are historical. His death is deeply lamented by all who knew him personally, and his friends, are thousands in this state and in Texas.
—Daily Alta California, *April 23, 1883*

Visit: Courthouse square, 111 East San Antonio Street.

COLONEL HAYS.

Adventures of Colonel Hays with the Indians.*

T<small>HE</small> war between the United States and Mexico brought into conspicuous notice individuals whose abilities for border warfare have since been a theme of wonder and admiration, both in America and Europe. Born amid the wilds of Texas or of the west,

* For the facts in this sketch we are indebted to Lieutenant Reid's "Scouting Sketches of the Texas Rangers."

Ranger captain Jack Hays in his prime. *Library of Congress.*

Texas State University

The Southwestern Writer's Collection, part of the Witliff Collection at TSU's Alkek Library, has a room dedicated to the now classic made-for-TV miniseries *Lonesome Dove*. Based on Larry McMurtry's 1985 Pulitzer Prize–winning novel, the 1988 series is an action-filled saga built around a cattle drive from Texas to Montana led by two ex–Texas Rangers, Captain Woodrow Call (Tommy Lee Jones) and Gus McCrae (Robert Duvall). Bill Witliff, who founded the writer's collection, wrote the screenplay and later donated much material related to the series.

Visit: Seventh floor of the Alkek Library on the Texas State University campus in San Marcos. Visit thewitliffcollection.txstate.edu for specific on-campus directions and parking information.

Wimberley

William Washington Moon (1814–1897)

Busy dodging arrows and shooting during a running fight with Comanches, Ranger William Moon nevertheless managed to get a glimpse of the large springs and inviting clear water at the head of the San Marcos River in what is now Hays County. After his service with Captain Jack Hays ended, Moon returned to the area in 1845 and built a cabin for his family—the first residence in future San Marcos. Soon a widower, he raised his four children and spent the rest of his life in and around the town he started. He fought in the Mexican War, later got elected as Hays County sheriff and briefly served in a ranger-like capacity early in the Civil War. After the war, before settling in as a San Marcos blacksmith, he rode as a cowboy on trail drives.

Visit: Wimberley Cemetery, Farm to Market Road 3237 and Old Kyle Road. A 1975 historical marker at the intersection of C.M. Allen Parkway and Hutchinson in San Marcos explains Moon's significance in the history of Hays County.

CENTRAL TEXAS

KENDALL COUNTY
Boerne
TOMBSTONE POETRY

John Woodward "Wood" Saunders (1856–1913) served as a Frontier Battalion ranger off and on in the 1880s and 1890s, eventually making sergeant. Much of his service was under Company D captain John R. Hughes. While Saunders rode with the rangers, his wife, Mary, in 1884 wrote a poem lauding the state lawman.

At some point after his death, Saunders's tombstone was lost or stolen. In 1989, his descendants, working with the National Association for Outlaw and Lawman History (now the Wild West History Association), placed a new marker on his grave. Carved in the marker are two verses from Mary Saunders's poem:

> *He may not win the laurel*
> *Nor trumpet tongue of fame*
> *But beauty smiles upon him,*
> *And ranchmen bless his name.*

> *Then here's to the Texas Ranger*
> *Past, present and to come.*
> *Our safety from the savage,*
> *The guardian of our home.*

Visit: Boerne Cemetery, 700–800 North School Street.

Sisterdale

BATTLE OF WALKER CREEK

Returning from a fruitless scout for Indians along the Pedernales River, Captain Jack Hays detailed one of his rangers to lag behind the rest of his command, alert to the possibility of their being backtracked.

On June 8, 1844, the rear guard rode into the ranger camp to report that he had found ten sets of Indian pony tracks following the rangers' trail. Hays soon spotted several Indians in the distance, but they quickly faded into the brush. The captain ordered his men to mount and ride toward the trees. As the rangers

advanced, a few warriors emerged and made a show of surprise at seeing the rangers. Then they ducked back into the cover on the east bank of a creek.

The captain had only fourteen men. But a potent equalizer rested in each of their holsters—the five-shot, .36-caliber Paterson Colt revolver.

Slowly, the rangers advanced. Having higher ground behind them, the Indians fell back, moving to a position of even more advantage over the approaching Texans. At the crown of the hill, the Comanches dismounted. Brandishing their crow feather–draped lances and raising and lowering their tough buffalo-hide shields, some knew enough English to taunt the rangers with cries of "Charge! Charge!"

Hays then demonstrated the genius for fighting that established his reputation. He knew the Indians could not see him from where they were. Rather than charge uphill, clearly what the Comanches wanted, Hays spurred his horse and wheeled around the rocky ridge. The rangers followed, circling to the Comanche's exposed flank.

Seeing the Texans galloping toward them on level ground, the Indians remounted. The shock of the charge broke their line but only for a moment. Regrouping, the warriors split and attacked the rangers from two sides.

When the last of the gun smoke blew away, twenty Comanches lay dead. Another thirty had been wounded. Ranger Peter Fohr took several arrows and later died. Three other rangers suffered wounds, including slim, redheaded Samuel Walker, pinned to the ground with a lance through his body. Incredibly, he survived to fight again.

The fight represented more than a clash of two proud cultures. It demonstrated the power of nineteenth-century technology over stone-age weaponry. With the Colt repeating pistols, the rangers had the frontier equivalent of nuclear bombs.

> *Back to back, the Texians received them and the close and deadly fire of their pistols emptied many a saddle. Thus, hand to hand the fight lasted fifteen minutes, the Indians using their spears and arrows, the Texians their repeating pistols. Scarcely a man…was not grazed.*
>
> —Clarksville Northern Standard

Visit: Historians have debated for years exactly where the fight occurred. It is believed to be on private property in Kendall County. Sisterdale Dance Hall and Opera House, 1210 Sisterdale Road. Historic nineteenth-century log and frame structures (with historical exhibits) amid 360-year-old oaks on the bank of Sister Creek.

CENTRAL TEXAS

KERR COUNTY
Center Point
RANGER CEMETERY

No one knows why the small Center Point Cemetery came to be the final resting place of so many Texas Rangers, but with thirty-five ranger tombstones, the cemetery has more ranger burials than anyplace in the state.

For years, the count stood at thirty-two, but the burial of three modern-day rangers, including noted Captain John M. Wood, who until his death in 2013 had been the state's oldest living ranger, has raised the number to thirty-five.

The three best-known nineteenth-century rangers lying in the cemetery are Andrew Jackson Sowell Jr., Neal Coldwell and Nelson Orcelus Reynolds.

Modern rangers during the 1986 historical marker dedication at Center Point Cemetery, which has more ranger graves than anywhere else in Texas. *Photo by Mike Cox.*

GUNFIGHTS & SITES IN TEXAS RANGER HISTORY

A.J. SOWELL (1848-1921)

Like his father Asa Sowell, who had ridden with Jack Hays's rangers, Andrew Jackson Sowell served Texas as a ranger as well. Born in Seguin in 1848, A.J. Sowell joined the Rangers in 1870. Soon after mustering in, he participated in the force's 1870–71 campaign against the Wichita Indians. Unlike his father, A.J. proved as adroit with a pen as with horses and guns. After his ranger service, he wrote three classics of Texas history: *Early Settlers of Southwest Texas* (1880), *Rangers and Pioneers of Texas* (1884) and *The Life of Big Foot Wallace* (1899). Sowell died in Center Point in 1921 at seventy-three.

NEAL COLDWELL (1844-1925)

When the Frontier Battalion organized in the spring of 1874, Coldwell became captain of Company F. His seventy-five rangers took their oaths of office in Kerr County on July 4 that year. Coldwell continued as a company commander until 1879, when he was promoted to ranger quartermaster, a job he held until 1883. He spent the last years of his life at Center Point, dying there at eighty-one.

N.O. REYNOLDS (1846-1922)

Reynolds joined the Rangers on May 25, 1874, serving first under Company D captain Rufe Perry and later as a lieutenant under Captain Coldwell in Company E. As a Frontier Battalion lawman, Reynolds was involved in mitigating the deadly Horrell-Higgins feud in Lampasas and the 1878 breakup of the Sam Bass gang in Round Rock. After rangers returned killer John Wesley Hardin to Texas, Reynolds guarded the notorious gunman during his trial and then escorted him to prison at Huntsville. The lieutenant resigned from the Rangers in 1879 and later settled in Center Point. He died there in 1922, at seventy-five.

Visit: Center Point is on State Highway 27 between Kerrville and Comfort. The cemetery is off Farm to Market Road 480, half a mile from town. A historical marker placed in 1986 lists the ranger burials. At 318 San Antonio Stree is one of the community's oldest buildings, the two-story Woolls Building. Built in 1873-1875, it served as the meeting place of the local

Rising Star Masonic Lodge. Many of the former rangers buried at Center Point had belonged to this lodge. A native limestone house former ranger Reynolds lived in from 1918 to 1922 is across from the cemetery at Farm to Market Road 480 and Elm Pass Road. A 2001 historical marker stands outside the house.

Kerrville

Joseph A. Tivy (1818–1892)

With his two sisters, Joseph Tivy immigrated to the Republic of Texas from his native Canada by way of New York in 1837. He served four enlistments under ranger captain Jack Hays for various periods from 1844 to 1846. After the discovery of gold in California in 1849, he and his sisters joined the westward rush. Back in Texas in 1858, he settled in Karnes County for a time. When the Civil War began, he spent two years in Confederate military service. After the war, Tivy worked as a surveyor for the Texas General Land Office and eventually began ranching. In 1872, he moved to Kerr County. He served in the legislature and in 1889 as mayor of Kerrville. While mayor, he donated land for the city's schools. Tivy; his wife, Ella (along with her pet cat); and his sister Susan were buried on the mountain overlooking town.

Visit: A historical marker commemorating the former ranger and his family stands two miles east of Kerrville on Farm to Market Road 1341, just south of Loop 534. A dirt road off nearby Cypress Creek Road leads to the summit of the mountain, but the grave site is not open to the public.

Captain Charles Schreiner (1838–1927)

Born in Alsace-Lorraine, France, to a family of nobility, Charles Schreiner came to San Antonio with his parents in September 1852. Two years later, only sixteen, Schreiner enlisted as a Texas Ranger. He served under Captain John W. Sansom until 1857, when he resigned to take up ranching in newly organized Kerr County.

In 1861, Schreiner joined the Confederate army and saw action throughout most of the war. Back in Texas, he returned to ranching in Kerr County. In 1869, Schreiner opened a general mercantile store. The store did

well, and Schreiner expanded his business interests to banking and the sale of wool and mohair.

While Schreiner learned how to keep accounts, price his goods sharply and judge livestock, his ability to ride and shoot did not atrophy. That proved useful in 1870 when Kerr County organized a ranger-like company that elected Schreiner its captain, a title he held the rest of his long life.

Y.O. Ranch

In 1880, Captain Schreiner bought the former Taylor-Clements Ranch and its Y.O. brand in western Kerr County. Once covering 600,000 acres, by the late twentieth century, the Y.O. had been reduced to 65,000 acres. The Schreiner family still owns 27,000 acres, both a working ranch and hunting resort. When Schreiner's grandson Charles Schreiner III inherited the Y.O. in 1954, he began building a large collection of Texas Ranger firearms and other memorabilia he kept at the ranch. Retired and current rangers were frequent guests. Following his death at seventy-four in 2001, his collection sold at auction.

Visit: A historical marker erected in 1986 stands at the ranch entrance, sixteen miles west of Mountain Home on State Highway 41.

Schreiner Mansion

Noted San Antonio architect Alfred Giles designed a two-story, six-bedroom house for Captain Schreiner in 1879 that was the first native limestone structure in Kerr County. Sixteen years later, Schreiner paid Giles to add an elaborate porch. Pink granite columns shipped from Italy enhanced the addition. Schreiner lived in the mansion until his death, after which his heirs sold it to the local Masonic lodge. Since 2009, it has been owned by Schreiner University, a Kerrville liberal arts college endowed by the captain in 1923. The mansion was added to the National Register of Historic Places in 1975.

Visit: 216 Earl Garrett, Kerrville.

CENTRAL TEXAS

LAMPASAS COUNTY
Lampasas
Horrell-Higgins Feud

Most customers walking into Terry the Barber's in downtown Lampasas don't pay much attention to the shop's front door. They're wanting a haircut, not studying architecture. Occasionally, however, someone with an eye for detail may notice what look like worm marks in the old wood around the door's lock. But insects didn't make those small holes—shotgun pellets punched them during a wild shootout on the courthouse square in the summer of 1877, the climax of one of Texas's bloodiest feuds.

Sixty-seven miles northwest of Austin, in the 1870s, Lampasas lay on the rough edge of Texas's western frontier. The county had a duly elected sheriff, but he could not hope to keep the peace all the time in a community full of men with guns generally inclined to settle things their way.

In 1876, cattleman John Pinckney Calhoun Higgins, better known as Pink, began losing calves, and he rightly suspected the brothers Horrell—Martin, Merritt, Sam and Thomas. Particularly Merritt. Higgins tried it the legal way first, filing charges against Merritt for cattle theft. But a jury acquitted him.

On January 22, 1877, Higgins confronted Horrell in the Gem Saloon. "Mr. Horrell," he said almost politely, "this is to settle some cattle business." And then Higgins proceeded to "Winchester" him, permanently breaking him from rustling. While that shooting had to do with one man righting a wrong the way he saw fit, when someone kills someone else, it tends to create resentment among the family and friends of the dearly departed. In this case, violence soon spread like pooling blood.

Two months later, on March 26, 1877, someone ambushed Tom and Mart Horrell on a branch of Sulphur Creek as they rode toward town. They shot back and survived, though one got wounded. Rangers rode in pursuit of the attackers, presumed to be Higgins and some of his men, but they did not find them. Soon, however, Higgins and his brother-in-law Bob Mitchell had been named in arrest warrants. Higgins and Mitchell eventually turned themselves in and were freed on $10,000 bail each. On June 4, someone broke into the county courthouse and destroyed all the district court records having to do with their case.

Three days later, when the two men rode into town with some of their friends to make new bonds, the Horrells and their supporters stood waiting. Soon, right on the courthouse square, lead started flying. The June 7

Holes punched by shotgun pellets are still visible in the door of this old
building on the courthouse square in Lampasas. *Photos courtesy Jane McMillan.*

gunfight lasted an incredible two hours with scores of rounds fired—mostly
from Winchester rifles but also from handguns and shotguns. Higgins and
Mitchell and the Horrells all survived, but one man from each faction
died, with a third man wounded. Likely more would have ended up in the
cemetery had it not been for the armed intervention of local officers and
three deputized citizens.

A week later, Frontier Battalion commander Major John B. Jones led
fifteen rangers into town. He stayed until tensions eased and then left
Lieutenant N.O. Reynolds and a small detachment behind to keep things
quiet. Back in late July after Reynolds and his men had rounded up the
Horrells, Jones got each faction to sign letters that amounted to a peace
treaty, one of the more unorthodox (if successful) feud mitigations in the
history of the Old West.

> [W]e believe the troubles are over, and once more it can be said that
> Lampasas county is free from local broils and her population quiet and
> law-abiding.
>
> —Lampasas Dispatch, *August 9, 1877*

CENTRAL TEXAS

Visit: The barbershop with the shotgun-sprayed door is at 413 East Fourth Street in the Alex Northington Building, one of Lampasas's oldest structures. The door originally hung on the front of the building, facing the square.

A historical marker summarizing the feud stands on the west side of the courthouse.

Another historical marker was placed in 2002 at the site of the March 26, 1877 battle, near a stream that came to be called Battle Branch. That marker is 3.8 miles east of Lampasas on U.S. 190.

The rangers camped near Hancock Springs on Sulphur Creek in Lampasas, the exact spot lost and unmarked.

Lieutenant Reynolds, after resigning from the Rangers, later became sheriff of Lampasas County. After leaving law enforcement, he ran a saloon there for a time.

Lampasas County Museum, 303 South Western Avenue, Lampasas.

MASON COUNTY

THE HOO-DOO WAR

One of the Frontier Battalion's less-than-inspiring performances came during the Hoo-Doo, or Mason County, War. The near anarchy that gripped the county from 1874 to 1877 resulted from a volatile mix of lingering post–Civil War grudges, cultural differences ("Americans" versus settlers of German heritage) and ranchers bent on exterminating cattle thieves. Overzealous law enforcement at the county level and indifference on the part of some rangers didn't help.

The trouble started when a posse under newly elected Sheriff John Clark jailed a number of Llano County residents for rustling. After their release, escorted by a delegation of partisans on their way back to Llano County, a Methodist church mysteriously burned down about the time they rode by.

Clark jailed another ten men for rustling in early February. Out on bail, they fled the county, which they weren't supposed to do. Soon the sheriff had five of them back in the Mason County lockup.

Meanwhile, on February 15, someone found a seventeen-year-old "American" shot to death. A note pinned on his coat observed, "He would not stop rustling." Three days later, a group of concerned citizens forcibly

removed the five alleged cow thieves from jail and took them to a large oak tree on the south side of town.

Substantially outgunned, Sheriff Clark and ranger lieutenant Dan Roberts could only watch and lamely say, in effect, "Please don't do that," as the vigilantes strung up four of the men and shot the fifth. At least the officers cut down one of the men in time to save him.

In March, the anti-rustling crowd even threatened to lynch rancher Tom Gamel for declining to participate in the mass hanging the month before. Clearly, the flame of law and order had flickered out in Mason County. Equally as plain, the ranking ranger in charge—Roberts—did not see the extra-legal adjudication of cattle thieves as a threat to social order.

The killing continued.

On May 13, suspected rustler Tim Williamson died of sudden onset lead poisoning as deputy sheriff John Worley escorted him to the county seat for a bond hearing. That summer, a man hunting stray cattle on Gamel's ranch found death instead. Not three weeks later, the sheriff and his volunteer force killed a suspected rustler and wounded another man in a shootout at a rural general store.

Four days after that in-the-name-of-the-law killing, on August 10, former ranger Scott Cooley killed and scalped deputy Worley. The man killed while in Worley's custody had been a friend of Cooley's.

On September 28, four additional Hoo-Doo murders later, Major John B. Jones—determined to end the violence—led a large contingent of rangers into Mason County. But the following day, while the rangers vigorously scouted elsewhere, Cooley and pal John Ringo (later famously known as Johnny Ringo) shot and killed Mason County hide inspector Dan Hoerster in front of the Mason House Hotel.

With two county officials already dead, Sheriff Clark concluded the time had come to pursue other career opportunities and vacated both his office and Texas.

One more payback murder happened in Llano County, and that summer, Cooley died under curious circumstances in Blanco County, possibly of poisoning.

Thirteen men had died violently, and a fourteenth had died young under highly suspicious circumstances. Only one person was convicted in any of the deaths, and he spent only a short time in prison before paroled.

Any hope of widespread prosecution in connection with the feud went up in smoke when the Mason County courthouse burned in 1877. Metaphorically, the intentionally set fire ended the feud, though hard feelings between certain Hill Country families smoldered for years.

Visit: Mason Square Museum, 130 Fort McKavett Street. The museum has a permanent Hoo-Doo War exhibit. The rock-lined well Worley was digging when Scott Cooley killed him is near Westmoreland Street and Avenue F, Mason. A historical plaque marks the site. Dating to 1870, the two-story Mason House at 100 Live Oak Street was Mason's earliest hotel, serving as a stage stop on the San Antonio to El Paso route. Ranger lieutenant Roberts was staying there when mob action broke out on the nearby courthouse square. Scott Cooley and John Ringo breakfasted there before killing hide inspector Hoerster. After the hotel closed, the owner converted the building into rental units.

Former ranger Scott Cooley killed a Mason County sheriff's deputy while the hapless lawman was digging this well. *Photo by Mike Cox.*

MASON COUNTY JAIL

Built in 1894, the two-story stone lockup has held many a ranger's prisoner. The first sheriff to live on the ground floor of the new jail was noted former ranger P.C. Baird, who served as Mason County's top lawman from 1888 to 1896 and again from 1912 to 1916. As a ranger corporal in charge of a three-man detail, Baird took part in a fierce gun battle with fence cutters at the Green Lake Ranch in Edwards County. The old jail is still in use.

Visit: 122 Westmoreland Street, just south of the courthouse.

McLENNAN COUNTY
Waco
FORT FISHER

In 1837, rangers under Captain Thomas H. Barron made their way up the Brazos River to a longtime Waco Indian campground. Clearing a wagon road as they went, it took the company three weeks to get from the Falls of the Brazos to the recently vacated Indian village. The rangers built a few crude cabins near a spring on the river, but less than a month later, a courier arrived with orders for the company to return to the falls. Hardly a true fortification, the rangers nevertheless named the place Fort Fisher in honor of Secretary of War William S. Fisher. Rangers would return to the fort at various times for brief periods, but only its name would last.

> *We built some shanties for barracks…but only remained there three weeks, when an order came…for us to return to the falls, as we were too far out to do good service.*
>
> *–Ranger George B. Erath*

FIRST STREET CEMETERY

Waco's first public burial ground dates to 1852—only five years after the town's founding—when the local Masonic lodge purchased an acre south of the Brazos River near the site of old Fort Fisher.

THOMAS HUDSON BARRON (1796–1874)

Virginia-born Thomas Barron, whose ranger company established Fort Fisher, must have liked what he saw when he first beheld the mid-Brazos River. In 1847, a decade later, he homesteaded 340 acres there and built Waco's first residence. Later, he served as McLennan County tax assessor-collector. He died on February 2, 1874 at his daughter's home in what is now Bruceville-Eddy and was buried there. In 1976, the former ranger's remains were moved to First Street Cemetery in the city he founded. A historical marker stands near his grave.

CENTRAL TEXAS

Visit: The cemetery, listed on the National Register of Historic Places, is part of Fort Fisher Park, adjacent to the Texas Ranger Hall of Fame and Museum at 100 Texas Ranger Trail, Waco.

OAKWOOD CEMETERY

Established in 1878, the cemetery is the final resting place of two noted former rangers, including one who went on to be governor.

GEORGE BERNARD ERATH (1813–1891)

A well-educated gentleman from Vienna, Erath came to the United States from Austria in 1832, settling in Texas eight months later. A surveyor, when he joined John H. Moore's ranger company in 1835, he soon demonstrated he could be as accurate looking down the barrel of a rifle as he was sighting a transit. When the Texas Revolution began, he served in the regular military, participating in the Battle of San Jacinto. After Texas won its independence from Mexico, he enlisted in a ranger company led by Captain William H. Hill. In 1837, he was among the rangers who established Fort Fisher.

Erath platted the towns of Caldwell, Waco and Stephenville. As a member of the Republic of Texas Congress and later the state legislature, he always argued for what he thought best for Texas. In 1858, he successfully stewarded the legislature's authorization of a one-hundred-man ranger company commanded by John S. "Rip" Ford.

When the Civil War broke out, Erath stood ready to fight for Texas again. In 1864, with the rank of major, he commanded a regiment in the Second Frontier District. With men enlisted from Brown and Coryell Counties, Erath's rangers conducted regular patrols to keep hostile Indians from preying on the settlements while most of the state's able-bodied men were away at war.

The former ranger's final contribution was to posterity. In 1886, he dictated his life story to his daughter. Though not widely published until 1956, his memoir stands as one of the best sources on the early-day rangers and the struggle for Texas independence. He died on May 13, 1891.

> *There is no page too bright for Major Erath's name. He is a subject for the sculptor, and a proper hero for the song. He has written his memoirs,*

and when the public is allowed to read his story, told in his own strong, but simple language, light will be thrown upon many a page now darkened by error. Major Erath…was a soldier, a scholar, a gentleman and a good citizen.
—Waco Day, *May 1891*

Sul Ross (1838–1898)

The second of three Texas governors who served as rangers early in their lives, Ross led the ranger company that found Cynthia Ann Parker in 1860. By then, twenty-four years after her capture by Indians in the attack on Fort Parker, it was too late for the young mother of three Indian children to readjust to her former culture. But the incident helped boost Ross's career. Ross's success as a Civil War general helped even more, and after serving as McLennan County sheriff from 1873 to 1875, followed by four terms in the state senate, he was elected governor and held office from 1887 to 1891. After leaving Austin, he became president of what is now Texas A&M University and led the institution until his death in 1898.

Visit: Oakwood Cemetery, 2124 South Fifth Street.

Texas Ranger Hall of Fame and Museum

The story of the Texas Ranger Hall of Fame and Museum goes back to 1964, when DPS Director Colonel Homer Garrison accepted an offer from the Waco Chamber of Commerce to construct a building that would serve both as a headquarters for ranger Company F and a museum.

Four years later, on October 25, 1968, dignitaries gathered for the dedication of the new Ranger office and museum—Fort Fisher returned. All six ranger captains and many of their men attended, but the man who had pushed hard for the facility wasn't there. Colonel Garrison, whose title usually also included the designation "Chief of the Texas Rangers," had died on May 7. But he had been present on December 12, 1967, to participate in the groundbreaking for the new museum.

The name of the complex, which sits on thirty-two acres donated by the City of Waco on the south bank of the Brazos River adjacent to downtown, was later changed from Fort Fisher to the Texas Ranger Hall of Fame and Museum.

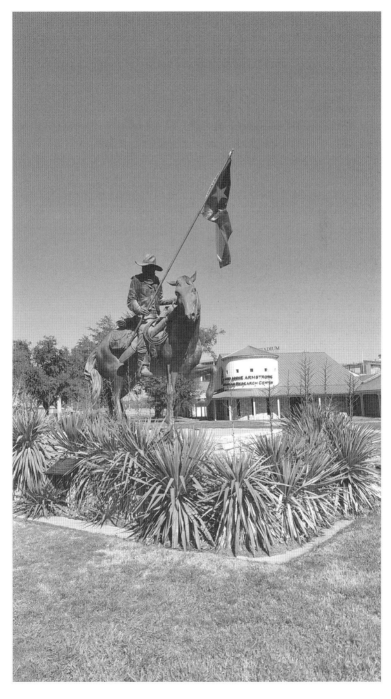

A statue of a flag-carrying mounted ranger in front of the Texas Ranger Hall of Fame and Museum in Waco. *Photo by Mike Cox.*

Since it opened, the museum has continued to grow by all measures—physical size, the extent of its artifacts and archives and the number of visitors it sees each year.

RANGERS IN BRONZE

Two works of Ranger-related public art stand outside the museum. The first is a bronze by Glen Rose artist Robert Summers of noted ranger and surveyor George B. Erath, placed in 1976. The second, a larger-than-life bronze by San Antonio artist Don Day of an early-day horseback ranger bearing the Texas flag was placed in 2008 to mark the fortieth anniversary of the museum. Inside the museum is a third piece, a life-size ranger statue, *Old Ranger*, also by Summers.

Visit: Exit 335B off Interstate 35 in downtown Waco on the south side of the Brazos River.

Riesel

MARVIN "RED" BURTON (1885–1970)

"Red" Burton toughened up as a construction worker before joining the Waco Police Department in 1917, but facing up to a riotous mob of hooded Ku Klux Klan members is what proved to a governor that Burton had what it took to be a ranger.

Burton left the Waco police in 1919 and hired on as a McLennan County sheriff's deputy. His defining moment came in October 1921, when the KKK staged a parade in Lorena, south of Waco. Neither the sheriff nor Burton cared about the march—that was the secret organization's free-speech right no matter their onerous stances—but the sheriff had insisted that its leaders identify themselves so he would know who to look for in case of trouble. In the mêlée that soon followed, a Klan member shot the sheriff (he survived), and Burton got roughed up. In the process, however, Burton shot and wounded several hooded men.

Nine days later, in Waco, KKK members turned out en masse again, vowing to lynch Burton. Armed with his pistol, a sawed-off shotgun and guts, the deputy succeeded in almost singlehandedly backing down the mob.

That incident and the officer's efforts to break up bootlegging operations during Prohibition caught the eye of another Wacoan—Governor Pat Neff.

The governor appointed Burton to the Rangers in 1922, and the McLennan County native served with distinction for eleven years. Burton furthered his no-nonsense reputation as an oil boomtown tamer. One of the high points in his career came when he worked to clear two African American men accused of a series of rapes and murders in McLennan County. When the real killer was convicted, Burton prevented his lynching. On the day in 1923 set for the man's lawful execution—the last legal hanging before the state took over the function—Burton helped with crowd control.

After leaving the Rangers in 1933, he went back to the Waco Police Department first as chief of detectives and later as police chief. He retired in 1951.

> *Those men think they want to kill me but they don't…because they realize that…some of them will be killed.*
> —Red Burton, October 10, 1921

Visit: Burton is buried in Riesel Cemetery, one mile north of Riesel on the west side of Texas 6 (North Memorial Street).

MILLS COUNTY
Goldthwaite
RANGERS SAVE TWO STOLEN CHILDREN

Early rangers often saddled up to deal with something that had already happened, but sometimes they went looking for trouble.

On October 21, 1858, scouting in what is now Mills County, ten rangers from San Saba County under Lieutenant D.C. Cowan discovered numerous unshod pony tracks. The trail led to a settler's cabin near a crossing of Pecan Bayou, but the rangers found no one home. Continuing on the trail, the company discovered a wrecked wagon and the arrow-studded, scalped bodies of a woman, a teenage girl and an infant. About 150 yards from those three bodies, the rangers found the scalped corpse of a man.

Neighbors identified the victims as Moses and Lydia Jackson and two of their children. They also said that two of the Jackson's children, Joshua and

Rebecca, were missing, apparently captured by the Indians who had killed the rest of their family. After burying the Jacksons, the rangers and armed civilian volunteers began following the Indians.

Eight days later, some 140 miles to the west near present Sweetwater, the rangers found two sets of small footprints. Dismounting to search the area, two of the rangers discovered the Jackson children hiding in the brush. They had managed to escape their captors but likely would have died of exposure, thirst or starvation if the rangers had not found them when they did. Rather than continuing their pursuit of the Indians, as Cowan reported, he decided that "humanity dictated the Children should be brought in."

In addition to saving two young lives, the lieutenant and his men had demonstrated the importance of rangers being in the field on regular patrols, not solely when the need arose. The incident proved to be another step in the evolution of the Rangers into a standing force. A historical marker telling the massacre story was dedicated in 1998.

Visit: West of Goldthwaite 14.2 miles on FM 547. Mills County Historical Museum, 1119 Fisher Street, Goldthwaite. Old Mills County Jail Museum, 1003 Fisher Street. Built in 1888, the jail remained in use until 1950.

TRAVIS COUNTY
Austin
RESCUE OF SARAH HIBBINS'S CHILD

In January 1836, a company of rangers led by John J. Tumlinson made camp about ten miles below future Austin while on their way to build one of a series of blockhouse forts intended to protect the settlements from Indians.

As the men readied their supper, a bleeding, nearly nude woman staggered into the light of their campfire. Comanches had killed her husband and brother and taken her prisoner along with her three-year-old son and baby. When the infant started crying, the Indians had killed it. She had managed to escape her captors, leaving her little boy with them.

After hearing her story, Tumlinson and his men left immediately to find the Indians and rescue the child.

On the morning of January 20, in present Travis County, twenty rangers caught up with the Comanches. The rangers killed two of the

Indians before the rest fled, leaving their young captive behind. Two rangers suffered minor wounds.

> *Not an eye was dry. She* [Mrs. Hibbins] *called us brothers, and every other endearing name…She hugged her child to her bosom as if fearful that she would again lose him. And—but tis useless to say more.*
> —*John J. Tumlinson Jr. (His father had been killed by Indians thirteen years before.)*

Visit: From what is now Guadalupe County, where the Indians had killed Mrs. Hibbins's husband and brother, the Comanches crossed the Colorado River and likely worked their way north along Shoal Creek in present Austin. Somewhere along the creek (some say at a feature called Split Rock Waterhole) is where Mrs. Hibbins escaped. Where the rangers fought the Indians was never marked, and the exact location is unknown.

FORT COLEMAN

In late September 1836, a company of rangers under Robert M. Coleman constructed a log fort between Walnut Creek and the Colorado River, a post variously known as Fort Colorado, Coleman's Fort or Fort Coleman. A blockhouse and several cabins surrounded by a sturdy stockade, the fort remained active through the fall of 1838.

By that time, Coleman was gone from the Rangers. President Houston had ordered him dismissed and arrested for the brutal punishment meted out to a drunk ranger. A lieutenant, not Coleman, had ordered the ranger tied to a post (he had passed out and strangled), but the president held Coleman responsible.

The fort that Coleman established vanished over time, but in 1936, the state placed a granite historical marker at the site, long since surrounded by the city of Austin.

> *I have selected the most beautiful site I ever saw for the purpose. It is immediately under the foot of the mountains. The eminence is never the less commanding, and…suited to the object in view.*
> —*Coleman to Sterling Robertson, October 16, 1836*

Visit: East Martin Luther King, Jr. Boulevard, west of Russet Hill Drive, on the right when driving east.

GUNFIGHTS & SITES IN TEXAS RANGER HISTORY

MOUNT BONNELL

The view from Austin's highest point has always been impressive, but when early resident and future ranger Bigfoot Wallace arrived in 1839, he did not come for the scenery. Stricken with a disease he called the "flux" (probably cholera), he had lost all his hair and did not want his fiancée to see him that way. He camped in a cave at the base of Mount Bonnell (a shelter later collapsed or inundated by Lake Austin) and spent his time hunting and fishing until he recovered and got his hair back. When he returned to the small capital city, he found that his ladylove had fallen for another suitor and eloped. That broke him of women, and he spent the rest of his life single.

Visit: 3800 Mount Bonnell Road. A small city park, at 780 feet above sea level, it still offers the best view in Austin. A historical marker placed in 1969 outlines the landmark's history, including Wallace's stay there.

ANGELINA EBERLY STATUE

Six years after Texas won its independence from Mexico, in December 1841, a group of Austin citizens had to fight to keep their town as the capital. In what became known as the Archives War, a party of rangers under orders from President Sam Houston attempted to remove the nation's archives from the General Land Office in Austin to Washington-on-the-Brazos. The townspeople resisted, with boardinghouse owner Angelina Eberly even firing a cannon at the rangers. Austin Area Statues, Inc. commissioned Pulitzer Prize–winning cartoonist and artist Pat Oliphant to do a life-size bronze of Eberly (1798–1860) firing the cannon. The public artwork was dedicated in 2004.

Visit: Southwest corner of Sixth and Congress Avenue, where Eberly touched off the cannon. Serious historians point out the absence of any primary or contemporary evidence that Eberly took as proactive a role as legend holds.

HORNSBY FAMILY CEMETERY

The oldest cemetery in Travis County is the final resting place for many members of one of Texas's pioneer families, the Hornsbys. Among the burials

are fifteen former rangers. The cemetery also has monuments honoring four other rangers, who, while not buried there, were part of the Hornsby clan.

Originally from Mississippi, Reuben Hornsby Sr. and his wife, Sarah Morrison Hornsby, came to Texas in 1830 and, by July 1832, had settled in a bend of the river nine miles downstream from future Austin. While the area became known as Hornsby's Bend, their well-fortified Hornsby cabin was called Hornsby Station.

The elder Hornsby not only served as a ranger and later as a soldier in the Texas Revolution, but he also planted the first corn ever sown in Travis County, sat on the county's first jury, helped lay out the county's earliest roads, assisted in the surveying of Austin in 1839 and fathered the first Anglo child born in the county.

> *In their lives…* [the Hornsbys] *did much to make Texas history and pave the way for those who followed in the more secure paths of civilization. It is meant that they should lie here in perpetuity, the little forest of their headstone serving as a lasting memorial, not only to their own bones, but to the vivid scenes and stirring times in which they took so large a part.*
> –Dallas Morning News, *1921*

Visit: From Farm to Market Road 969 east of Austin, turn on dirt road at Hornsby Family Cemetery sign. Cemetery is marked "No Trespassing," but respectful visitors are welcome. For the names of the rangers buried in the historic cemetery, see hornsbybend.com.

Austin Memorial Park Cemetery

Frank Hamer (1884–1955)

Thanks to one of many shootouts he took part in, particularly the one on May 23, 1934, in which the outlaw couple Bonnie Parker and Clyde Barrow died in a hail of bullets near Arcadia, Louisiana, Captain Hamer became one of the best known twentieth-century rangers. Hamer first joined the Rangers in 1906 and served off and on until 1931. For a man said to have been in dozens of gunfights and wounded multiple times, sunstroke is what finally claimed his life.

MANNY GAULT (1886-1947)

When Hamer picked the partner he wanted to go after Bonnie and Clyde, he said, "I want Manny Gault."

Born and raised in Austin, Gault went on the Ranger payroll on January 31, 1931, but he had helped Hamer with bootlegging and gambling cases before then, and the two were friends. He served as a ranger until Miriam "Ma" Ferguson was elected governor in 1933 and resigned before she fired virtually the whole force to replace them with men more in line with the politics of her and her husband, impeached former governor Jim "Pa" Ferguson.

After the two Texans caught up with Bonnie and Clyde in Louisiana, Gault returned to the Rangers and served until his death in 1947.

Visit: 2800 Hancock Drive, Austin.

Oakwood Cemetery

Established in 1839, Oakwood is Austin's oldest cemetery.

JOHN B. ARMSTRONG (1850-1913)

Ranger Lieutenant Armstrong made up for the merciless ribbing he took from his fellow rangers after accidentally shooting himself in the leg by capturing one of the Old West's most notorious outlaws.

Born in Tennessee, Armstrong came to Texas at twenty-one by way of Missouri and Arkansas. Settling in Austin in 1871, he enlisted in Captain Leander McNelly's company on May 20, 1875.

Under the unconventional McNelly, Armstrong participated in several gunfights in South Texas and soon earned promotion to sergeant along with a reputation as a solid lawman. When McNelly resigned due to poor health, Armstrong remained in the company under its new commander, Captain Lee Hall.

When former Dallas police officer John Duncan, operating undercover in John Wesley Hardin's old stomping grounds in Gonzales County, learned the fugitive lived in Alabama under an assumed name, Armstrong volunteered to bring him back to Texas. Finding that Hardin often took the train to Pensacola, Florida, to gamble, with the cooperation of the railroad

and help from local officers, the ranger and Duncan waited until Hardin boarded the train in Pensacola. Following a shootout that left one of Hardin's cronies dead, the officers succeeded in taking the wanted Texan into custody.

After leaving the Rangers, Armstrong established a ranch in Willacy County in 1882. He died at sixty-three.

> *Arrested…Hardin…this P.M. He had four men with him. Had some lively shooting. One of their number killed. All the rest captured. Hardin fought desperately.*
> —*Telegram to Adjutant General William Steele from Lieutenant Armstrong, August 23, 1877*

JOHN B. JONES (1834–1881)

He had a common name but was an uncommon man. Slight of stature but smart and battle-tested in the Civil War, as major in command of the Frontier Battalion, soft-spoken John B. Jones successfully presided over the Ranger transition from Indian fighters to state lawmen. Had he failed, arguably, the Rangers would not have survived into the twentieth century.

No desk-bound administrator, Jones spent much of his time in the field, traveling by buggy or horse with an escort company from trouble spot to trouble spot. He took part in the Lost Valley Indian fight in the summer of 1875 and the shootout with outlaw Sam Bass in 1878. No trigger-happy lawman, he intervened in several vicious feuds hoping to negotiate peace.

In addition to the actual fighting he did, the major also sparred with a penurious legislature always eager to spend less money on the Rangers if not to abolish them altogether.

Though a strict disciplinarian who quickly culled bad apples, Jones had the respect of his men. On his watch, the Rangers won their enduring reputation as highly effective professional peace officers.

In 1879, Jones gained promotion to adjutant general, but he continued to have operational control of the Rangers. Only forty-six, he died in Austin on July 19, 1881, of complications following a surgical procedure. Delirious from fever, he died quoting Shakespeare.

> *Although the force is too small, and the appropriation insufficient to give anything like adequate protection to so large a territory, the people seem to*

GUNFIGHTS & SITES IN TEXAS RANGER HISTORY

think we have rendered valuable service…and there is a degree of security felt in the frontier counties that has not been experienced for years.
—Major Jones to Adjutant General William Steele

WILLIAM STEELE (1820-1885)

A New Yorker who graduated from West Point in 1840, Steele ended up in the Lone Star State because he married a Texas woman. He saw active service in the Confederate military, reaching the rank of brigadier general. When the Frontier Battalion was organized, Governor Richard Coke named Steele adjutant general. That gave him overall authority over the Rangers, though Major John B. Jones coordinated the activities of the force. Steele served until 1879 when succeeded by Jones.

JOHN HARRIS ROGERS (1863-1930)

In his memoir, *Trails and Trials of a Texas Ranger*, Captain W.W. "Bill" Sterling beatified four rangers as the "Four Great Captains." One of the quartet the former adjutant general singled out "by virtue of their long, outstanding, and unhampered service" was Captain John H. Rogers.

Born in Guadalupe County on October 19, 1863, he first flirted with farming as a way to make a living. But just shy of his nineteenth birthday, Rogers signed up at Colorado City as a private in Company B, Frontier Battalion, on September 5, 1882.

Less than five years into his Ranger career, Rogers suffered a critical wound in a wild gunfight in Sabine County on April 1, 1887. Rogers recovered, but nearly twelve years later, he was seriously wounded again in another shooting incident in Laredo. By that time, he had been promoted to captain.

A deeply religious man and teetotaler, the captain always carried a Bible.

Evolving from a mounted lawman who began his career in the fading days of the Wild West into a twentieth-century peace officer who could be as comfortable in an automobile as he had been on a horse, Rogers spent most of his adult life enforcing the law. He left the Rangers in 1911, but in 1913, President Woodrow Wilson appointed him U.S. marshal for the western district of Texas. He held that position until 1921, when he hired on with the Railway Express Agency as an investigator and guard. On April 1, 1924, he began a brief stint as Austin's police chief.

CENTRAL TEXAS

After a short respite from official gun toting, in 1927, Rogers returned to the Rangers. At sixty-four, a time most men are planning retirement, he assumed command of Company C in South Texas.

Three years later, still in the Rangers, he died of an aneurysm on November 11, 1930, at Temple's Scott and White Hospital following gall bladder surgery.

If Rogers couldn't preach the fear of the Lord into 'em, he was prepared to shoot the Hell out of them.

—Anonymous, attributed to an old ranger

OSCAR F. PRIDGEN (1854-1944)

Pridgen served as a ranger under Captain Leander McNelly from April 1, 1875, to August 31, 1875. Carved on the base of his tombstone are eight words indicating he died willing to ride for law and order in the hereafter: "Tell them to meet me–A Texas Ranger."

Visit: The original portion of Oakwood Cemetery is at 1601 Navasota Street. The newer addition is at 1601 Comal Street.

Texas State Cemetery

The beginning of the Texas State Cemetery, the final resting place of thirty rangers and hundreds of other notable figures, traces to one former ranger's death.

Edward Burleson served the Republic of Texas as a ranger, soldier and statesman. When the one-time vice-president of the republic died on December 26, 1851, in the capital city, he was buried on a tract of land in East Austin donated to the state by House member Andrew Jackson Hamilton. That afforded Burleson one additional distinction—his was the first grave in a cemetery that now holds more than three thousand graves.

Noted sculptress Elisabet Ney did a bronze in 1904 for Civil War general Albert Sidney Johnson's grave, and six years later, the remains of Stephen F. Austin were relocated to the cemetery. By then, the burial ground was well on its way to being the Arlington of Texas. In the mid-1990s, Lieutenant Governor Bob Bullock was the prime mover in a major renovation of the cemetery and construction of a visitor's center.

Texas State Cemetery in Austin is the final resting place of many noted rangers. *Photo by Mike Cox.*

Counting Stephen F. Austin, considered the father of the Rangers, twenty-four rangers who served before 1935 are buried in the cemetery along with six who served after 1935. For the names of all the rangers buried there, visit cemetery.state.tx.us.

JOHN LEMON WILBARGER (1829–1850)

Unfortunately for the Wilbarger clan, scalping seemed to run in the family. In August 1833, a four-person surveying party that included Josiah P. Wilbarger encountered an Indian war party near the Colorado River. When an arrow thudded into his body, Wilbarger thought it best to play dead before any additional shafts flew in his direction. The Indians fell for the ruse, and Wilbarger managed to keep quiet while they collected his scalp. Two of his companions were actually dead, and the fourth had escaped. That night, as Wilbarger lay suffering from his wounds, his sister had a dream in which she envisioned not only where he was but also that he was still alive. The next day, searchers found him about where she said he would be. Wilbarger's son would not be so fortunate. Seventeen years later, on August 20, 1850, a substantial party of Indians attacked twenty-year-old John Lemon Wilbarger and fellow Texas Rangers D.C. "Doc" Sullivan and Alpheus D. Neill near the Rio Grande in Webb County as they returned to Captain John S. "Rip" Ford's company from leave. The warriors killed and scalped Wilbarger and Sullivan, but Neill escaped to tell the tale. The irony of the story continues. On February 6, 1877, Neill—then a Waco police officer—was shot to death in the line of duty while trying to break up a family disturbance. Wilbarger had been buried in the vicinity, but in 1936 his remains were exhumed and he was reburied in the State Cemetery along with his father.

BEN McCULLOCH (1811–1862)

Originally from Tennessee, McCulloch adroitly handled artillery during the Battle of San Jacinto. After the revolution, he rode as a ranger with Captain Jack Hays, served in the Republic of Texas Congress, fought in the Mexican War and, on the eve of the Civil War, led a group of volunteers who, without a shot, seized the federal arsenal in San Antonio on February 16, 1861. He was killed in action on March 7, 1862, at the Battle of Pea Ridge, Arkansas, during the Civil War. A historical marker placed on the courthouse grounds

in Brady in 1936 commemorates McCulloch as the county's namesake. A marker erected in 1964 gives more details on McCulloch's Confederate service. Originally buried in Arkansas, his remains were later reinterred in the State Cemetery.

JOHN R. HUGHES (1855–1947)

Born in 1855 in Cambridge, Illinois, Hughes grew up in Mound City, Kansas. At fifteen, he struck out on his own, spending some time in Indian Territory as a cowboy. After participating in several cattle drives from Texas to the railhead in Kansas, he settled in Texas in 1878, running a horse ranch in Williamson County, northwest of Austin. When rustlers stole sixteen of his best animals in 1886, he trailed them to New Mexico, recovered his stock and killed three of the thieves in a shootout.

Back in Texas, Hughes joined the Rangers on August 10, 1887. Figuring on spending only six to eight months as a state lawman, Hughes turned those months into twenty-seven years.

By the spring of 1890, he had made sergeant. Three years later, when Captain Frank Jones died in a gun battle with Mexican outlaws on the Rio Grande below El Paso, Hughes gained his captaincy.

Despite his success as a ranger, Hughes had never calculated on living to an old age. "For several years," he said, "I did not expect to live to the age that I am now. I expected to be killed." In retirement, he returned to ranching and eventually became a bank president.

Hughes was ninety-two before a bullet finally did end his long and rich life—a bullet fired by his own hand. On June 3, 1947, the old ranger's body, his .45 nearby, was found in a garage behind a relative's house in Austin, where he had been staying. The captain's health had been fading, and he did not want to be a burden to his family.

Unfortunately, I have been in several engagements where desperate criminals were killed. I have never lost a battle that I was in personally, and never let a prisoner escape.

—Captain Hughes

Visit: Texas State Cemetery, 909 Navasota Street, Austin.

CENTRAL TEXAS

STATE CAPITOL

After Texas's statehood in 1845, the old wood frame Republic of Texas capitol continued in use until a new limestone capitol rose at the head of Congress Avenue in 1853. In addition to the house and senate chambers, that structure included office space for the governor and other state officials.

Prior to 1874, the governor had overall command of the Rangers, though field captains held operational control. The capitol, then, amounted to Ranger headquarters. Periodically, ranger companies camped on the grounds, living in white canvas tents and cooking over fires until they and their horses were needed elsewhere.

When an accidental fire gutted the capitol in the fall of 1881 (destroying, among other things, a small museum's worth of Indian trophies collected over the years by the rangers), the state soon began construction of the red granite capitol still in use today. From the capitol's opening in 1887 until the mid-1930s, the adjutant general's department had its offices there. Rangers were in and out all the time, and old rangers often worked as assistant sergeants at arms for the house and senate.

After 1935, rangers generally only appeared at the capitol to testify before legislative committees or handle occasional security assignments, such as gubernatorial inaugurations or potentially violent or destructive protests.

Life-sized marble statues of Stephen F. Austin and Sam Houston, both important figures in Ranger history, stand inside the south foyer of the capitol. The two pieces by sculptress Elizabet Ney were dedicated on January 19, 1903.

A bronze statue by sculptors Terry and Cindy Burleson of a high-booted ranger holding a lever-action rifle was dedicated on the second floor of the capitol on March 1, 1986, during the Texas Sesquicentennial celebration.

On capitol grounds, Texas Peace Officer Memorial, dedicated in 1999, lists all rangers and other law enforcement officers killed in the line of duty in Texas since August 5, 1823.

Visit: Congress Avenue at Eleventh Street, Austin. Bullock Texas History Museum, 1800 Congress.

CAMP MABRY

Established in 1892 as a training encampment for the state militia—predecessor of the Texas National Guard—the facility was named for

Adjutant General W.H. Mabry, who died of illness in Cuba during the Spanish American War.

For most of the first three decades of the twentieth century, Ranger horses, wagons, weapons and other equipment were sometimes stored at the camp, though most state property on the force's inventory stayed in the field with the various companies.

When the legislature removed the Rangers from the adjutant general's department and merged the force with the highway patrol to create the Texas Department of Public Safety in 1935, that agency had its headquarters at the camp until a new complex was constructed on what was then the northern edge of Austin in 1953.

Visit: Thirty-fifth Street and MoPac Boulevard. The DPS and Ranger headquarters occupied Buildings 10 and 11, a pair of two-story stone structures built by the U.S. Army in 1918 during World War I. The Rangers also had a stable at the camp. Two historical markers inside the camp's old main entrance honor important figures in Ranger history, John B. Jones and William Steele, and a third marker explains the role of the state adjutant general, a gubernatorially appointed officer who from 1874 to 1935 oversaw the Rangers. Texas Military Forces Museum sheds light on the long relationship between the state's military and the Rangers. DPS Museum, 621 West St. Johns.

WILLIAMSON COUNTY

Georgetown

THE DEMISE OF MANUEL FLORES

When rangers cut a suspicious north-bound trail in Central Texas in May 1839, they surmised a party of Mexican or Indian raiders was probably up to no good.

On a bluff overlooking the San Gabriel River, in what is now Williamson County, the rangers caught up with riders, an armed body of Mexicans led by one Manuel Flores. He and two of his men died in the shooting that followed. The rest hit the brush, leaving their remuda and supply-laden pack animals behind.

The rangers found documents in Flores's saddlebags that proved—at least to the satisfaction of the Texas government—that Mexico hoped to get its

lost territory back by forming an alliance with Texas Indians, particularly the Cherokees. Flores, who had fought for Texas during the revolution, had become an agent for the Mexican government.

Visit: A state historical marker placed in 1936 eleven miles west of Georgetown and two miles east of Liberty Hill on County Road 260 just off State Highway 29 notes that the battle occurred "in this vicinity." The Williamson Museum, 716 South Austin Avenue, Georgetown.

THREE-LEGGED WILLIE STATUE

He is not thought to have ever set foot in his namesake county, but early-day ranger Robert McAlpin (Three-Legged Willie) Williamson is now a permanent resident—in a manner of speaking. Commissioned by the Williamson Museum and sculpted by local artist Lucas Adams, a life-sized bronze statue of Williamson was dedicated in downtown Georgetown on November 29, 2013.

Visit: On sidewalk in front of the Williamson Museum.

Leander

TUMLINSON BLOCKHOUSE

Most of the log fortifications rangers constructed during the days of the Republic of Texas fell to ruin after their abandonment. But the blockhouse built by ranger captain John J. Tumlinson Jr. in 1836, the first government building in what would become Williamson County, was burned down by Indians in 1837. Destroying the empty fort, while doubtless satisfying for the Indians, had no impact on their ongoing displacement. A granite historical marker was placed at the site in 1936.

Visit: Off U.S. 183, one and a half miles south of Farm to Market Road 2243 in Leander.

Republic of Texas–era ranger captain Nelson Merrell built this impressive stone house in Round Rock in 1870, eight years before younger rangers would deal with outlaw Sam Bass only a short distance from here. *Library of Congress.*

Round Rock

CAPTAIN NELSON MERRELL HOUSE

As a ranger captain operating out of Bastrop, in 1839, Nelson Merrell (1810–1879) helped protect the new capital city of Austin from Indians. He later settled in Travis County but in 1870 built a two-story rock house on his plantation along Brushy Creek and lived there the rest of his life. The captain had a distinctive square cupola constructed atop the house, often keeping lookout with his brass telescope to make sure his laborers were not malingering. The house has been listed on the National Register of Historic Places since 1970.

Visit: 1516 East Palm Valley Road. Privately owned office building and wedding venue.

CENTRAL TEXAS

SAM BASS

Sam Bass had no ties with the community that would become famous as the place his young life ended. What brought him to Round Rock was strictly business—armed robbery.

Originally from Indiana, Bass came to Denton County via Mississippi in 1870. He wanted to be a cowboy but at first had to settle for being a farmhand and teamster. Later, he bought a sorrel mare that gained him some nice horseracing purses. In 1875, he finally got a taste of the cowboy life, pushing a herd from San Antonio to Nebraska with friend (and future outlaw pal) Joel Collins. With the money they made from that, the two went to the Black Hills of North Dakota to prospect for gold. That left them broke, but as Bass later said, they "took to robbing stage coaches."

Back in Nebraska, his biggest heist came on September 17, 1877, when he and five others held up a train, taking $60,000 in gold. Returning to Texas for obvious reasons, Bass and a new group of associates (Collins had been shot dead shortly after the robbery) started robbing trains in the Dallas area—four brazen holdups inside two months.

By this time, he had gained the attention of the Rangers, who already held a warrant for his arrest in the Big Springs, Nebraska train robbery. But Bass proved embarrassingly difficult to capture. Remaining on the lam, he outrode various posses in North Texas and had running gunfights with rangers under Captains Lee Hall and June Peak. What finally did him in was an informant, a criminal defendant who agreed to trade insight into Bass's whereabouts and plans in exchange for immunity.

Bass had done fairly well for himself gambling on horseflesh back in Denton County, but when he decided to raise the ante and sit in on the higher-stakes game of bank robbery, his luck finally ran out. The Rangers had stacked the figurative deck.

With the informant riding along, in July 1878, Bass and his gang headed toward the relatively new railroad town of Round Rock. There they intended to make a six-shooter withdrawal at the community's supposedly prosperous banking establishment.

THE SHOOTOUT

Learning of Bass's plans, Major John B. Jones scrambled to get as many rangers to Round Rock as he could. He sent three men from Austin, Rangers

Chris Connor, George Herold and Dick Ware, with instructions to keep a low profile. Before joining them, he dispatched another ranger on a Paul Revere–like ride to Lampasas with orders for Lieutenant N.O. Reynolds to bring his company to Round Rock as soon as possible.

About four o'clock on Friday afternoon, July 19, Bass, Seaborn Barnes and Frank Jackson walked along Main Street, headed toward Henry Koppel's store to buy tobacco. As they did, Williamson County deputy sheriff A.W. Grimes and Maurice Moore, a former ranger then serving as a Travis County sheriff's deputy who had joined Jones on the train to Round Rock, followed them at a discreet distance. Moore told Grimes he thought one of the strangers had a gun beneath his coat.

When the three men walked into the store, Grimes followed them since he had jurisdiction and asked if they were armed. They were. All of them drew their pistols and started shooting at Grimes, who fell dead just outside the store.

Moore opened up on the outlaws while they were still inside the gunsmoke-filled store, shooting off one of Bass's fingers but causing no other harm. Seconds later, one of the outlaws put a bullet through Moore's chest as they burst from the building.

Hearing the shooting, Jones and his three rangers came running toward the store as the outlaws hurried toward the alley where they had hitched their horses.

Ranger Ware put a .44-40 Winchester round through Barnes's head, ending his story. Bass caught a rifle bullet from Herold. Amazingly, considering all the lead in the air, Jackson escaped in perfect health. He helped the gravely wounded Bass get on his horse, and together they galloped out of town.

Reynolds's company had not yet reached Round Rock, and all the other lawmen could find were jaded horses not up to a fast pursuit. Even so, they rode out after the two surviving outlaws but came back empty handed at nightfall.

The next day, a detachment led by Sergeant Charles Nevill found Bass sitting against a tree a short distance from town. Jackson, realizing his friend would die, had ridden on and was never seen again in Texas—at least under his real name.

Bass lingered until Sunday, July 21.

> *When the doctor arrived, he told Bass he couldn't live more than a few hours. Bass ridiculed the idea.*
>
> *–Sergeant Charles Nevill*

Visit: The one-story limestone building where Grimes died and Moore took a bullet (the former ranger survived only to be killed in the line of duty in Travis County on November 10, 1887) still stands at the southeast corner of Main and Mays in Round Rock. Extensively remodeled, in 2015, it accommodated an upscale bar. A historical marker placed in 1981 at West Main and Round Rock Avenue stands at the approximate site of Bass's death.

Old Round Rock Cemetery

Dating to 1851, Old Round Rock Cemetery has the graves of Bass, Barnes and the former ranger they killed. The young officer's widow and other members of his family objected vehemently to the two outlaws being buried in the same cemetery with her husband.

AHIJAH W. GRIMES (1855–1878)

Born and raised in Bastrop, Grimes had served as a city marshal in his hometown, as a Bastrop County constable and finally as a ranger under Captain Neal Coldwell before hiring on with the Williamson County Sheriff's Office as a deputy in Round Rock. At the time of his death, Grimes's brother was serving as a ranger. The young deputy left behind a wife and three children. He has had three tombstones since he died in the line of duty—a Masonic monument placed soon after his death, one set in 1978 on the centennial of his murder and one erected by the Williamson County Sheriff's Office in 2015. The grave also has a Ranger cross placed by the Former Texas Rangers Association. The city's police headquarters at 615 East Palm Valley bears a plaque dedicating the building to Grimes's memory.

SAM BASS (1851–1878)

The outlaw had no tombstone until his sister had one placed over his grave a few years after his death. Its epitaph read, "A brave man reposes in death here. Why was he not true?" Souvenir hunters chipped pieces from the stone until it practically disappeared, so another marker was placed on his grave in 1953. In 1978, a third marker with details of his demise was added.

"The notorious Sam Bass died Yesterday at 4:20 He made no request, Two minutes before his death he said, 'This world is but a bubble,—trouble wherever you go.'"
> —Ranger John R. Banister in a letter to his mother two days after the rangers gunned down the outlaw.

WILLIAM JOHN L. SULLIVAN (1851–1911)

Six-foot-six, Sullivan joined the Rangers in 1888 and served in Company B until 1900. After promoting to sergeant, he reported to Captain Bill McDonald. The tall Mississippian was active in suppressing the so-called San Saba Mob in 1896–97. To guard against any escape attempt, Sullivan once spent the night in the jail cell of a disgraced preacher about to be hanged for poisoning his wife. They talked about religion and shared a quart bottle of whiskey until the preacher-gone-bad's execution.

Clearly with some anonymous writer's help, Sullivan self-published *Twelve Years in the Saddle for Law and Order on the Frontier of Texas* in 1909. He had been living with a relative in Round Rock when he died a couple years later. The location of his grave had been lost until the 1980s, when researchers finally located the spot.

> *Assuring a man he was trying to disarm and arrest that he would not "hurt a hair on his head for the world," the ranger added, "If you do make a bad break…I will cut you off at your pockets."*
> —Ranger Sullivan from his book.

Visit: The cemetery is off Sam Bass Road just east of Clark Street, Round Rock.

Taylor

BATTLE OF BRUSHY CREEK

In the fall of 1925, more than a decade before Texas celebrated a century of independence from Mexico by putting up hundreds of historical markers across the state, Taylor schoolchildren collected money for a stone marker commemorating a little-known fight between Comanche warriors and rangers—the Battle of Brushy Creek.

On January 26, 1839, seasoned Fayette County Indian fighter John H. Moore led sixty-three rangers and several Lipan Apache scouts on an expedition against a Comanche village on the upper San Gabriel River.

In retaliation, the following month, a Comanche war party three hundred strong rode down the Colorado River into Central Texas, killing Elizabeth Coleman and two of her children on February 24 in Bastrop County. The raiders also struck the nearby cabin of Dr. James W. Robertson, capturing seven slaves.

Fourteen Bastrop County men under Captain John J. Grumbles pursued the raiders. They overtook the war party but pulled back when they realized the Indians outnumbered them. Following the arrival of an additional fifty-two men, the volunteers resumed the pursuit under the command of Jacob Burleson.

Twenty-five miles from the scene of the Coleman massacre, Burleson's men caught up with the Comanches on the prairie near Brushy Creek in present Williamson County. As the Indians tried to reach timber for better cover, Burleson ordered his men to gallop between the Indians and the trees. Fourteen-year-old Winslow Turner and veteran Indian-fighter Samuel Highsmith did as told, dismounting to face the Indians. But the other men, having counted the warriors, turned their horses to flee.

Knowing he could not face the Comanches with only one man and a boy, Burleson shouted to retreat. Just as Burleson started to spur his horse, he saw the teenager having trouble getting back on his nervous mount. Burleson jumped down to lend a hand and caught an Indian bullet in the back of his head.

Jacob's elder brother Edward Burleson, soldier-ranger and future vice-president of the Republic of Texas, soon arrived with reinforcements. Assuming overall command, Burleson rode after the Indians who had killed his brother. In several skirmishes and one heated fight, he lost three other men, but by some estimates, the force killed as many as thirty Indians.

> [T]*he loss of the Indians is not known; it, however, must have been considerable, as most of the men under Burleson were excellent marksmen, and had often been engaged in Indian warfare.*
>
> –Houston Telegraph

Visit: Off Circle G Ranch Road just to the west of State Highway 195, four miles south of Taylor. Private property. In addition to the 1925 monument, a state historical marker detailing the battle was erected in 1993.

SOUTH TEXAS

BEXAR COUNTY
San Antonio
The Alamo

Thirty-two Texas Rangers died here on March 6, 1836, after answering Colonel William B. Travis's call for volunteers. The Daughters of the Republic of Texas maintained the old mission, the shrine of Texas liberty,

Thirty-two rangers died in the Alamo on March 6, 1836. *Author's collection.*

until 2015, when the state General Land Office assumed full operational control. For more information on the most-visited landmark in Texas, see thealamo.org.

Visit: 300 Alamo Plaza in downtown San Antonio.

HENRY KARNES MONUMENT

Tennessean Henry Karnes (1812–1840) fought for the Republic of Texas as a soldier and ranger, but when he died of yellow fever in San Antonio, he could not be buried in the town's Campo Santos (Camp of Saints) because he was a Protestant. They laid him to rest just outside the Catholic cemetery, and there he remained until Santa Rosa Hospital was constructed on the site in 1875 and the graves were either moved or lost. His final resting place proved to be one of the latter.

In 1932, a three-foot red granite state monument with a bronze plaque was placed in Milam Park in honor of the former ranger. Just across the street from the old cemetery, that was as close to Karnes's remains as possible.

Visit: West Houston Street and North San Saba Streets, northwest corner of park.

SALADO CREEK BATTLE

Six years after Santa Anna's defeat at San Jacinto, Mexico still had not recognized the Republic of Texas. As far as Mexico City was concerned, Texas belonged to Mexico.

In September 1842, 1,500 troops under General Adrian Woll crossed the Rio Grande and marched toward San Antonio. On the morning of the eleventh, hidden by a thick fog, Woll's force quietly surrounded the town and took control.

But Captain Jack Hays and his rangers were not there. While the Mexican force had adroitly avoided Hays and taken San Antonio by surprise, the captain wisely rode to Seguin to spread word of the invasion and gather reinforcements.

A week later, on September 18, no more than 250 Texans, a mixed force of rangers, regular soldiers and volunteers under the command of

Matthew Caldwell and Hays, fought roughly 950 Mexican army regulars along Salado Creek.

During the fight, fifty-three men under Captain Nicholas Dawson, responding to Hays's call for assistance, rode up on the battle in progress. An overwhelming number of Mexican cavalrymen encircled the new arrivals, who took cover in a mesquite thicket. Mexican artillery raked their position, and then the cavalry charged. Only seventeen men survived—fifteen were captured and two escaped. What came to be called the Dawson Massacre had claimed thirty-seven lives, but in the main battle, only one Texan fell.

Neither side won a decisive victory in the battle, but losing roughly sixty men in fierce fighting convinced Woll that Texas would not be easily returned to the fold. Soon he withdrew to Mexico.

Later that fall, in retaliation, a Texas force rode south to cross the Rio Grande into Mexico. The affair proved unsuccessful and an unauthorized sidebar incursion resulted in the capture of scores of men. Following an escape attempt as the prisoners were being marched from Mier to Mexico City, the Mexican military ordered the execution of all who had been recaptured. In a torturous gesture of mercy, the order was changed to execute only every tenth man. The men were forced to draw beans from a jar. In the lottery of death, those who pulled a black bean would die by firing squad. A white bean meant survival.

Five years later, during the Mexican War, a captain who had survived the so-called Black Bean Episode got permission to go where the executed Texans had been buried and exhumed their remains. The bones were shipped to Galveston and then taken by wagon to La Grange. The remains of the Dawson Massacre victims also were dug up, and both sets of bones were placed in a common grave atop a bluff overlooking the Colorado River in 1848. Now known as Monument Hill, the site is operated as a state park.

Visit: Present-day San Antonio, north of Rittiman Road and east of Holbrook Road. Historical marker erected in 1936 stands one block north of Rittiman Road on the east side of Holbrook Road. The tomb of the Dawson Massacre victims and those executed at Perote is at Monument Hill and Kreische Brewery State Historic Site just off U.S. 77, south of La Grange.

MENGER HOTEL

German immigrant William Menger opened a two-story, fifty-room hotel on February 1, 1859, adjacent to his brewery on Alamo Plaza. Considered the Alamo City's finest hostelry throughout the nineteenth century, the Menger hosted presidents, generals, cattle kings, actors, famous writers and other notables. Among the guests were many rangers and former rangers, including Captain John S. "Rip" Ford. Near the end of his long, eventful life, Ford was staying at the hotel when artist Frederick Remington interviewed him in 1896 for an article published in *Harper's Weekly*, "How the Law Got into the Chaparral."

In 1898, future president Theodore Roosevelt recruited some of his Rough Riders in the Menger bar. Some of those volunteer soldiers had earlier served as rangers. During the 1930s, San Antonio–based ranger Zeno Smith briefly shut down the hotel's bar for serving mint juleps on Sundays. Much expanded and remodeled, the Menger remains in business.

Visit: 204 Alamo Plaza. For more on the hotel and its history, see mengerhotel.com.

Rangers were frequent guests at San Antonio's venerable Menger Hotel, which is still in use. *Author's collection.*

SOUTH TEXAS

Buckhorn Saloon

Working as a bartender and bellhop at the old Southern Hotel, at some point it occurred to seventeen-year-old Albert Friedrich that there might be more money in saloon ownership and management than pouring drinks or carrying luggage. In 1881, he opened the Buckhorn Saloon. Soon discovering that not every cowpoke who hit town had sufficient funds for a cold brew, Friedrich cleverly decided to accept cattle horns and deer antlers in lieu of cash. Before long, he had the walls of the saloon covered with wide longhorn mounts and trophy whitetail deer antlers. The Buckhorn became one of the Alamo City's first tourist attractions.

The horns and the saloon are still there. Additionally, since 2006, the Former Texas Rangers Association has had an agreement with the Buckhorn to maintain an eight-thousand-square-foot Ranger museum at the popular downtown destination.

Visit: 318 East Houston Street.

John S. "Rip" Ford (1815-1897)

His nickname, standing for "Rest in Peace," gives the impression that John Ford had a penchant for deadly violence. But while he never shied from a fight, he was an erudite gentleman who did much more for his adopted state than engage its enemies.

Born in Tennessee and trained as a doctor, Ford intended to come to Texas to take part in its revolution against Mexico. He reached Texas in the later part of 1836 too late to fight for independence, but as a ranger and Confederate officer, he would make up for it in future years.

He practiced medicine in San Augustine before deciding to study law. After being admitted to the bar, even with two means of earning a living, he soon ventured into a third profession—newspaper publishing.

During Sam Houston's second presidency, Ford served in the Republic of Texas Congress. When annexation to the United States brought on war with Mexico in 1846, Ford served as adjutant in federalized Rangers under Jack Hays. One of his duties included writing letters to the families of those killed in the fighting, and he always included the hopefully comforting words "Rest in Peace" on his correspondence. That's how he got his nickname.

In 1858, Governor Hardin Runnels asked him to lead one hundred rangers on a punitive expedition against the Comanches. His command proceeded nearly five hundred miles from Austin to the unsettled vastness of what is now Oklahoma, where the rangers fought and won a major battle with the Indians.

A year later, Ford commanded a ranger force that had several fights along the border with Juan Cortina, a Mexican most Texans considered a bandit while many of his people viewed him a hero.

During the Civil War, Ford again led armed Texans into conflict, this time as a Rebel officer. Loath to abandon the Southern cause, he fought federal forces at Palmito Ranch in the Lower Rio Grande Valley in what turned out to be the last battle of the long, bloody war.

After the war, he reentered politics, first as mayor of Brownsville and then as a state senator in Austin. Ford's last public service came as superintendent of the Texas State School for the Deaf. Leaving that position in 1883, he began writing his memoir, a document that eventually consisted of 1,300 handwritten pages.

The old doctor, lawyer, newspaperman, ranger, soldier, politician and historian spent the last fourteen years of his life in San Antonio, where he died on November 3, 1897. His memoir went unpublished until 1963 but is regarded as a significant contribution to what is known of Texas in the 1840s, '50s and '60s.

Visit: Confederate Cemetery (also known as City Cemetery Number 4), East Commerce and New Braunfels Avenue.

George Wythe Baylor (1832–1916)

George W. Baylor was not a man to be crowded.

Near the end of the Civil War, in a hotel room in Houston, fellow Confederate officer John A. Wharton slapped Baylor and called him a liar. Rather than argue the point, Baylor pulled his revolver and shot Wharton dead. Tried and acquitted, he later said that killing Wharton had remained a "lifelong sorrow."

Born at Fort Gibson in present Oklahoma, Baylor came to Texas in 1845. He attended Rutersville College in Fayette County and Baylor University. He later spent some time in the California gold fields and in Parker County until the Civil War, where he distinguished himself fighting for the South.

His six-year ranger career began in the summer of 1879 with his appointment as lieutenant of the always-busy ranger company in El Paso County. He oversaw the state's role in the 1881 military campaign against renegade Apache Chief Victoria, earning him the distinction of being the last ranger to take part in an Indian fight.

Promoted to captain in 1882, Baylor served until budget cuts resulted in the disbanding of his company. He stayed in El Paso several years but eventually moved to San Antonio, where he died on March 17, 1916.

Visit: Confederate Cemetery, San Antonio.

CHARLES LILBORN NEVILL (1855–1906)

His teeth still gripping his favorite pipe, Ranger Charles Neville popped above the swirling water of the Rio Grande in the Big Bend's Santa Elena Canyon.

The captain and three of his rangers had been escorting surveyors by boat down the river when the craft hit rough water and crashed into a big rock, dumping the occupants into the cold, white water. Weighted down by a heavy coat, boots, ammunition belts and his six-shooter, Neville sank. Struggling to the surface, he climbed onto a rock, only to fall back in. This time he spit out the pipe, figuring he was about to die. Somehow, he and the other men all survived.

Originally from Alabama, Nevill served in the Rangers from 1874 to 1881 and is the lawman who found the wounded Sam Bass near Round Rock in 1878. In January 1882, in addition to almost drowning, Nevill had the distinction of being the first and last ranger captain to encounter hostile Indians while sitting in a rowboat. Floating downriver with the surveying party before his spill, Nevill saw armed Indians on the bank but knew they were too far apart to bother shooting at each other.

After leaving the rangers, Neville served as Presidio County sheriff (1882–88) before moving to San Antonio. When he died in 1906, he was district clerk of Bexar County.

Visit: San Antonio City Cemetery No. 6

R.A. GILLESPIE (1815-1846)

Robert Addison Gillespie and his two brothers came to Texas from Tennessee hoping, like many others who left the United States for the new Republic of Texas, to make a good living as merchants and land speculators. But neither success in business nor longevity could be taken for granted along a frontier exposed to hostile Indians and a Mexican military hoping to get its lost territory back.

The brothers Gillespie ran a general store and land business in Matagorda, but within a couple years, they moved up the Colorado River to La Grange. There, in 1840, Gillespie volunteered to ride with John Henry Moore on an expedition against the Comanches. Having had a taste of the ranger life, in September 1840, Gillespie decided to enlist in Captain Jack Hays's company.

One of Gillespie's fellow rangers was Samuel Walker. Together, under Hays, they helped to establish the Ranger legend. Gillespie rose to lieutenant under Hays, and when the Mexican War began, he organized a company and joined Hays's now-federalized Ranger battalion. Again, he would fight side by side with his friend Walker, at least until March 25, 1846, when he suffered a mortal wound during the Battle of Monterrey.

> *Boys, place me behind that ledge…and give me my revolver, I will do some execution on them yet before I die.*
> —*Gillespie after taking a Mexican bullet in the stomach*

Visit: Odd Fellows Cemetery, northeast corner of North Pine and Paso Hondo Streets. Walker's request to be buried next to Gillespie was honored, but it took a decade before the remains of the two soldiers could be exhumed in Mexico and returned to San Antonio for re-interment.

SAMUEL HAMILTON WALKER (1817-1847)

For three good reasons, his fellow rangers called him "Lucky." But any gambler knows that whatever the game, sooner or later, the odds turn against you.

Born in Maryland in 1817, Walker came to Texas in 1842 by way of Florida, where he had fought in the Seminole Indian War. In Texas, he soon took part in the unsuccessful Texas military incursion into Mexico known as the Somervell and Mier Expeditions and, along with other captured soldiers, endured being marched in chains from the border to the infamous,

castle-like Perote Prison near Mexico City. His first piece of good luck came in selecting a lifesaving white bean when the prison's military commander complied with orders to execute every tenth Texan. Later escaping, in late 1843 or early 1844, Walker joined Captain Jack Hays's ranger Company and served either under Hays or Robert A. Gillespie for most of the next three years.

In addition to other scraps, he participated in the June 8, 1844 Walker's Creek Battle, the first time the Rangers are known to have used Colt revolving pistols against Indians. The state-of-the-art weapons carried the day, but during the fierce fight, a Comanche warrior pinned Walker to the

Ranger Samuel Walker, who went on to help perfect the Colt six-shooter, barely escaped a Mexican lancer's blade at the Battle of Resaca de la Palma in 1846. *Library of Congress.*

ground with his lance. Still, he survived the serious wound, a second big piece of luck.

As a ranger captain, Walker and his men guided General Zachary Taylor's army through South Texas as he marched to war with Mexico in the spring of 1846. In the first major battle, Walker had his horse shot out from under him, and as a Mexican lancer rode hard in his direction with his long-bladed pike lowered, Walker shot and killed him. That proved the third and last time his luck would hold.

During a break in the hostilities, he returned to Maryland and accepted an invitation to meet with gun designer Samuel Colt to discuss possible improvements to his five-shooter. The battle-hardened ranger had two major suggestions: allow for larger caliber bullets with more powder behind them, and increase the size of the cylinder to accommodate six rounds instead of five. Colt made those changes and named the new weapon the Walker Colt.

Back in Mexico not long after the fighting resumed and armed with a set of the new Colts, Walker was shot and killed on October 9, 1847, at Huamantla, Mexico, in the last major battle of the war. His dying request was to be buried next to his old friend and fellow ranger Robert A. "Ad" Gillespie.

Visit: Odd Fellows Cemetery.

WILLIAM GERARD TOBIN (1833–1884)

William Gerald Tobin had a lackluster ranger career, but he had an idea that left the nation an enduring gastronomical legacy.

Born in South Carolina in 1833, at age twenty, Tobin came with his brother to Texas, settling in San Antonio. He first rode as a ranger in 1855, a year later serving as city marshal of the Alamo City. In 1859, he led a ranger company to Brownsville following Juan Cortina's raid.

After Confederate service in the Civil War, Tobin turned his attention to what may have been his strongest suit: business. He opened a hotel in the 1870s, but in 1881, Tobin negotiated a contract with the federal government to sell canned chili con carne to the military. He built a processing and canning plant, but in 1884, just as his venture began to take off, he died. Soon after, the chili canning business went bust.

Not until 1921 did someone finally get around to following up on Tobin's idea. That was Lyman T. Davis of Corsicana, who started peddling canned chili from the back of a wagon. He named his product after Kaiser Bill, his

pet wolf. Wolf Brand Chili remains on the grocery shelf today, but nowhere on the label is any credit given to former ranger William Tobin.

Visit: City Cemetery Number 1.

Indian Fighting to Dude Ranching

Birds now nest in the narrow rifle ports of the thick-walled stone ranch house that Republic of Texas–era ranger Peter Gallagher built in the 1850s northwest of San Antonio.

Gallagher left Ireland for America at seventeen. Arriving in New Orleans, he apprenticed as a stonemason. In 1837, he moved to San Antonio. Practicing his new trade, he built a store for William Elliott and then hired on as a clerk. At twenty-nine, he joined the Santa Fe Expedition, an attempt by President Mirabeau B. Lamar to wrest New Mexico from Mexico. The expedition ended in failure with most of its participants, including Gallagher, sent to a Mexican prison. Gallagher served as the expedition's diarist, and his account remains an important source for historians.

Back in Texas in 1842, Gallagher enlisted in Jack Hays's ranger company, spending four years riding with the legendary captain. After his rangering days, he went back to Ireland, married and brought his bride back to Texas.

In 1850, he began acquiring ranch land north of San Antonio and built a rambling, fortified ranch house that still stands. Prospering as a merchant, real estate investor and rancher, from 1861 to 1864, he served as Bexar County's chief justice. Extending his reach farther west, he helped develop the town of Fort Stockton in 1877. He died the following year.

The Gallagher Ranch and its Circle G brand passed to his wife's nieces and went through another owner before millionaire V.H. McNutt bought it in 1927. His wife, Amy, turned the place into a combination dude and cattle ranch that attracted noted guests ranging from the girls of the Ziegfield Follies to Orson Wells and cowboy writer-artist Will James. Under subsequent ownership, the ranch has continued as an upscale resort and venue for weddings, retreats and corporate training. Some of the scenes from the movie *All the Pretty Horses* were filmed at the ranch.

Visit: 19179 State Highway 16 North, Bexar County. A historical marker placed in 1967 stands at the old ranch house.

SOUTH TEXAS HERITAGE CENTER AT THE WITTE MUSEUM

This large, newly opened addition to the Alamo City's venerable Witte focuses on the diverse cultures that shaped South Texas, from the Comanches, the nemesis of the Rangers, to the Spanish, Mexicans, Germans and others, as well as cowboys and outlaws. Also has an exhibit on the *carretas*, the ox-drawn carts that figured in the Cart War of 1857.

Visit: 3801 Broadway Street.

BROOKS COUNTY
Falfurrias
A COUNTY'S NAMESAKE

Brooks County was named for Captain J.A. Brooks, one of the Ranger commanders known as the Four Great Captains.

Born in Kentucky on November 20, 1855, Brooks moved to Texas around 1876, where he farmed for a time in Collin County. He joined the Rangers in 1883, serving in Company F. He was active in the fence-cutting trouble and suffered a serious wound in the Sabine County shootout with the Conner clan in 1887.

Moving quickly up the ranks, Brooks gained promotion to lieutenant of Company F in March 1888 and took over as captain a year later. Pick a trouble spot in Texas from the late 1880s to the early 1900s, and Brooks likely was there. He took part in the hunt for Catarino Garza in 1892 and later helped restore law and order in Southeast Texas oil boomtowns.

Resigning from the Rangers in 1906, Brooks moved to Falfurrias and became active in local and state politics. He served in the Thirty-first and Thirty-second Texas Legislatures. As a member of the house, in 1911, he sponsored the bill that created the county named in his honor. Leaving the legislature, he won election as the first county judge, an office he held until 1939. The old captain died on January 15, 1944, and was buried in Falfurrias.

Visit: Falfurrias Burial Park on West Travis Street, 0.4 miles west of Business U.S. 281. The Heritage Museum, 515 North St. Marys Street, Falfurrias. The museum has an exhibit featuring Captain Brooks and other South Texas rangers.

SOUTH TEXAS

CAMERON COUNTY

Brownsville

BATTLES OF PALO ALTO AND RESACA DE LA PALMA

Following Texas statehood, when hostilities broke out between Mexico and the United States with the May 3, 1846 shelling of a U.S. fortification across from Matamoras, rangers under Jack Hays veteran Samuel Walker guided General Zachary Taylor's regulars toward future Brownsville. On May 8, at a point called Palo Alto in present Cameron County, 2,300 U.S. troops and the small ranger company battled 4,000 Mexican soldiers.

The next day, the two armies met again at Resaca de la Palma, and the Americans prevailed. During the fight, when a bullet killed his horse, Walker nearly escaped being impaled on a bladed pike by a Mexican lancer. While

Contemporary engraving depicting the battles of Resaca del Palma and Palo Alto at the outset of the Mexican War in 1846. *Library of Congress.*

the Mexican-American War of 1846–1848 is its own story, this is the conflict that would make the Texas Rangers internationally famous.

Visit: Palo Alto Battlefield National Historic Park is on the north side of Brownsville, at the northeast corner of Farm to Market Road 1847-Paredes Line Road and Farm to Market Road 511/550. Interpretive exhibits.

The Cortina Troubles

At times, both Texas and Mexico wanted to hang Juan Nepomuceno Cortina.

On July 13, 1859, Cortina rode into Brownsville to break bread with amigos at Castel's Saloon. As Cortina sat with his friends he heard a commotion outside. When he went to see what was going on, he found Marshal Robert Shears beating a Mexican man who had worked on his family's ranch, Rancho del Carmen. Incensed, Cortina intervened and shot him. Then he galloped out of town with the beaten vaquero on the back of his horse.

The lawman recovered, but Cortina soon faced charges. He tried to buy his way out of it, but when that didn't work, he moved across the river to Mexico. The next time he crossed over to Brownsville, he did so at the head of a small army of seventy well-armed and mounted men.

While the governments of Texas and the United States saw Cortina's September 28 incursion as an invasion, Cortina had merely come to town with a mental list of personal grievances to settle. He and his Cortinistas didn't get everyone he wanted, but by the time he rode out of town, two men lay dead and three others wounded. Some accounts report five deaths.

When word of the raid reached San Antonio, former city marshal William Tobin decided to raise his own company of volunteers and ride to the aid of the terrified valley community. On his way south, Tobin sent a letter to Governor E.M. Pease offering his services as a ranger captain. The governor took him up on it and gave him an official commission.

Not long after Tobin and his rangers arrived in Brownsville, the situation grew even worse. A party of vigilantes—historians today suspect Tobin's men—lynched a Cortina officer who had been captured before the arrival of the rangers. That made Cortina so mad he threatened to burn the town. Brownsville survived, but it took another company of Rangers under the celebrated John "Rip" Ford plus elements of the U.S. Army to squelch Cortina's mini-war on South Texas.

Despite all the fighting, Cortina died of old age in Mexico in 1894.

Juan Cortina's invasion of Brownsville put rangers on his trail. *Library of Congress.*

Visit: Neall House, 230 Neal Road (moved from original location, 625 East Fourteenth Street). Built in the 1850s, it is the city's oldest frame residence and in poor repair. Its first residents were English-born Brownsville mayor William Neall (1807–1896) and his family. When Cortina staged his raid, his men torched a store Neal owned and fired on this house, killing his son. Donated by family descendants to the Brownsville Art League in 1950, the house is now owned by the City of Brownsville.

GUNFIGHTS & SITES IN TEXAS RANGER HISTORY

PALO ALTO PRAIRIE FIGHT

On June 12, 1875, rangers under Captain Leander H. McNelly had a running gun battle with Mexican cattle thieves near Brownsville.

During the fight, a ranger bullet killed the horse of one of the outlaws. (Savvy rangers, as had knights of old, often tried to unhorse their enemy, a tactic to prevent their escape.) When the suddenly dismounted bandit hopped up behind one of his still-mounted colleagues, Ranger Lawrence Baker Wright fired at him. Though surely not planned, the single shot killed both outlaws.

The battle resulted in twelve to fifteen dead bandits (accounts vary, but no matter the number, all the Mexicans were killed) and one slain ranger, sixteen-year-old Barry Smith. While some sources say he may have been seventeen or even eighteen, he was still the youngest Texas Ranger ever to die in the line of duty.

> *They attacked me, when I overtook them. It was a running fight...* [The rangers] *killed the whole party. They fought desperately...My men are all trumps.*
> —Leander McNelly, telegram to Austin, June 12, 1875

Visit: The fight took place in the general vicinity of the 1846 Mexican War battle, now a National Historic Site.

FORT BROWN

Ranger captain Bill McDonald earned his subsequent description of "not being afraid to charge Hell with a bucket of water" in a standoff with U.S. troops following a racially inspired disturbance involving black troops at Fort Brown in 1906. One Brownsville citizen died in the mêlée. When he heard about it, McDonald got arrest warrants for thirteen soldiers and vowed that he intended to see the cases prosecuted in state court. But despite much posturing on the part of the captain, the military handled the matter, and McDonald got what amounted to a hands-off order from the governor. To forestall further trouble, the army shipped the black troops out of town. The fort remained active until 1946, when after a century, the army finally left the Rio Grande Valley.

Brownsville at the time of the 1906 racial incident that led Captain Bill McDonald to take on the U.S. Army. *Author's collection.*

Visit: Campus of Texas Southmost College, Gorgas Street, Brownsville. Historic Brownsville Museum, 641 East Madison Street.

J.T. CANALES HOUSE

As a young man, J.T. Canales saw his father welcome rangers to his Nueces County ranch as they scouted in South Texas. Rangers like Captain John R. Hughes, he later wrote, were "some of the noblest men I know." But during the Mexican Revolution, not all rangers distinguished themselves along the border. Abuses occurred, and numerous innocent Mexican Americans died at the hands of rangers.

Well educated and with a law degree, Canales won a seat in the state legislature, serving from 1905 to 1910 and again from 1917 to 1920. During his second stint in Austin, he launched a legislative investigation that went a long way toward professionalizing the state law enforcement body.

Canales married in 1910 and a year later purchased a lot in Brownsville. Two years after acquiring the property, he built at house on it in 1913 that still stands.

Having received threats on his life, including one from then ranger sergeant Frank Hamer, Canales opted to leave government. But he spent the rest of

As a state legislator, Mexican American lawyer J.T. Canales investigated the rangers and endured death threats, but he lived a long life, much of it in this house he built in Brownsville. *Photo courtesy George Cox.*

his long life advocating for Mexican American rights. Having made history with his stand against Ranger excesses, he also wrote books and articles on the history of his part of Texas. He died on March 30, 1976, at ninety-nine.

Visit: 505 East St. Charles Street, Brownsville. The house is privately owned, but a historical marker placed in 2009 stands in front of it.

CALHOUN COUNTY
Port Lavaca
RANGER CEMETERY

The old graveyard called Ranger Cemetery had been in use for a decade before it got its name. The first burial was that of Major H. Oram Watts, the Republic of Texas customs collector at Linnville killed by Comanches in what came to be called the Great Comanche Raid.

SOUTH TEXAS

In 1850, Texas Ranger James T. Lytle lost his wife, Margaret Peyton Lytle, and buried her here. She was known as the poet of the Rangers.

Mrs. Lytle had another ranger connection, of sorts. Her mother was Angelina Eberly, the feisty woman who fired a cannon at Texas Rangers sent by Republic of Texas President Sam Houston to remove the young nation's governmental records from Austin. The scheme failed, in large measure to the resistance on the part of Mrs. Eberly and other incensed Austinites.

After leaving Austin, Mrs. Eberly opened the first hotel in Indianola. She died on March 15, 1860, having outlived her daughter by a decade.

Former ranger Lytle only survived his wife by four years, dying on February 6, 1854. For some reason, rather than being afforded the opportunity of rejoining his wife in eternal repose at the Ranger Cemetery, Lytle's family buried him at the Port Lavaca Cemetery.

Visit: Cemetery on Harbor Street. Calhoun County Museum, 301 South Ann Street, Port Lavaca.

DIMMITT COUNTY

Espantosa Lake

So long ago that no one remembered why, the small natural waterhole on the old Spanish road from San Antonio to Mexico had come to be called Espantosa Lake. In Spanish, *espantosa* means "fearful" or "horrid." Clearly, something bad had happened there in the distant past, and something bad—at least from the perspective of four outlaws—would happen again.

Near midnight on September 30, 1876, four rangers under John B. Armstrong rode quietly through the brush toward the lake, hoping the prisoner they had in tow had been telling the truth about a party of horse thieves and cattle rustlers being camped near the lake.

The lawmen had made it within seventy yards of the lake when they saw orange flashes and bullets began flying their way. The prisoner hadn't been lying. In the shootout that followed, the rangers added three more dead men whose spirits some believe joined the other ghosts haunting the lake. The fourth outlaw had been badly wounded but survived. Meanwhile, according to Armstrong's report, the cooperative prisoner tried to escape and was shot to death. They had four dead bodies to deal

with, but rangers recovered fifty stolen horses and all the weaponry the outlaws had been carrying.

A granite historical marker was placed at the lake in 1936 but has been badly defaced.

> *We responded promptly* [to the gunfire] *and a lively little fight ensued, resulting in the death of three of them and the wounding of another in five places.*
> —*Ranger John B. Armstrong's report to headquarters*

Visit: Off Farm to Market Road 1433, twenty-six miles northeast of Carrizo Springs, at the dam on the south end of the lake. Brush Country Museum, 201 South Stewart Street, Cotulla.

DUVAL COUNTY

Politics South Texas Style

Following their Ranger service under Captain Leander McNelly, Linton Lafayette Wright and brother Lawrence Baker Wright settled in Duval County—L.L. serving a decade (1880–90) as sheriff and L.B., having become a physician, practicing medicine.

As sheriff, former ranger Wright became a pioneer practitioner of the sort of shady politics that later made Duval County world famous when future president Lyndon B. Johnson magically came up with just enough votes in that county's infamous Box 13 to gain election to the U.S. Senate in 1948.

When Canadian-born John Buckley, a Duval County sheep rancher and grandfather of future pundit William F. Buckley Jr., ran for sheriff against L.L. Wright in 1888, the incumbent won. Buckley challenged the results in court, claiming election officials supporting Wright had failed to count ballots in his favor and that Wright had imported voters from Nueces and Starr Counties. The Texas Supreme Court agreed and ordered Buckley sworn in as sheriff in 1890, ending Wright's law enforcement career.

The former ranger moved to New Mexico Territory but returned to the county seat of San Diego in 1892 when his brother died during an epidemic. L.L. got sick while there and soon died also.

John Buckley, who served as sheriff until 1896, lived until 1903. Forty-five years later, when officials recounted Box 13 they discovered that Buckley had apparently continued his support of the Democratic Party even in death, having cast his vote for LBJ.

Visit: Duval County Museum, 208 East St. Joseph Avenue, San Diego.

FRIO COUNTY

WILLIAM ALEXANDER ANDERSON "BIGFOOT" WALLACE (1817–1899)

His name ran long, just like his six-foot, two-inch, 240-pound body. Far better known as Bigfoot Wallace, his friends called him Foot.

Wallace came to the Republic of Texas at twenty. Unlike other new arrivals, he did not seek land or adventure. He wanted revenge. His elder brother Sam had been one of 330 Texans executed at Goliad by the Mexican army in March 1836 during the revolution. By 1839, after farming for a while near La Grange, Wallace was living in newly established Austin, the republic's log cabin capital city. That's where he earned his nickname by killing in self-defense an Indian with unusually large feet.

When General Adrian Woll invaded Texas in 1842 in yet another attempt by Mexico to reclaim its lost territory, Wallace enlisted under ranger Captain Jack Hays and finally got his chance to avenge his brother's death. He later joined the Somervell and Mier expeditions. Captured and imprisoned, he survived the infamous lottery of death at Perote Prison by drawing a white bean.

Back in Texas, Wallace served on and off as a ranger under Hays—steadily building a reputation as a hard fighter—until the Mexican War, when he joined Hays's federalized regiment under R.A. Gillespie for duty in Mexico. Wallace's last ranger service came in the spring of 1851, but as a stagecoach driver along the San Antonio-El Paso Road, he would do more Indian fighting.

Wallace settled on Chicon Creek in Frio County in the 1870s and remained in the county the rest of his life.

Here is a soldier whom Napoleon would have made a marshal of France.
He has demonstrated that there are men who love a battle better than a ball.
—Captain Jack Hays on Wallace following the Battle of Salado

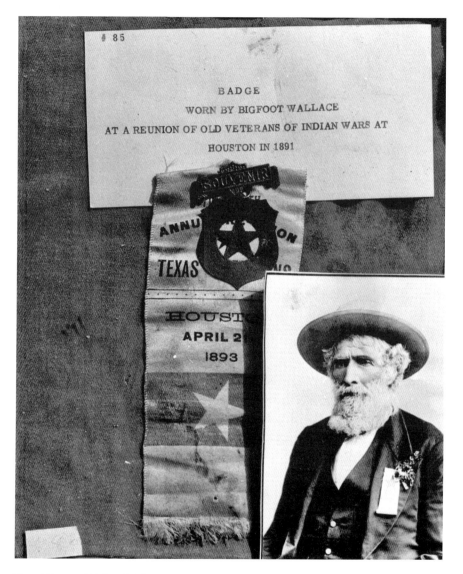

Noted Ranger Bigfoot Wallace and a reunion ribbon and badge he once wore. *Photo by L.A. Wilke.*

Visit: Opened in 1954 in a replica of the log cabin in which Wallace lived, the Bigfoot Wallace Museum has a large collection of material related to the old ranger. A historical marker placed in 1936 stands across from the museum at the intersection of Farm to Market 472 and Farm to Market 462 in Bigfoot.

SOUTH TEXAS

LONGVIEW CEMETERY

When Bigfoot Wallace died on January 7, 1899, his friends and neighbors buried him in Longview Cemetery, a small graveyard near the community that bears his name. A substantial white marble monument in the cemetery honors the old ranger. "Here Lies He Who Spent His Manhood Defending The Homes Of Texas," the monument asserts, adding, "Brave, Honest and Faithful." That may be a fair description of Wallace, but the first line is not at all honest. Forty-eight days after his burial, the Ex–Texas Rangers Association had the old ranger disinterred and shipped to Austin for reburial in the State Cemetery. To be fair, the unusual tombstone—placed in 1960—does note that fact and even records the date of Wallace's second departure: February 24, 1899.

Visit: One mile west of Bigfoot off Farm to Market Road 462.

OLD FRIO COUNTY JAIL

Built in 1884, the Frio County Jail remained in use until 1967. From 1892 to 1896, the two-story brick structure, the oldest in Frio County, served as the residence of sheriff and former Company D ranger J. Walter Durbin (1860–1916). Durbin was in the Rangers from 1884 to 1889.

In the summer of 1893, Sheriff Durbin traveled by train to Arizona to fetch a Texas man who, as the *Arizona Republic* phrased it, faced charges of "irregular cattle transactions" in Frio County. Displaying the get-with-it-ness that had made him an effective ranger, when Durbin got to Maricopa and learned he would have to wait for another train to get to Tempe, he decided to just walk. He finally got a ride, but not before hoofing it most of the way.

> *The rangers will attend to all killing done in this locality for the present.*
> *–Corporal J. Walter Durbin, writing to a newspaper from a trouble spot*
> *in South Texas in the fall of 1888*

Visit: Frio County Pioneer Jail Museum, 410 East Pecan Street, Pearsall.

GONZALES COUNTY
Gonzales
THE "IMMORTAL 32"

When news reached Gonzales on March 13, 1836, that the Alamo had fallen with all its defenders slain, General Sam Houston ordered the town torched. As flames lit the night sky, the Texas army, the grieving widows and children of the thirty-two rangers who had made the sixty-five-mile ride to San Antonio and all other Anglo inhabitants fled eastward. That marked the beginning of a mass exodus that came to be known as the Runaway Scrape.

The townspeople did their work well. No house or building in Gonzales dating from this period is known to have survived to the modern era. But there remains a very tangible reminder of the sacrifice made by the men of the Gonzales Ranging Company: an eight-foot, ten-inch pink granite cenotaph placed atop a three-foot base in front of the Gonzales Memorial Museum during the 1936 Texas Centennial.

A sculpted bronze plaque on the monument lists the names of the Gonzales men who died at the Alamo, but permanence should not be confused with accuracy. Historians later learned that two of the men named on the marker,

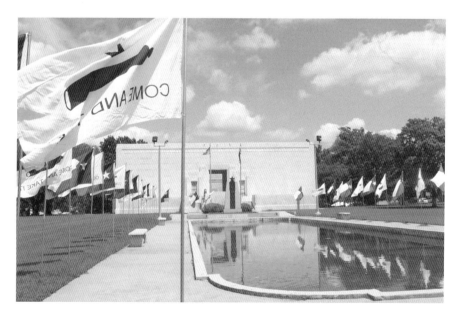

This museum and monument built in Gonzales during the Texas Centennial honors thirty-two rangers who rode to the Alamo and never returned. *Photo courtesy Valerie Reddell.*

John G. King and John McGee, were not among the "Immortal 32." The names that should be on the marker instead of King (it was actually his fifteen-year-old son who died) and McGee (who had already been in the Alamo) are rangers Andrew Duvalt and Marcus Sewell. For a list of the thirty-two rangers, visit tamu.edu.

Visit: 414 Smith Street.

Matthew "Old Paint" Caldwell (1798–1842)

They called him "Old Paint" because of white splotches on his facial hair and chest some thought made him look like a paint horse.

Born in Kentucky, Caldwell came to Texas in 1831 by way of Missouri as part of Green DeWitt's colony. He rode from Gonzales to Bastrop (then called Mina) to gather armed volunteers to keep the Mexican military from reclaiming a small cannon kept at Gonzales for Indian defense, a confrontation in October 1835 that saw the first shots of the Texas Revolution. On March 2, 1836, he was a signer of the Texas Declaration of Independence. After the revolution, he served as captain of an active ranger company that operated out of Gonzales and in 1839 a company based in Seguin, a town he helped found.

As a ranger, Caldwell made the difference in the 1840 Battle of Plum Creek. Commanding two hundred men, he also contributed to the Texas victory in the Battle of Salado in Bexar County during Mexico's 1842 attempt to reestablish control of its lost state.

He died later that year of complications from wounds received in that fight and his earlier imprisonment following the ill-fated Santa Fe Expedition. A 1930 historical marker stands near his grave, and two other markers on the Caldwell County courthouse square in Lockhart honor his memory.

Old Paint Caldwell was equal to a thousand men. As soon as the bullets began to whistle, he seemed to grow taller and look grander.
—*Fellow Ranger Robert Hall*, Life of Robert Hall

Visit: Gonzales City Cemetery, North College at Clay Street.

OLD JAIL MUSEUM

Built in 1887, the old Gonzales County Jail held many ranger prisoners over the years before a new lockup replaced it in 1975. In addition to cells, the three-story brick jail housed the sheriff's department, a residence for the sheriff and his family or jailer. The hoosegow also had a built-in gallows, where three men dropped through the trap on their way to eternity from 1891 to 1921 before the state took responsibility for capital punishment beginning in 1923.

Sheriff Richard Glover, his wife and six children lived in the jail on June 14, 1901, when the sheriff led a posse in search of Gregorio Cortez, who two days before had shot and killed the sheriff of Karnes County. In the shootout that broke out when they found Cortez, Glover died. The incident happened on the ranch of Henry J. Schnabel, who also was killed, probably by a stray bullet from one of the posse members.

Cortez was held in the Gonzales jail during his trial for Sheriff Glover's murder in 1904. Convicted and sentenced to life in prison, he was transferred from Gonzales to Huntsville on New Year's Day 1905. He was later pardoned.

Visit: 414 St. Lawrence Street. The jail is listed in the National Register of Historic Places.

HIDALGO COUNTY

Edinburg

MILLIONAIRE RANGER

Investigating the theft of several head of cattle on the El Sauz Division of the King Ranch, ranger sergeant Anderson Yancy Baker, two privates and a ranch hand rode up on a man branding a calf. Seeing the rangers, the rustler dropped his red-hot running iron—a cow thief's prime tool—and pulled one of the two six-shooters he wore.

Baker's horse reacted to the pistol shot by rearing, and a bullet that otherwise would have torn into the ranger's chest went into the horse's left eye. As the dead animal collapsed, Baker fired his rifle and hit the gunman in his forehead. Checking the body, the ranger recognized the dead man as Ramon de la Cerda of Brownsville. He came from a large family and had a lot of friends.

What normally would have been an open and shut case of a cattle thief caught in the act and killed while resisting arrest, the May 16, 1902 shooting set off what one ranger later described as "a virtual state of war between the Rangers and the border bravos."

On September 9, someone ambushed and killed Ranger Emmett Roebuck as he returned to camp from Brownsville. Soon, rangers had Alfredo de la Cerda, the late Ramon's younger brother, and four other suspects jailed for the ranger's murder. Anticipating public outrage at the killing of the ranger, Captain J.A. Brooks took special measures to prevent the fifteen-year-old from being lynched. The prisoner went unmolested, at least until he made bail.

Not quite a month later, Sergeant Baker ran into young Alfredo outside a grocery store. The ranger later said he thought Alfredo had been reaching for a weapon and he had to defend himself. Others said Baker simply executed him. The sergeant was tried for murder in both deaths and acquitted.

Baker stayed in the Rangers another couple years and then joined the U.S. Customs Service. Leaving federal employment in 1908, he entered politics, gaining election as treasurer of Hidalgo County. In 1912, Baker successfully ran for sheriff, an office he held for the rest of his life.

Meanwhile, as one newspaper reported, "He began to build an agriculture and real estate fortune from lands he acquired inexpensively." People called him the "millionaire ranger." The political power Baker wielded is reflected in statistics connected to his funeral: six thousand mourners showed up, and it took seven trucks to deliver all the flowers sent to his family.

Visit: Baker is buried at Hillcrest Memorial Park, 1701 East Richardson Road, in Edinburg. As sheriff, Baker first managed a two-story jail built in 1909 and opened the following year. The lockup, which had a built-in gallows, remained in use until 1922. The old jail still stands, since 1970 a part of the Museum of South Texas History at 200 North Closner Boulevard, Edinburg.

JIM WELLS COUNTY

Alice

Battle with Comanches

In the 1850s, Mexican War veteran John S. "Rip" Ford emerged as the state's new Jack Hays, who by this time had permanently moved to California. Ford

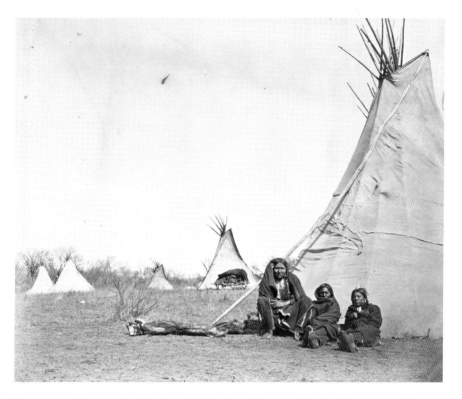

Rangers and Comanches fought each other hard for more than half a century. *Library of Congress.*

recruited a ranger company in Austin in the summer of 1849 and established a camp forty miles east of Laredo.

The following May, scouting toward newly established Fort Merrill in present Live Oak County to pick up newer weapons for his men, Ford and forty rangers had two fights with Comanches, the first on May 12 and the second, and bloodiest, on May 29 in present Jim Wells County. In that running battle, rangers killed four warriors, wounded seven and took one prisoner. Ranger William Gillespie, cousin of Captain R.A. Gillespie took an arrow in one of his lungs and later died. During the fight, Ford shot and wounded Chief Otto Cuero, with Ranger David Steele finishing the headman off with a 125-yard rifle shot. The ranger collected the chief's weapons, headdress and other regalia and sent them to Governor Peter H. Bell, a former ranger. A historical marker was placed near the site in 1969.

SOUTH TEXAS

"Damn them, they've shot my horse."
"Oh, is that all?"
"No, they've shot me too."
　　　　—Exchange between the wounded Sergeant David M. Level and
　　　　Captain Ford, as recorded in Ford's memoir, Rip Ford's Texas

Visit: Marker is 14.4 miles north of Alice on U.S. 281. South Texas Museum, 66 South Wright Street, Alice.

KARNES COUNTY
Karnes City
OLD HELENA AND THE CART WAR

When armed Anglos in 1857 began waylaying Mexican *carteros* along the road from San Antonio to the port of Indianola, a branch of the famous Chihuahua Trail, Governor E.M. Pease called for a ranger company to end the violence. Born of racial prejudice and market competition, the series of robberies and killings came to be called the Cart War.

Founded in 1852 by Thomas Ruckman and named for his wife, Helen, Helena figured prominently in the short-lived "war." The community died in 1886 when another form of transportation, the railroad, bypassed the town. In 1894, the county seat was moved to Karnes City, and Helena became a ghost town. Two historical markers erected in 1967 tell the story.

Visit: Six miles north of Karnes City at the junction of State Highway 80 and Farm to Market 81 at the old courthouse. Built in 1873 and used until the county seat moved, the old Karnes County courthouse houses the Karnes County Museum.

WILLIAM T. "BRACK" MORRIS (1860-1901)

On June 12, 1901, Sheriff William T. "Brack" Morris, who had served in 1882 as a ranger in Company D, rode out of town to question Romaldo Cortez about a stolen horse. Faulty English-Spanish translation devolved into a gunfight. Morris shot and wounded Romaldo, and his brother

Gregorio shot and killed Morris. The shooting marked the beginning of an epic pursuit by possemen and rangers that ended in Cortez's capture while making him an enduring South Texas folk figure. To prevent his being lynched, rangers under Captain J.H. Rogers took Cortez to the Bexar County Jail in San Antonio.

Visit: The former ranger is buried in the city cemetery at Runge, sixteen miles from Karnes City. Built in 1894, the jail where Morris lived continued in use until 1957 but was then razed.

KLEBERG COUNTY

Kingsville

KING RANCH

Ranger history is entwined with the history of the storied King Ranch like the strands of a finely woven rawhide quirt. Little known is that Richard King—the man who gave the ranch its name—had a partner when he first began acquiring land along Santa Gertrudis Creek.

Headquarters of the King Ranch, where rangers were always welcome. *Author's collection.*

King's partner was Gideon K. "Legs" Lewis, a ranger. Unfortunately for Lewis, he had an eye for the ladies, and it cost him what would become a ranching empire. When a Corpus Christi doctor discovered the ranger's ongoing affair with his wife, the physician prescribed a couple of loads of buckshot for Lewis. And the good doctor did nothing to treat his "patient" when he went down.

The bachelor ranger having no heirs, his share of what would become the largest ranch in the world sold at auction on the courthouse steps in Corpus Christi. King's bid came in highest.

By the 1870s, King had even more land. When Captain Leander McNelly and his rangers arrived in 1875, King so appreciated the presence of state lawmen that he presented them better horses and rifles. Always welcome guests on the ranch, the rangers greatly lessened King's loss of livestock.

BATTLE AT NORIAS STATION

Forty years had passed since George Durham, the old McNelly ranger who then managed the El Sauz Division of the giant King Ranch, had battled Mexican outlaws in South Texas. But in the summer of 1915, word reached ranch general manager Caesar Kleberg that a large party of well-armed Mexican Seditonistas planned an attack on the ranch's sub-headquarters at Norias Station.

Kleberg wired for help, and a force of U.S. soldiers and customs inspectors, plus rangers and local officers, hurried by train to the ranch. Led by ranger captain Henry Lee Ransom, on August 8, the rangers began scouring the brush for the raiders, while a handful of men remained at Norias, a stop on the Missouri, Kansas and Texas Railroad.

Riding under a blood-red flag, the raiders somehow slipped past the rangers and charged Norias about sundown. Though substantially outnumbered, the officers, soldiers and ranch hands repulsed the first attack, but both sides continued to pot shoot at each other from behind cover. Finally, the Mexicans made a second charge. But when one of the defenders shot the leader of the raiders out of his saddle, the attack lost its momentum and the attackers disappeared into the thick mesquite.

About an hour after the last shot had been fired, the rangers returned to Norias to find they had missed out on the action. Five to ten of the bandits lay dead, with the wife of one ranch employee also dead. Rangers skirmished with some of the raiders four days later, killing one, but the main body escaped.

Visit: Norias is in Kenedy County, thirty-two miles south of Sarita on U.S. 77 and twenty-two miles north of Raymondville. The King Ranch headquarters and visitors' center is six miles from Kingsville at 2205 State Highway 141 West. For years, access to the ranch was by invitation only, but its now-corporate ownership has opened the ranch to paying visitors through general and specialized tours. King Ranch Museum, 405 North Sixth Street, Kingsville.

MATAGORDA COUNTY

Matagorda

A KNIFE IN THE NECK

Brothers Abner and Robert H. Kuykendall came to Texas with Stephen F. Austin in 1821. Arguably, Abner (circa 1777–1834) deserves recognition as Texas's first ranger captain. As captain in charge of the Austin colony's militia, Kuykendall fought Indians and served as a lawman. At San Felipe in June 1834, one Joseph Clayton got on a bad drunk, and Kuykendall went to either settle him down or arrest him. But Clayton did not like that idea and stabbed Kuykendall in the neck. The blade broke off in the wound, and Kuykendall died the following month.

In murdering the captain, Clayton gained his own historical footnote. Tried for the killing and quickly convicted, he had the dubious honor of being the first Anglo legally hanged in Texas.

Visit: Captain Kuykendall was buried in Matagorda, but his grave has been lost. His younger brother Robert Hardin Kuykendall, also for all practical purposes a ranger, had died in 1831 of complications from a wound he suffered fighting Indians. His grave at Matagorda also has been lost, though a simple marker in the old Matagorda Cemetery gives his name and years of birth and death. Matagorda County Museum, 2100 Avenue F, Bay City.

SOUTH TEXAS

MAVERICK COUNTY
Eagle Pass
OLD MAVERICK COUNTY COURTHOUSE

A frontier Ranger equivalent of a *CSI*-style whodunit began with a body bobbing in the Rio Grande and ended with a hanging in the old Maverick County courthouse.

Within a few days in February 1889, the bodies of three women and one man were pulled from the river above Eagle Pass. After killing them, someone had tied heavy rocks to their bodies and thrown them in the river. What the slayer had not counted on was that the decomposition process would cause the corpses to float to the surface. Soon, Rangers took on the case, and their detective work solved the quadruple homicide.

Pioneer forensic work on the part of Ranger Sergeant Ira Aten and Private John R. Hughes, including the nation's first known use of dental records to confirm the identity of a dead person, led to the eventual indictment of Richard H. "Dick" Duncan. When the case went to trial in December 1889, evidence showed that the San Saba man had killed four members of a Central Texas family on their way to Mexico after he bought their San Saba County farm. A jury found the defendant guilty, and after the case went all the way to the U.S. Supreme Court, the conviction was upheld. Duncan was hanged in the county jail, then part of the courthouse, on September 18, 1891.

Built in 1884–85, the two-story brick and stone courthouse where the trial and execution occurred continued in use until 1979, when Maverick County officials moved to a new facility. After standing vacant for years, the old courthouse, listed on the National Register of Historic Places, was restored in 2005. It's now home to the local public library. A historical marker mentioning the case was dedicated in 1971.

Visit: Jefferson and Quarry Streets in downtown Eagle Pass. Fort Duncan Museum, 310 Bliss Drive.

NUECES COUNTY
Corpus Christi
NUECESTOWN RAID: A TURNING POINT

On May 26, 1875, Mexican bandits attacked a farm near Nuecestown, taking prisoners and stealing livestock. Then they rode to the small community and attacked and burned the store of Thomas and Mary Noakes. The bandits shot and seriously wounded a store customer, but the Noakes family escaped injury. The real significance of the raid was that it caused state officials to raise a Ranger force under Captain Leander H. McNelly and send it to South Texas. That went a long way toward reestablishing law and order south of the Nueces River as well as the Ranger mystique.

Visit: 11800 Upriver Road.

W.W. STERLING (1891-1960)

"Bill" Sterling is the only ranger to have risen from private to state adjutant general. Born in Bell County, Sterling entered Texas A&M at seventeen and got two years of college in before leaving to work on ranches in South Texas. During the bandit troubles brought on by the Mexican Revolution, he served along the border as a scout for the U.S. Army and as a ranger. After World War I, during which he held a second lieutenant's commission, he worked as a Webb County deputy sheriff in the oil boomtown of Miranda City.

In 1927, Governor Dan Moody made Sterling a ranger captain. He worked the border and participated in the cleanup of various oil boomtowns before Governor Ross Sterling (no relation) appointed him adjutant general. He held that post until the election of Governor Miriam Ferguson, when he resigned.

After serving as a colonel in World War II, Sterling managed the large Driscoll Ranch in South Texas. Late in life, he wrote *Trials and Trails of a Texas Ranger*, a well-received memoir. He died in Corpus Christi on April 26, 1960.

Visit: Seaside Memorial Park Cemetery, 4357 Ocean Drive. A historical marker placed in 1969 stands near the grave.

SOUTH TEXAS

REFUGIO COUNTY
Bayside
HORSE MARINES

Rangers generally perform their duties on dry land, which makes what happened on Copano Bay in the late spring of 1836 one of the more unusual events in the force's long history.

On May 29, 1836, Captain Isaac Watts Burton, commanding a twenty-man ranger company, received orders to conduct a scout in present Refugio County. Four days later, Burton learned a suspicious vessel had appeared in the bay off Copano, a port founded by Spain in 1785.

Reaching Copano late in the day, the rangers hid their horses in the brush and made a cold camp to avoid detection. The next morning, June 3, Burton saw a two-masted schooner riding at anchor in the bay. It flew no flag, an ominous sign. Using a spyglass, one of the rangers could make out its name: *Watchman*.

Not satisfied that the vessel really had an American crew, Burton sent two of his men, unarmed, to signal the ship as if they needed help. When the vessel ran up the Stars and Stripes, Burton told the rangers not to respond. After a while, the captain of the schooner took down the U.S. flag and raised a Mexican flag, revealing what Burton had suspected all along. At that, the rangers frantically waved their arms, pleading for assistance. Obeying the unwritten law of all mariners, the captain and four sailors rowed ashore, thinking to assist kinsmen.

Burton and the other rangers quickly commandeered the boat. Leaving four men behind with the prisoners, Burton and the rest his men rowed to the schooner and easily seized it as a prize for the new Republic of Texas.

Still at Copano, on June 17, the rangers spotted two more ships and commandeered them as well. Those vessels and the *Watchman* were laden with food, ammunition and muskets—all badly needed by the Texas army. Two days later, the rangers and their prisoners set sail for Velasco. Later, at Galveston, an admiralty court awarded the cargo of the ships to Texas but released the vessels—which had been leased to Mexico—to their American owners.

Burton moved to Houston County in 1841 and died there in January 1843 at thirty-eight.

> *On yesterday* [news came] *of the capture of three Mexican vessels by a troop of…"Horse Marines" I suppose.*
> –*Letter from Edward J. Wilson published in the* Kentucky Gazette,
> *July 26, 1836*

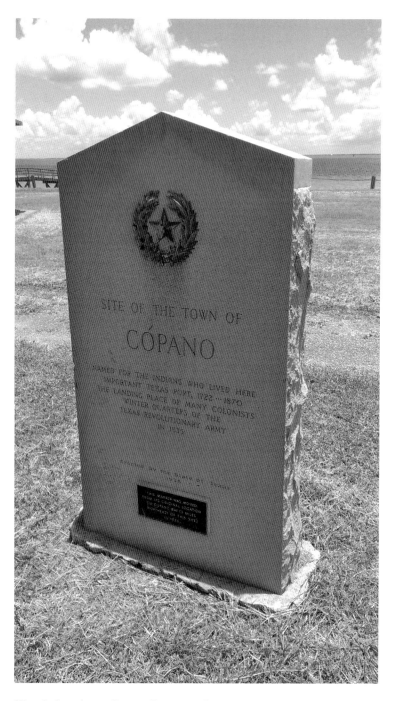

Historical marker at Copano Bay, near where rangers captured three ships shortly after the Texas Revolution. *Photo by Mike Cox.*

Visit: The ruins of Copano, remnants of ten shellcrete structures and an old cistern, stand precariously on the edge of a bluff overlooking Copano Bay. The site is on private property, where archaeological work in 2005 indicated much of the old town had already fallen into the bay with the rest likely to follow unless mitigation is undertaken soon. Since the shoreline has already receded at least one hundred feet since the mid-1930s, where Burton camped in 1836 likely is already gone. A granite historical marker placed at the site in 1936 was moved to Driscoll Rooke Covenant Park in Bayside, five miles to the south, after it toppled into the water in 1978. Burton is buried at Glenwood Cemetery in Crockett. A granite historical marker placed in 1936 stands near his grave. Refugio County Museum, Heritage Park, Refugio.

STARR COUNTY
Rio Grande City
RANGERS VS. CORTINISTAS

In 1859, two days after Christmas, Rangers under John S. "Rip" Ford and U.S. Army troops commanded by Major S.B. Heintzelman fought some 450 partisans of Juan Cortina near the Rio Grande in what is now Rio Grande City. Cortina made it across the river into Mexico. Many of his men splashed across afoot, but he had been defeated and the so-called Cortina War effectively ended. A historical marker placed in 1970 marks the battle location.

Visit: Old Cemetery Park, Second and West Streets, Rio Grande City. Fort Ringgold (occupied 1848–1944) visitor's center, 1 South Ringgold Street off U.S. 83.

UVALDE COUNTY
Uvalde
KING FISHER'S ROAD

By all odds, a ranger should have killed John King Fisher, a young man who famously posted a sign in the South Texas brush country that read, "This is King Fisher's Road, Take the Other One."

A cattle thief who claimed to have killed seven men "not counting Mexicans," Fisher proved to be a mesquite thorn in ranger captain Leander McNelly's figurative saddle. Rangers collected evidence resulting in twenty-one indictments against Fisher at various times and on various charges, including cattle rustling, horse stealing, assault and murder. But, primarily due to reluctance on the part of witnesses to testify against him, convictions always went wanting.

Besides being one lucky felon, Fisher had the reputation of being something of a dandy, always a sharp dresser. That reportedly led the frustrated Captain McNelly to tell him, "You better be careful. You look good now, but you'll look just as good dead."

Others agreed with that, and at Jack Harris's Vaudeville Variety Theater in San Antonio on the night of March 11, 1884, someone shot Fisher to death along with another nefarious character, outlaw-turned-lawman Ben Thompson. No arrests were ever made, but the killer wasn't Captain McNelly, who had died seven years earlier.

Visit: Fisher's grave is in Uvalde's Pioneer Cemetery, 500 block of Park Street.

VAL VERDE COUNTY
Del Rio
A WOLF POSING AS A SHEEP RANCHER

The Wright brothers were flying planes, but Ed Putnam still operated like an Old West outlaw. Killing a sheep rancher in November 1906 near Box Springs in Val Verde County, Putnam drove off the man's large flock. A few days later, posing as a livestock dealer, the killer conman approached B.M. Cauthron and said he knew where he could get some sheep at a bargain. That sounded interesting, so Cauthron accompanied Putnam to look at the stock. He liked what he saw and agreed to buy half interest in the animals.

After rounding up the money, on December 1, Cauthron rode with Putnam to gather up the sheep. But as soon as they were out of town, Putnam back-shot him and collected his cash. Unfortunately for the killer, someone with grit saw what had happened and, with pistol drawn, rode hard toward Putnam. Seeing the armed rider approaching fast, Putnam galloped toward town. At

Del Rio about the time young Ranger Frank Hamer took part in a wild shootout there. *Author's collection.*

the first house he saw, which happened to belong to Glass Sharp and his family, Putnam dismounted and ran inside.

The witness went to notify law enforcement, and soon Captain John H. Rogers and three of his rangers—rookie Frank Hamer, Marvin E. Bailey and R.M. "Duke" Hudson—had the place surrounded. Putnam graciously allowed the occupants to leave and then began firing at the rangers. The lawmen fired some three hundred rounds into the small frame house, but Putnam kept shooting. Finally catching a glimpse of Putnam through a window, Hamer quickly put a round into the outlaw's head, instantly ending his career while establishing his own reputation as a dead shot.

Visit: Glass T. Sharp owned Lot 1, Block 44 in Del Rio, now 309 West Sixth Street. The house, privately owned, still stands.

GLENN-DOWE HOUSE

Luke C. Dowe served as a Frontier Battalion ranger from 1890 to 1892, taking part in the joint U.S. Army–Texas Ranger search in South Texas for Catarino Garza, a newspaper publisher who led a force bent on starting a revolution in Mexico. One ranger was killed in the trouble, later called the Garza War. After leaving state law enforcement, aside from brief stints with the Maverick County sheriff's office in Eagle Pass, Dowe spent most of his

long border law enforcement career as a federal officer, first as a mounted customs inspector and later as deputy customs collector at Del Rio. The former ranger and his wife moved into the one-story brick house (built by Daniel Glenn in 1900–01) following their 1906 marriage and lived there for nearly fifty years. After retiring in 1935, Dowe settled into a quiet life, often going on fishing-camping trips on the Devils River. Dowe died in El Paso on June 25, 1956. A historical marker was placed at the house in 1985.

Visit: 301 Garfield Avenue.

Jess Newton Corralled at the Rodeo

Many Del Rio residents, including one visitor recently arrived from Illinois, were enjoying a Fourth of July rodeo in 1924 when former Texas Ranger Harrison Hamer, younger brother of Frank Hamer, showed up.

Harrison Hamer appreciated cowboy competition as much as the next Texan, but on this hot afternoon, he had not come to the arena to take in the performance. Though no longer a ranger (he would serve as one again), he held a peace officer's commission as an inspector for the Sheep and Goat Raisers Association. And he was about to make one of the most important arrests of his long career.

On June 12, the Newton Gang—Uvalde-raised brothers Doc, Jess, Joe and Willis—had pulled the biggest train robbery in American history near Chicago. The Texas boys escaped with $3 million, and now Jess was living it up on what remained of his share of the money, just an easy bridge crossing from Mexico if necessary. But Hamer had gotten word that Newton was in Del Rio. Finding Newton at the rodeo, Hamer waited until he started to leave.

"Don't make a move," Hamer said as he took hold of Newton's right arm. "You're under arrest."

"I ain't going to do nothing," the wanted Texan answered, and he didn't—other than go to jail. He served a light sentence of one year and one day.

Visit: The arrest likely took place at the Val Verde County Fairgrounds. The old arena is no longer there, but the fairgrounds are at 2006 North Main Street, Del Rio.

Oscar Latta (1868–1954)

Former Frontier Battalion ranger Oscar L. Latta played down his role in ridding the nation of the last of one of the most infamous outlaw gangs that ever rode the Owlhoot Trail—the Daltons.

Born in Xenia, Kansas, on September 14, 1868, Latta came to Texas with his parents at six and grew up in West Texas. He married at twenty-two in 1890, and a year later, he had a son. But soon the marriage soured, and Mrs. Latta filed for divorce. What role her parents had in the breakup is not known, but any chance of reconciliation ended when Latta shot and killed his father-in-law. A jury agreed with Latta and his lawyer that the shooting had been justified and acquitted him of murder. After that, he turned to law enforcement, hiring on as a deputy sheriff in Kimble County.

On February 6, 1897, riding in a posse led by Sheriff John L. Jones, they encountered three suspected cattle rustlers on a ranch near the Kimble-Menard County line. The outlaws opted to take their chances on gunplay, which proved a bad idea. After the final hammer fell that winter day, Jourd Nite and Jim Crane had been lastingly rehabilitated of their criminal ways. The wounded survivor, Jim Nite (Jourd's brother) turned out to be one of the last members of Bill Dalton's gang, wanted for the violent robbery of the First National Bank of Longview on May 23, 1894.

Not long after arresting Nite, Latta became a Ranger, serving with Company F in Duval County in South Texas. After leaving the state force, he worked for a time in Brady as a deputy city marshal. In 1932, after Rangers had evolved from horseback lawman to state cops with cars, Latta again pinned on a Ranger badge for a time. He died on August 2, 1954, in Del Rio.

Visit: Westlawn Cemetery, 1200 West Second Street. Whitehead Memorial Museum, 1308 South Main Street.

WEBB COUNTY
Laredo
Los Ojuelos (The Springs)

A stopping place on the El Camino Real, the old Spanish road across Texas to Mexico, the springs had been a camping place since before

Captain Will Wright's company in South Texas during the Prohibition era. *Author's collection.*

recorded history by the time ranger captain John S. "Rip" Ford and his men pitched their tents there in 1850. Most Ranger camps saw only temporary use, but rangers continued to periodically occupy the site through the Prohibition era.

The town of Los Ojuelos grew near the springs, but when the Texas-Mexican Railroad bypassed the community, it began to fade. Despite an oil boom at nearby Miranda City in the 1920s, it became a ghost town. The site was added to the National Register of Historic Places in 1976.

Visit: Forty miles east of Laredo, two and a half miles south of Mirand City on Farm to Market 649. Private property.

RANGERS FIGHT SMALL POX—AND GUNMEN

Rangers more used to dealing with killers and cattle rustlers faced a new enemy on the streets of Laredo in the spring of 1899—smallpox.

With an outbreak of the dreaded disease known along the Rio Grande as *la viruela* rapidly spreading in the border city, Captain J.H. Rogers and one of his men came to town to assist state health authorities in preventative measures, including a quarantine. Largely due to lack of education and

a general distrust of outside authority (particularly the Rangers), some residents decided to forcibly resist.

As rumors to that effect began circulating, Rogers wired for more rangers. When a local hardware store notified the sheriff's office that a former city policeman had placed an order for two thousand rounds of buckshot shells, officers raided his residence. Captain Rogers and his rangers were there as well, and the situation soon deteriorated into a shooting that mutated into a riot.

The captain caught a rifle bullet that nearly took his arm off, but he and another ranger killed the gunman. Then, using a favorite Ranger line, as Rogers later reported, "shooting…became general." Numerous residents suffered wounds of varying severity in a riot that continued through the night, but no one else died. Cavalrymen from Laredo's Fort McIntosh finally restored order.

Visit: The riot spread from a southeast Laredo residential neighborhood to the combination city hall and public market now known as El Mercado, an 1884-vintage brick structure still standing at 500 Flores Avenue. Rangers carried their badly wounded captain to the newly opened Hamilton Hotel at 815 Salinas Street. Listed on the National Register of Historic Places, the old hotel is now an apartment building.

Villa Antigua Border Heritage Museum, 810 Zaragosa Street and Republic of the Rio Grande Museum, 1005 Zaragosa Street.

WILLACY COUNTY
Raymondville
George Preston Durham (1856–1940)

George Durham's father fought with Leander McNelly during what Southerners tended to call the "War of Northern Aggression." Listening to his father talk about McNelly convinced young Durham to come to Texas. Only nineteen, Durham found McNelly at the post office in Burton and said he wanted to join the ranger company he had heard McNelly was organizing. Durham seemed solid, and McNelly added the Georgian to his roster.

After riding with the Rangers for two action-filled years, during which time he took part in the so-called Las Cuevas Affair a Ranger invasion of Mexico

in pursuit of cattle thieves, Durham went to work for cattleman Richard King. He later married Caroline H. Chamberlain, the niece of King's wife, and eventually rose to foreman of the King Ranch's El Sauz Division. Late in Durham's life, newspaperman Clyde Wantland interviewed him for a series of western magazine articles. Following his death in 1940, each of Durham's sons, in turn, served as El Sauz manager. (It is now a separate ranch, no longer part of the King Ranch.) In 1962, Wantland's work was compiled into *Taming the Nueces Strip*, an essential read for anyone interested in the story of McNelly's rangers.

Visit: Raymondville Memorial Park Cemetery.

WILSON COUNTY
Floresville
RANGER BREEDING GROUND

Maude T. Gilliland, whose grandfather, father and husband all had served as rangers, loved history. In researching one and then a second now highly collectible book on ranger activities in South Texas, she noticed something unusual about Wilson County: all its rangers.

Though sparsely populated, over the years, the county produced forty-four rangers, including Will Wright, Frank Hamer and three other captains. Nearly half the rangers came from the near-ghost town of Fairview. Admittedly, several families had contributed multiple rangers, and to be fair, some had not been born in Wilson County. But Mrs. Gilliland knew of no other small county with so many rangers who had called it home. That discovery led in 1977 to her third and long out of print final work, *Wilson County Texas Rangers*.

WILLIAM LEE WRIGHT (1868-1942)

Born in Lockhart and reared in DeWitt County, Captain Will Wright served as a Wilson County sheriff's deputy (1898–1902), as county sheriff (1902–17), and variously in the Rangers from 1918 to 1939. A historical marker placed in 1967 outside the 1887 jail where he once lived calls him

a "fearless, colorful, cultured man whose honesty and diplomacy often prevented bloodshed."

> *Don't worry, I won't hurt you.*
> *—Sheriff and future ranger Wright to a convicted murderer*
> *he was about to hang*

Visit: As sheriff, Wright lived in the two-story brick 1887 county jail, 1143 C Street. Remodeled in 1936, the facility continued in use until 1974. Wright is buried in Floresville City Cemetery, 2012 Third Street.

ZAVALLA COUNTY

Whoever buried former Ranger James W. King disliked him so much they planted him facing west, a strong insult.

A fair hand with a fiddle, King enlisted in the Frontier Battalion in 1882. He served under various officers in two different companies before joining Captain Frank Jones's Company D in 1887.

In 1888, Jones ordered King to sparsely populated Zavalla County. Posing as a dishonorably discharged ranger, King tried to make cases against cattle thieves. Fiddling his way to acceptance, he made some inroads with the locals, but no criminal cases. Returning to his company and other duties, three days after reenlisting on September 1, 1889, he got fired for drunkenness—this time for real.

For some reason, King decided to go back to Zavalla County. Maybe he figured on hiring on as a sheriff's deputy or cowboying. Again, King told folks he had been let go by the Rangers. But he'd said that before.

Someone killed the former ranger on the W.L. Gates ranch near Loma Vista on February 11, 1890. Less than two months later, three men were charged with King's murder, but a Frio County jury found them not guilty.

For years, only a mesquite stump marked the former ranger's lonesome burial spot. A modern marker makes no mention of the ranger's violent demise, merely recording for posterity these words: "James W. King/ Feb. 11, 1890/ Texas Ranger/ Co. D."

Visit: Loma Vista Cemetery. Take Farm to Market 1867 fifteen miles north from intersection with State Highway 385 in Big Wells.

WEST TEXAS

BREWSTER COUNTY
Alpine
THE STEER (OR BULL) BRANDED M-U-R-D-E-R

A ranger and two former rangers had a hand in one of the Old West's more bizarre tales.

Fine Gilliland, representing several ranchers at the annual winter roundup on January 21, 1891, got into a dispute over an unbranded steer (some sources say a young bull) with rancher Henry Harrison Powe, a one-armed Civil War veteran. Words led to gunplay. Gilliland killed Powe and galloped away.

Having watched his father die, Powe's son raced his horse to Alpine and notified Sheriff James B. Gillett. The former ranger saddled up and headed to the crime scene. Meanwhile, in a gesture of solidarity with Powe, some of the cowboys who witnessed the shooting had taken a running iron and branded the letters M-U-R-D-E-R on the side of the critter that led to the fatal dispute.

Seventy-two hours later, Ranger Jim Putnam and former ranger Thalis Cook, then a Brewster County deputy sheriff, encountered Gilliland in the Glass Mountains. The fugitive cowboy immediately "went to shooting," his first round shattering Cook's knee. When Putnam shot Gilliland's horse as he tried to ride off, the wanted man used the dead animal as cover until the ranger put a bullet between Gilliland's eyes.

Back in Alpine, a doctor wanted to amputate Cook's leg, but the lawman refused. However, he did have the doctor break the leg and set it with somewhat of a bend so he could still sit a horse. The former ranger lived with pain until July 21, 1918, when he died during surgery after finally consenting to the leg's amputation.

Considered a harbinger of doom for anyone who saw it, the lonely animal branded M-U-R-D-E-R roamed the county for years before its owner finally sold it.

Visit: The shooting occurred on the Leoncita Ranch located north of Alpine, privately owned.

SUL ROSS STATE UNIVERSITY

Founded as Sul Ross Normal School for Teachers in 1917 and opened three years later, the university is named for Texas Ranger Lawrence Sullivan "Sul" Ross, who led the company that recovered Comanche captive Cynthia Ann Parker in 1860. Ross later served as governor from 1887 to 1891 and as president of Texas A&M University from 1891 to 1898. A historical marker on the Administration Building outlines Ross's background, including his Ranger service. A six-foot bronze statue of former ranger Ross by New Braunfels sculptor Paul Tadlock was unveiled on the campus in 2014. Retired Fort Worth educator and businessman Charlie Nichols, a 1959 Sul Ross graduate, donated $100,000 for the piece of public art.

FATHER OF BIG BEND NATIONAL PARK

Born in Colorado County in 1871, Everett Ewing Townsend served in the Rangers from 1891 to 1893 and again from 1898 to 1900. While his record as a state lawman would be unblemished, he lied about his age to join the Rangers, claiming to be twenty-one when he was only twenty. Between Ranger stints, he worked in the Big Bend area first as a deputy U.S. marshal under former ranger Dick Ware and later as a mounted U.S. Customs inspector.

Moving from Presidio to Alpine in 1916, he bought a twelve-thousand-acre ranch and built a home in town. Two years later, he became sheriff of sprawling Brewster County—the nation's largest county—holding office until 1926.

Based in Presidio during his time as a federal officer, Townsend became enthralled with the rugged mountains and canyons along the big bend of

the Rio Grande. Elected as a state representative in 1932, as a member of the legislature, and later as a private citizen, he played an important role in developing Big Bend National Park.

Living long enough to see the formal opening of the huge national park in 1944, Townsend died on November 19, 1948.

Visit: Elm Grove Cemetery, TW Ranch and Cemetery Road. Museum of the Big Bend, Sul Ross University, U.S. Highway 90.

BROWN COUNTY
Brownwood
FENCE CUTTER WAR

Ill will between those who fenced their land with barbed wire and those still partial to the old open range days ran particularly strong in Brown County. What came to be called the Fence Cutter War only claimed two lives in the county, but twice, local lawmen and rangers barely prevented gunfights that likely would have killed many more.

When violence did erupt in the county on November 8, 1886, rangers under Captain William Scott killed a couple fence cutters in a nighttime gunfight on L.P. Baugh's ranch north of Brownwood. One close call came the next day outside the courthouse when a sheriff's deputy, believed to be a fence-cutter, confronted a deputized ranger informant as he walked with a ranger. The county lawman demanded the man's pistol, an order the ranger took exception to, drawing his weapon on the deputy. Sheriff W.N. Adams saw what was happening, ran up and threw down on the ranger. Fortunately, Captain Scott walked up and smooth-talked everyone into holstering their hardware.

The other close call had happened earlier, when Sheriff Adams succeeded in calming a potential mob that descended on the courthouse following a mass meeting of those opposed to fences.

Visit: A historical marker on the Fence Cutter War stands outside the Texas Ranger Hall of Fame and Museum in Waco. Another marker dealing with the conflict is on the Coke County courthouse square at Seventh Street and Austin Avenue in Robert Lee. The Brown County shootout occurred on Baugh's ranch in an area covered by Lake Brownwood in 1933. Technically,

the 1884-vintage courthouse where Sheriff Adams reasoned with both factions still stands, but it was so extensively remodeled in 1917 that it is essentially a different building. A two-story stone building constructed in 1876 at Brownwood and Center Streets was owned by Moses and Sam Coggin, ranchers and businessmen who figured in the fence-cutting imbroglio. The fence cutter faction met in the opera house on the building's second floor before marching across the street to the courthouse for their meeting with Sheriff Adams.

C.M. GRADY (1854-1949)

Caleb Grady, an Indian-fighting ranger who lived to see the atomic age, played a significant role in developing the Ex-Ranger Association Park at Santa Anna. Born in Kentucky, he came with his family to Texas in 1872. Following his Ranger service, he took up farming in Coleman County near Santa Anna and stayed there most of his life. His daughter, Mrs. R.C. Gay, helped him get his colorful recollections into print with his book, *Into the Setting Sun*. Grady died at ninety-five on June 29, 1949 in Brownwood.

> *Look! Can't you see them—the Rangers! There go the boys.*
> *—Grady to his daughter, shortly before he died*

Visit: Greenleaf Cemetery, 2701 U.S. 377 South. Public Ground West Addition. Built in 1902, the four-story, castle-like old Brown County Jail at 212 North Broadway Street houses a firearms museum. Across from the jail at 209 North Broadway is the Brown County Museum of History.

COLEMAN COUNTY
Coleman
COLONEL JAMES E. McCORD (1834-1914)

Judging by some early histories, the Rangers disappeared for several years in the 1860s, not reconstituted until the creation of the Frontier Battalion in 1874. But the Rangers were around during the Civil War, filling the void left when the U.S. Army marched away at the beginning of the conflict.

Confederate Indian fighters were not always called rangers, but that had been the case since the early 1820s.

One important Ranger figure during the sectional war was James McCord, who came to Texas from South Carolina in 1847. After its creation in 1856, he helped survey Coleman County. Three years later, he rode with ranger lieutenant Edward Burleson, scouting the area he had covered with tripod and transit. As colonel in charge of the state's frontier defenders during the latter part of the war, McCord maintained his headquarters at Camp Colorado, twelve miles from Coleman.

Even though the county had been created twenty years earlier, it was not organized until 1876. When that happened, McCord came back and stayed. He was president of Coleman National Bank when he died in 1914.

Visit: A historical marker commemorating McCord's life stands in the Coleman City Park on State Highway 206. The park features a 1936 replica of the Camp Colorado headquarters. McCord lies in the Coleman City Cemetery, East Ninth and Comal Streets. Heritage Hall and Coleman Museum, 400 West College Avenue.

Santa Anna

As mountains go, Santa Anna Peak isn't much of one, rising only three hundred feet above the surrounding terrain. But in comparison with the generally flat landscape in every direction around it, the feature has been a landmark for as long as people have been in the area.

Caleb Grady first saw the peak as a buffalo hunter in 1875. Later that year, when he joined the Rangers under crusty Captain Jeff Maltby, Grady and his fellow rangers had their camp on a creek four miles from the mountain. He and other rangers spent a lot of time on the peak keeping an eye out for Indians. In time, the rangers rode on, but as old men, many of them would be back.

When the Ex–Texas Rangers Association began holding annual reunions in the 1920s, Grady seldom missed one. In 1935, the association met at Santa Anna. About the same time, the organization's leadership decided to adopt a regular meeting place. Given that many of the old rangers once served in the vicinity, they picked Santa Anna.

With help from local donors, the association bought twenty-five acres on the slope of the peak to serve as a reunion ground. Grady helped secure federal Works Progress Administration money for construction of a rustic,

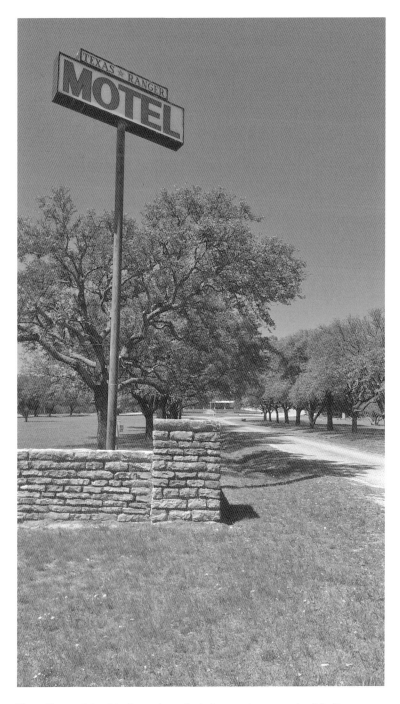

Texas Ranger Motel in Santa Anna includes reunion grounds of Indian-fighting Rangers. *Photo by Mike Cox.*

native stone meeting hall with a fireplace on each end. The work began in 1936, and the association held its first reunion there in 1937. From then, the rangers came back to their old stomping grounds every summer until 1951, when only one aged ex-ranger attended.

The local Veterans of Foreign Wars post took over the property after the reunions ended. Later, the property went to the Texas Highway Department and continued in use as a park. The state, in turn, deeded the acreage to the City of Santa Anna. In 1979, then Sheriff H.F. Fenton purchased the old meeting hall and built a ten-unit motel adjacent to it. He didn't have any trouble coming up with a name for it—the Texas Ranger Motel.

In January 2015, Bill and Nancy Massey of Odessa purchased the motel, the Depression-era meeting hall and slightly more than five acres around it. They extensively remodeled the motel and the historic meeting hall and hope to acquire other portions of the original park.

Visit: The Texas Ranger Motel and RV Park is at 401 U.S. 84 just east of Santa Anna. Visitors are welcome to take a look at the historic reunion hall. Rangers standing sentinel on Santa Anna Peak in the 1870s carved their names on two large rocks now sitting in front of the structure.

JOHN R. BANISTER (1854–1918)

Banister and brother William ran away from home in Missouri and came to Texas in 1867. After cowboying for a time, John joined the Rangers on October 9, 1877, with his brother following suit six weeks later. After leaving the Rangers in 1880, John Banister held a railroad job for a while, worked as an inspector for the Texas and Southwestern Cattle Raisers Association and then became sheriff of Coleman County in 1914. When he died on August 1, 1918, county commissioners appointed his widow to fill the last three months of his term. That made Emma Daugherty Banister the first female sheriff in U.S. history. She lived until 1956 and is buried next to her husband.

Visit: Santa Anna Cemetery. From junction of Farm to Market Road 2294 and Farm to Market Road 755, go north 6.4 miles on Farm to Market Road 755. Turn right on Saenz Lane and drive east 0.2 miles to an unnamed dirt road. Turn north and take road to cemetery. While sheriff, Banister lived in the 1890-vintage Coleman County Jail, still in use in Coleman. Historical exhibits, Santa Anna Visitors' Center, 704 Wallis Avenue.

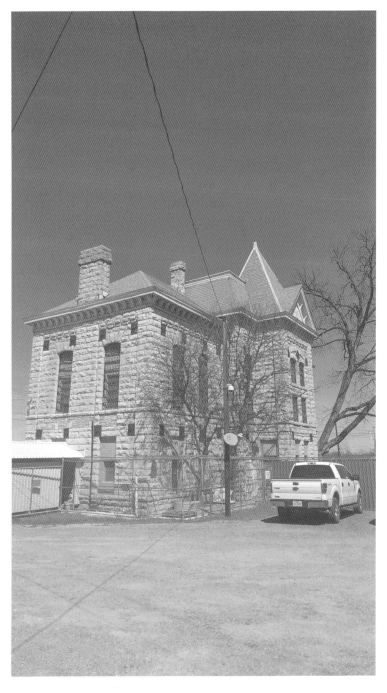

The old Coleman County Jail, once home to former ranger John Banister and his family, remains in use. *Photo by Mike Cox.*

COMANCHE COUNTY
Comanche
CLOSE DOESN'T COUNT IN GUNFIGHTS

On the night of May 26, 1874, outside a saloon in Comanche, a former ranger cleared leather and snapped off a round at John Wesley Hardin.

Unfortunately, he missed. Actually, the hastily dispatched .45 slug did graze Hardin's shoulder, but close only counts in horseshoes. Hardin did not miss. Charles Webb, a sheriff's deputy from nearby Brown County, dropped to the street with a bullet in his head.

The following day, rangers under Captain John R. Waller arrived in Comanche, and on May 30, the captain and five of his men flushed Hardin and his friend Jim Taylor out in the sticks. Following an exchange of gunfire, the pair escaped.

On June 1, a delegation of Comanche County residents removed Hardin's brother Joe and two Hardin cousins from jail and hanged them. Captain Waller, still hunting Wes Hardin, did not even consider the matter worthy of inclusion in his report to headquarters.

Three years passed before the Rangers caught up with Wes Hardin again.

Historical marker near the Brownwood grave of former ranger Charles Webb, gunned down by notorious shootist John Wesley Hardin in 1874. *Photo by Mike Cox.*

There is a great deal more danger from [Hardin and Taylor] *than from the Indians.*

—*Captain Waller to headquarters*

Visit: Former ranger Webb (1848–1874) died near the east door of Jack Wright's Saloon, northeast corner of West Grand and North Page Streets. A nearby historical marker details the shooting that put the Rangers on Hardin's trail. A 2012 historical marker stands near Webb's grave in Greenleaf Cemetery, Masonic Addition, Brownwood. Comanche County Historical Museum, 402 Moorman Road.

CROCKETT COUNTY

HOWARD'S WELL

One of the most important water holes in arid West Texas was Howard's Well in present Crockett County. Likely first used by Spanish explorers, former ranger Richard A. Howard rediscovered the water hole in 1848, and from then on, it bore his name. Howard had been part of an expedition led by Captain John Coffee Hays (a surveyor before he took up rangering) to map a wagon road from San Antonio to El Paso. The water source Howard found succeeded in temporarily abating the expedition's shortage of water, but the men and their Delaware Indian scouts eventually had to give up and return to San Antonio. A year later, Howard guided a U.S. military expedition along the same route, stopping at the well. After that, California-bound '49ers, stagecoaches along the Overland Mail Route, rangers and other travelers always stopped at the well.

Indians, of course, had known about the water source for years and continued to use it. In 1872, a band of Comanches attacked a wagon train near the well and massacred sixteen people.

Visit: The well site (the spring has been dry for years) is on private property, but its story is told on a historic marker at Fort Lancaster State Historic Site, thirty-six miles west of Ozona off U.S. 290. Crockett County Museum, 407 Eleventh Street, Ozona.

WEST TEXAS

CULBERSON COUNTY
Van Horn
CAPTAIN BAYLOR'S BREAKFAST

Captain George Baylor and his rangers had been on the Apaches' trail nearly two weeks.

The hunt began when rangers investigating the late arrival of the stagecoach at Fort Quitman found that Indians had attacked it in Quitman Canyon in present Hudspeth County. When the rangers rode up on the wreckage of the stage, they expected to find the bodies of its driver and passengers, but they were missing, along with all but one of the mules that had been pulling the coach. That animal lay dead. Determined to catch up with the Indians and their presumed captives, the rangers followed the warriors' tracks into Mexico and back into Texas.

From the Rio Grande, the trail headed north into the Eagle Mountains, thirty-plus miles above present Van Horn. The sign had grown increasingly fresh.

On the evening of January 28, 1881, Baylor noticed doves flying toward what he knew must be a water source in the mountains, which would be a logical place for the Apaches to be camped.

The next morning, the Rangers' Pueblo scouts found the Indians, and the lawmen attacked them as they cooked their breakfast. Killing four warriors, two women and two children, the rangers captured several others. Some of the rangers did not like having killed women and children, but it was done. As it turned out, the attack marked the last fight Rangers ever had with Indians.

After the shooting ended, Baylor and his men sat down to eat the breakfast the Indians had been preparing. Once full, the rangers took the prisoners to Fort Davis. The stagecoach occupants were never found.

> *Some of the men found horse meat pretty good, while others found venison and roasted weasel good enough.*
> —*Captain Baylor,* Into the Far, Wild Country: True Tales of the
> Old Southwest

Visit: The battle occurred in the Sierra Diablo Mountains on what is now the Figure 2 Ranch. A historical marker telling the story of the fight and giving a history of the ranch is located thirty-two miles north of Van Horn on State Highway 54. Culberson County Historic Museum, 112 West Broadway Street, Van Horn.

GUNFIGHTS & SITES IN TEXAS RANGER HISTORY

EL PASO COUNTY

El Paso

"Hell Paso" as some sarcastically called it, was a tough town. Starting with the bloody Salt War of 1877, during the nineteenth century, more rangers or former rangers died in the line of duty in and around El Paso than any other place in Texas.

SALT WAR

Rangers sometimes got caught up in other people's fights. That's what happened in the Salt War, a legal dispute over salt deposits that turned violent. Racial and religious differences, politics and weak local law enforcement added seasoning to a deadly stew that would claim the lives of two rangers.

The conflict arose over access to salt flats seventy miles east of El Paso, an area where people from both sides of the Rio Grande had been helping themselves to salt for generations. When El Pasoan Charles Howard gained control of the flats and began charging a fee to collect the all-important mineral, the town's Hispanic population—by far the majority—grew incensed.

But not everyone opposed to Howard's claim was a Mexican American or Mexican citizen. Louis Cardis, a Spanish-speaking Italian immigrant who represented the El Paso area in the legislature, did not like what Howard had done and liked it even less when Howard had two Mexicans charged with trespass over the salt issue. The friction boiled over on October 10, when Howard blew the lawmaker away with a double-barreled shotgun.

A plea for help resulted in Major John B. Jones coming to El Paso for a firsthand assessment. Agreeing the situation had become volatile, the major raised a twenty-man ranger company under Lieutenant John Tays. Satisfied Tays and his men would keep things quiet, Jones departed.

No matter the presence of the new ranger company, the bloodshed Jones hoped to forestall came anyway. At San Elizario on December 12, an armed mob surrounded the adobe structure Tays and six members of his company had taken shelter in to protect Howard. After a three-day siege, in which Ranger Conrad E. Mortimer was killed and Sergeant John E. McBride wounded, Howard agreed to give up, and Tays surrendered. But despite their leader's assurances, the anti-Howard faction executed

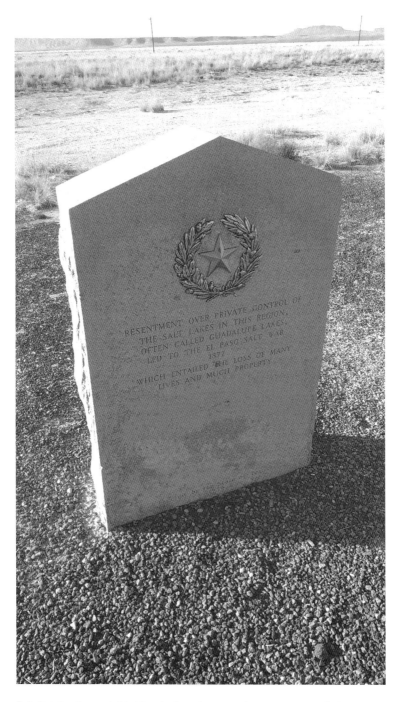

RESENTMENT OVER PRIVATE CONTROL OF
THE SALT LAKES IN THIS REGION,
OFTEN CALLED GUADALUPE LAKES,
LED TO THE EL PASO SALT WAR
1877
WHICH ENTAILED THE LOSS OF MANY
LIVES AND MUCH PROPERTY

Salt flats just beyond this historical marker started a war rangers tried to stop. *Photo by Mike Cox.*

Howard, along with ally John G. Atkinson and Sergeant McBride, whom the mob viewed as more Howard partisan than lawman. The other rangers were disarmed and released.

An El Paso grand jury indicted six men in the murders, but by that time, they had gone to Mexico and never faced trial.

Visit: Two historical markers providing brief overviews of the Salt War stand at the salt flats 3.4 miles east of Ranch to Market Road 1576 on U.S. 62/180 in Hudspeth County. A marker erected in San Elizario in 1984 also summarizes the war. Old El Paso County Jail Museum, 1551 Main Street, San Elizario. Built in 1850, the jail saw use during the two different periods that San Elizario was county seat. When the Salt War shootout happened, Ysleta was the county seat, but the old adobe and steel lockup stands not far from where the rangers died. The jail was restored and opened as a museum in 2013. Also in San Elizario is the Los Portales Museum and Visitors Center, 1521 San Elizario Road.

FOUR MEN DEAD IN FIVE SECONDS

Former ranger Gus Krempkau's questionable translation of Spanish-language testimony during the inquest following the killing of two young Mexican ranchers by cattle thief Johnny Hale near the Canutillo community led to a particularly sanguinary gun battle.

The April 14, 1881 legal proceedings in recess, an infuriated and still-armed Hale shot and killed Krempkau. Seeing this, city marshal Dallas Stoudenmire, himself a former ranger, drew his six-shooter and fired at Hale. That shot missed Hale, accidentally killing an innocent passerby. Immediately pulling the trigger again, the marshal's next shot took out Hale. When former city marshal George Campbell, a friend of Hale's, drew his pistol, the marshal's fourth and final shot dropped him. An estimated five ticks of the clock had passed, and four men lay dead on El Paso's dusty street.

Before his forced resignation, Stoudenmire had killed six people as city marshal. A running feud fueled by too much booze, and aggravated by a bad temper, ended on September 18, 1882, when he was killed in a gunfight with brothers Doc, James and Frank Manning.

Visit: A historical marker detailing the fight is at the southwest corner of South El Paso and West San Antonio Streets. Stoudenmire's body was shipped to his Texas hometown of Alleyton in Colorado County for burial. Take Alleyton Road one and a half miles south of Interstate 10 to the cemetery where he lies.

A Preacher's Son Gone Very Bad

John Wesley Hardin, a Methodist preacher's son who became the Old West's most prolific gunslinger (and the inspiration for John Wayne's classic 1976 movie *The Shootist*), has been blamed for as many as forty-one killings. He probably didn't shoot that many people, but by most accounts Hardin was not the sort of person someone would want to annoy, especially when he was in his cups.

Out of prison after serving time for former ranger Charles Webb's murder in 1874, Hardin had drifted west to El Paso. He had studied law in stir, but time behind bars had not broken him of boozing, gambling and an ongoing potential for violence.

On August 19, 1895, along with ample sips of whiskey, Hardin took three .45 slugs in El Paso's Acme Saloon. El Paso constable John Selman, no deacon himself, did the honors, though the rangers certainly had their chances over the years. Since Hardin had killed one former ranger and shot at other rangers or tried to, Captain Hughes and his El Paso–based rangers shed no tears. As the old Texas saying had it, some men just need killing.

If Selman enjoyed the notoriety attendant to having been the one who finally got rid of Hardin, he did not have long to do so. Not a year later, on April 6, 1896, U.S. marshal George Scarborough ended Selman's career in gun smoke.

Visit: Hardin died in the Acme Saloon, which stood at 227 East San Antonio Avenue. A historical marker placed in 1966 marks the site. The outlaw is buried in the city's historic Concordia Cemetery at 3700 East Yandell Drive. A century after his death, descendants tried to get Hardin's remains reburied at Nixon in South Texas, but a district court's permanent injunction ended that. For years, Hardin had only a flat granite marker. Today, to prevent vandalism or worse, the grave is protected by a stone and metal-barred enclosure appropriately reminiscent of a jail cell. A historical marker in the cemetery tells the story of Hardin's El Paso days.

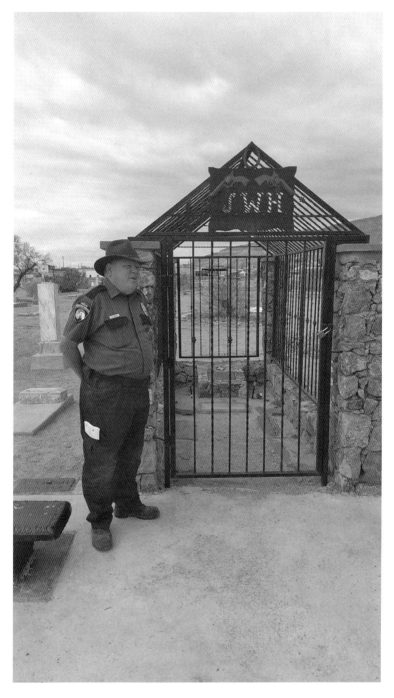

Rangers missed their chance to kill outlaw John Wesley Hardin, who lies in an appropriately jail-like grave in El Paso. *Photo by Mike Cox.*

At least four Rangers eternally stand guard over Hardin at the cemetery: noted Captain Pat Dolan (1843–1930); Ernest St. Leon (1859–1898), who died from a line-of-duty shooting on August 31, 1898, at Socorro; Carl Kirchner (1867–1911); and Robert Jefferson Carr (1830–1902).

Bazz Outlaw Shooting

Standing in a print shop talking with friends on April 6, 1894, Ranger Joe McKidrict heard a pistol shot followed by a police whistle coming from the red-light district. Running to see if he could help, he found an obviously drunk former ranger Bazz Outlaw waving his pistol around behind Miss Tillie's Parlor, one of the city's numerous "sporting houses." Constable John Selman had arrived moments before. Likely thinking to disarm Outlaw and leave it at that, McKidrict asked his former colleague to hand over his weapon. Instead, Outlaw shot him in the head and again in the back as he went down. The former ranger also got off a round at Selman, barely missing his head. His vision blurred by the muzzle blast and gun smoke, the constable fired toward Outlaw, hitting him just above the heart. Running on booze and adrenaline, Outlaw fired two more rounds, hitting Selman's leg and thigh. A good ranger gone bad, Outlaw died later that day.

Visit: Miss Tillie's Parlor stood at 307 South Mesa, then Utah Street. Outlaw died at the Barnum Show Saloon, 300 East Overland. Outlaw's grave is in El Paso's Evergreen Cemetery, 4301 Alameda Avenue. McKidrict (1871–1894) is buried in Austin's Oakwood Cemetery. His real name was Joe Colly. The young ranger reportedly adopted the alias to hide from his mother. The reason is lost to history, but maybe she had worried that being a ranger was too dangerous a line of work.

How Fusselman Canyon Got Its Name

In El Paso for court, on the morning of April 17, 1890, ranger sergeant Charles Fusselman dropped by the sheriff's office. The ranger found a deputy talking with city policeman and former ranger George Herold—the man generally credited with having killed outlaw Sam Bass—and Fusselman joined the conversation.

Not long after, a local rancher rushed in to report that parties unknown had butchered one of his calves and driven off with a good number of his horses. With the sheriff busy in court, the deputy couldn't leave. Fusselman said he'd go after the thieves, and Herold volunteered to join him.

With Fusselman in the lead, the small posse easily picked up the rustler's trail, which led farther into the Franklin Mountains from the scene of the crime. That afternoon, about ten miles north of town, Fusselman rode up on a hastily vacated camp, food (including meat from the rancher's calf), utensils and other gear scattered around.

As the ranger studied the scene, a rifle bullet from the rocky ridge above zinged past his head. Fusselman yelled a warning to the others, pulled his revolver and started firing. An instant later, a second shot hit him in the temple. Then another round caught the ranger under his chin, but by then it didn't make any difference. Realizing that the outlaws had the high ground and good cover, Herold and the rancher wheeled their horses and rode hell-for-leather back to El Paso for help.

A larger posse rushed to the canyon and recovered Fusselman's body and most of the stolen horses, which the killers had abandoned, but did not find the outlaws. Ten years later, after rangers finally caught up with him, triggerman Geronimo Parra hanged for the murder.

Visit: A 2002 historical marker telling the story of Fusselman Canyon stands off Woodrow Bean Transmountain Road (State Highway 375), two and a half miles west of U.S. 54. Fusselman was first laid to rest in Concordia Cemetery but soon was exhumed for reburial in Live Oak County's Logarto Cemetery.

CAPTAIN FRANK JONES (1856–1893)

In 1937, forty-four years after Mexican outlaws had cut him down, four old former rangers gathered for the dedication of a gray granite historical marker commemorating Captain Frank Jones. Each had known Jones well, and two of them had been there when he died. Afterward, they obligingly posed around the stone for a photographer. What they were thinking can only be imagined. Why did a well-respected ranger have to die in the prime of life? Could they somehow have prevented it? How come they survived?

On June 29, 1893, the thirty-six-year-old captain and four rangers, accompanied by an El Paso County deputy sheriff, rode out of Ysleta headed

for an area about thirty miles downriver known as Pirate's Island. Back in the 1850s, the Rio Grande had changed course, leaving an international no-man's land. The rangers carried arrest warrants for Jesus and Serverino Olguin, well-known cattle thieves. They also hoped to recapture brother Antonio Olguin, who had escaped from prison.

Finding only the Olguins' blind father at the family residence, the rangers pulled back and made camp for the night. The next morning, the state officers saw two suspicious looking riders who galloped off when the rangers approached. The rangers started on their trail, riding straight into an ambush. When the intense firefight ended, the captain lay dead. Substantially outnumbered, the rangers withdrew, leaving Jones's body behind.

Later, authorities discovered the incident had actually happened in Mexico, which complicated the return of Jones's body and personal effects. (The captain's pistol and handcuffs were never found.)

Fact or folklore, no one will ever know, but several writers have noted over the years that Captain John R. Hughes—Jones's friend and successor—kept a

Old lawmen gathered for the 1937 dedication of a state historical marker at Ysleta commemorating Captain Frank Jones, whom they all knew and worked with. *From left*: Ed Aten, Ira Aten and Ed Bryant. Kneeling is John R. Hughes, who succeeded Jones. *Photo by L.A. Wilke.*

list of twenty-one Mexican citizens and that, in time, he drew a line through eighteen of those names.

Visit: The Rio Grande has continued to alter the area's geography over the years, so the exact spot of the fight is no longer known. A historical marker stands at 8461 Alameda Avenue in Ysleta. Jones's grave there has been lost, his remains believed to have been swept away at some point when the Rio Grande changed course. The house in Ysleta where Jones lived, and Captain George W. Baylor before him, for years served as the Ranger headquarters for the El Paso area and much of West Texas. The structure continued in use as a private residence until it became the regional Texas Indian Commission office in the 1960s. In 1974, the U.S. Postal Service had the historic structure razed to make room for the Ysleta Post Office at 880 North Zaragosa Road.

RANGER FOILS A PRESIDENTIAL ASSASSINATION

As President William H. Taft and Mexican president Porfirio Diaz arrived for a historic meeting at the chamber of commerce building on October 16, 1908, a ranger and a private security operative possibly prevented an assassination.

Standing only a few feet from the president, Ranger C.M. Moore spotted a suspicious character in the crowd. He and the security man braced the man, and Moore found that he clutched a small pistol. The ranger arrested the man, but since he had made no move to point the weapon at the president or anyone else, once Taft had safely left town, he was released.

In 1969, the two-story brick building fell to the wrecking ball. One of many buildings designed by famed El Paso architect Henry C. Trost, the 1908 structure was the first in the Southwest built specifically for a chamber of commerce.

Visit: The building stood at 310–312 San Francisco Street. El Paso Museum of History, 510 North Santa Fe.

WEST TEXAS

EASTLAND COUNTY
Cisco
SANTA CLAUS BANK ROBBERY

On December 23, 1927, four gunmen—including one dressed as Santa Claus—robbed the First National Bank of Cisco. Collecting $12,400, they escaped using two little girls for human shields as the town's police chief and another officer exchanged gunfire with them.

Ranger captain Tom Hickman was sitting in Austin waiting for a train to Fort Worth when someone notified him of the robbery. Reaching Cowtown, Hickman learned that the Cisco police chief, an old friend, had been killed and one of his officers mortally wounded. One of the robbers, Louis Davis, also lay dying. The other three gunmen, including a not-so-jolly Saint Nick, remained at large.

Davis had been driven to the Fort Worth jail in a hearse. Hickman tried to get him to name his accomplices and tell where they might be hiding, but he would not talk.

Arriving in Cisco early on Christmas Eve, Hickman took charge, directing one of the largest manhunts the state had ever seen. His sergeant, Manuel T. "Lone Wolf" Gonzaullas, went up in an airplane as a spotter, participating in the first aerial search for criminals in Texas history.

When lawmen jumped the three suspects near the Brazos River several days later, Ranger Cy Bradford wounded one, Marshall Ratliff, in a wild shootout. Bandits Robert Hill and Henry Helms got away but were captured a few days later in Graham.

Hill got ninety-nine years for armed robbery, and Helms eventually died in the electric chair. Ratliff, the man who had played Santa Claus with a pistol, also drew a death sentence. But after Ratliff mortally wounded a jailer in an escape attempt, the people of Eastland County had had enough. The next day, November 19, 1929, a mob removed Ratliff from the county jail in Eastland and lynched him from a telephone pole.

Visit: Marked by a historical plaque, the old First National Bank, now vacant, is at 708 Conrad Hilton Boulevard. The old Eastland County Jail still stands at 210 West White Street in Eastland. Eastland Museum, 114 South Seaman Street; Old Jail Museum, 210 West White Street, Eastland. The rope used to hang Santa is displayed there.

JEFF DAVIS COUNTY
Fort Davis
GEORGE R. BINGHAM (CIRCA 1845-1880)

It may have been the day before Independence Day, but that meant little to ranger sergeant Edward A. Sieker, his civilian guide and five other rangers as they rode into the rugged Chinati Mountains looking for the hideout of Jesse Evans and his gang.

A convicted killer and hide-burner (as cattle thieves often were called), Evans had been released from prison in New Mexico in March 1879. Shortly after that, he and John Selman and several cronies drifted to the Fort Davis area and began helping themselves to other people's livestock.

After searching for three weeks, Sieker's men finally got a tip that led them to Evans's camp. As the rangers approached, the outlaws started shooting. In the running gunfight that followed, Ranger Bingham caught a bullet. As the wounded ranger tried to get another round in the chamber of his jammed .44-40 Winchester, one of the outlaws—likely Evans—finished him off. Sieker killed one of the outlaws, and the lawmen captured Evans and two others.

Convicted and sent to the state prison in Huntsville, Evans escaped in 1882 and was never seen again.

I should have killed them all.

—Sergeant Edward Sieker

Visit: The exact location of the gunfight is unknown. Ranger Bingham was buried at Fort Davis, but his grave also has been lost. Fort Davis National Historic Site Visitor Center.

Also of interest is the Overland Trail Museum located in the former home of colorful barber and justice of the peace Nick Mersfelder (1858–1939). The pipe-smoking German came to Fort Davis as a ranger in 1881 and never left.

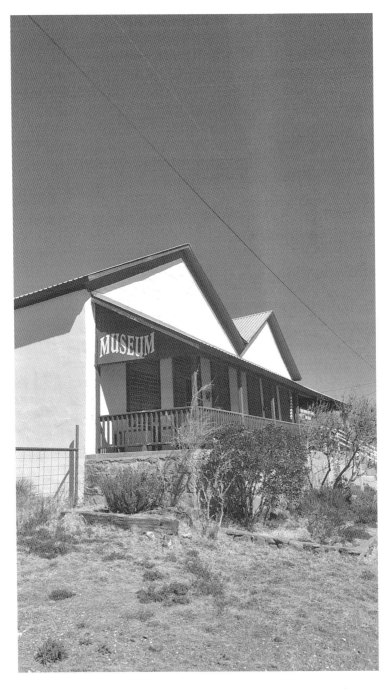

Overland Trail Museum in Fort Davis was the longtime residence of former ranger Nick Mersfelder, later a justice of the peace and barber. *Photo by Mike Cox.*

JONES AND TAYLOR COUNTIES
Abilene
PLEASANT LAVAGA WHITE (1848-1917)

Experiencing firsthand what it's like to be a crime victim is what inspired Pleasant White to join the Rangers. The six-foot, two-inch Virginian came to Texas in 1876 only intending to visit his brother. But not long after that, a slick-talking conman swindled him out of all but eighty-five cents of his money. That left him so strapped for cash that when he enlisted in Company C of the Frontier Battalion that August, White had to borrow money to buy a horse and a saddle. He eventually repaid the loan from his thirty-dollars-a-month Ranger salary.

Following his honorable discharge from the Rangers on July 31, 1879, White ran a livery stable at Buffalo Gap before buying the ranch he operated for the next thirty-four years.

In 1917, the former ranger took a train to Hope, Arkansas, to deliver some horses and mules to a buyer. Somehow, during the offloading of the animals, he suffered a hard blow to his head. Managing to make it back to his hotel, he sat down in the lobby to clear his head. When someone asked if he was all right, White said he was fine and then slumped over dead. The hotel staff, in gathering his personal items, found a Masonic pin among his things and contacted the local lodge. They, in turn, notified White's family, and a lodge member escorted the body back to Taylor County for burial.

Visit: City Cemetery, Masonic section. Frontier Texas!, 625 North First Street. Buffalo Gap Historic Village, 133 North Williams Street, Buffalo Gap.

KIMBLE COUNTY
Junction
FIRST COURT IN KIMBLE COUNTY

In the spring of 1876, district judge W.A. Blackburn, who sat in Burnet County but whose judicial district included newly organized Kimble County, presided over the first court session in what was then called Kimbleville. Court convened in the shade of a large live oak that still stands north of present Junction. A freshly cut log served as the judge's bench, with the gentlemen of the jury seated on

two other logs. Apparently having forgotten his gavel, the traveling jurist used a gnarled piece of oak to call court to order. The defendants—chained to nearby trees—were mostly suspected horse and cattle thieves rounded up by rangers who stood guard nearby. A historical marker describing the county's pioneer outdoor "courthouse" was erected in 1967.

Visit: North of Junction 1.5 miles on US 377/83. On private property, the live oak still stands.

CREED TAYLOR DIDN'T MIND TAKING CHANCES

When Creed Taylor (1820–1906) built a two-story, native stone ranch house here around 1869–71—for a long time considered one of the finest structures anywhere west of San Antonio—he had settled deep in Indian country well beyond the frontier. But placing himself at risk never seemed to bother Taylor. He had fought in the Texas Revolution, first in the 1835 Battle of Gonzales and then in the Battle of Concepción, followed by the Siege of Bexar. After Texas became a republic, he joined the Rangers, fighting in the Battle of Plum Creek. In 1841, he served under Captain Jack Hays in the Battle of Salado and later in the Mexican War.

When the original house burned in 1926, twenty years after Taylor's death, rancher Dillard Stapp rebuilt it. But thirty years later, it, too, was destroyed by fire.

Visit: Nineteen miles east of Junction on Farm to Market Road 479 to private road just west of the James River, about a half-mile off the roadway on private property. Taylor is buried in the cemetery off Farm to Market Road 479, a mile past the Noxville School. Kimble County Historical Museum, 101 North Fourth Street, Junction.

MENARD COUNTY

OLD JAIL

After Menard County's organization in 1871, a two-story limestone structure built by Patrick H. Mires served as a combination jail, courthouse and retail

establishment. A general store occupied the front part of the first floor, with the lockup in the back. Upstairs, accessible only by an outside stairway, was a courtroom. Rangers and other lawmen had to escort prisoners up the stairs to the courtroom, where a trapdoor and ladder served as the only entrance to the jail below. Prisoners reluctant to climb down sometimes descended headfirst into the one-room hoosegow.

A larger, freestanding jail constructed in 1886 served until 1931. It was razed, but the first jail, later home to Emil Toepperwein's Harness and Saddle Shop, still stands.

Visit: 101 East San Saba Street, Menard. Private town house.

THE SHOW DIDN'T GO ON

Out looking for a stray beef to feed their company, Rangers Scott Cooley and Wiliam B. Traweek quickly lost their appetites when they ran into a party of Comanches. The two rangers exchanged shots with the Indians before galloping back to camp for help. Led by newly commissioned Lieutenant Daniel Webster Roberts, the rangers caught up with the Indians about fifteen miles south of Menard and, in a running fight, chased them into present Kimble County. The rangers killed five warriors, including their headman, and captured one.

The November 21, 1874 fight would be just another brush with Comanches in Ranger annals had it not been for the prisoner, Little Bull. The rangers took him to Austin and booked him in the Travis County Jail. Then, Cooley, on his own, arranged with the owner of an opera house to put the Indian on public display—for a fee. The show went on, but only until the ranger commander found out about it and ordered the overly entrepreneurial ranger to cancel the event. Little Bull later died of disease at the state prison.

SCABTOWN SHOOTOUT

It bore an inelegant name, but Scabtown was not an inappropriate way to refer to the collection of saloons, gambling dens and bawdyhouses across the San Saba River from Fort McKavett.

On New Year's Eve, 1877, five rangers under Lieutenant N.O. Reynolds made camp near the post. If the rangers did anything special to celebrate the

coming of a new year, they did so in camp. But the squad's African American cook and teamster walked over to Miller's Dance Hall in Scabtown to kick up their heels.

They found the dance hall crowded with drunk ex–Buffalo Soldiers and other African Americans, some of them not having much use for those of their race who worked for white Texas Rangers. Owner Charles Miller, with help from some of his customers, disarmed the two state men, roughed them up and tossed them out.

When the pair sheepishly returned to camp to report what had happened, Reynolds and his men went to the dance hall to retrieve the state-issued firearms. As Mrs. Ida Miller cooperatively handed one of the handguns to the rangers, one of the inebriated celebrants grabbed it and snapped off a shot at Ranger Tim McCarty. The round missed, but when the ranger shot back, as was later reported, shooting "became general on both sides."

Ranger McCarty fell with a bullet in his chest, and soon Miller, his young daughter and two customers lay dead. The ranger died the next day. The Menard County sheriff investigated the incident, and a coroner's jury soon ruled that the four African Americans "came to their death while resisting officers in the discharge of their duties."

The army abandoned Fort McKavett in 1883, and Scabtown's denizens left for greener pastures.

Visit: Fort McKavett State Historic Site, 7066 Farm to Market Road 864. Take U.S. 190 west from Menard seventeen miles and then head south on Farm to Market 864 for six miles. Ranger McCarty's grave has been lost.

Frontier "Photo Op"

Rangers under Captain Dan Roberts maintained a camp in Menard County in 1878, and other rangers returned periodically over the years. While no trace of their tent and brush arbor camp survives, a series of six photos taken at the camp by pioneer San Angelo photographer McArthur Cullen Ragsdale gives modern viewers insight into what life in the field was like for frontier state lawmen. The photographs were first published in Mrs. Lou Robert's 1928 book, *A Woman's Reminisces of Six Years in Camp with the Texas Rangers*.

Visit: Local historians believe the rangers camped at various times at six or seven different sites in the county. One, known as Ranger Springs, is six miles

west of Menard on private property. Another camp, likely the one used by Captain Roberts's men, lay two to three miles east of town on the San Saba River. None of the sites have been marked.

MITCHELL COUNTY

Colorado City

ATTACK ON COMANCHERIA

In the deepest Ranger penetration of Comancheria during the Republic of Texas period, on October 24, 1840, John Henry Moore led 90 men, mostly from his home county of Fayette, and 17 friendly Lipan Apaches to a Comanche village on the eastern bank of the upper Colorado River in present Mitchell County. This was more than 250 miles from Austin, where the expedition began. The rangers killed an estimated 140 Indians and captured 34, mostly women and children. In the process, they recovered five hundred stolen horses and other property. Two rangers suffered wounds in the fight, but no men were killed in the one-sided engagement.

Visit: A 1936 historical marker in Ruddick Park at Houston and Sixth Streets in Colorado City notes that the fight occurred "in this vicinity." The exact location is unknown.

GUNFIGHT AT THE NIP AND TUCK

When the Texas and Pacific Railroad progressed across the upper Colorado River, a town called Colorado City sprang up, and Company B rangers established a camp at Hackberry Springs. The nearest rail connection for much of West Texas and the largest city between Fort Worth and El Paso, within two years, Colorado City had five thousand inhabitants. Using a dugout for an office, rangers collected pistols from visitors and held their "artillery" until they left town.

One of those rangers was Dick Ware, but with the organization of Mitchell County, he quit and successfully ran for sheriff. He defeated W.P. Patterson,

a rancher with an interest in Colorado City's newspaper. Described as a man of "fine intellect, great will power and good literary talent," Patterson's great willpower did occasionally weaken when it came to whiskey.

On the night of May 17, 1882, rangers heard gunfire at the Nip and Tuck Saloon. Rushing to the scene, three rangers saw Patterson, noticeably drunk, and suspected him as the shooter. Asked to hand over his pistol for inspection, he resisted and fired at one of the rangers. The shot missed, but Patterson got no second chance. Ranger Jeff Milton dropped him dead with one bullet. Adrenaline surging, another ranger put a second bullet in Patterson after he fell.

Saddle used by Ranger Jeff Milton, whose ashes were scattered on a western movie set outside Tucson. *Photo courtesy Russell Cushman.*

Patterson had many friends, and Milton ended up having to level his Winchester at bystanders to hold back a potential lynch mob. The rangers surrendered themselves to Sheriff Ware, their former colleague. All later got indicted for murder, but when the case came to trial in Abilene in November 1883, a jury acquitted them. By that time, after three years' service, Milton had left the Rangers.

Visit: The Nip and Tuck Saloon stood at First and Elm Streets. When former ranger Milton died in Arizona in 1947, in accordance with his wishes, they scattered his ashes on the Old Town movie set at Tucson.

R.C. "DICK" WARE (1851–1902)

Dick Ware, born in Georgia, joined the Rangers in 1878. That summer, he took part in the famous gunfight with outlaw Sam Bass and two of his fellow

felons in Round Rock. Ware did not kill Bass, as some have written, but he did kill gangmember Seaborn Barnes.

Leaving the force to run for Mitchell County sheriff, Ware served until 1892. After that, he got appointed U.S. marshal for the western district of Texas, a job he held from 1893 to 1897.

Following his law enforcement career, Ware focused on ranching and business. Never married, he died in Fort Worth but was taken back to Colorado City for burial. A 1967 historical marker stands near his grave.

Visit: Colorado City Cemetery, Chestnut Street. Heart of West Texas Museum, 340 East Third Street.

MIDLAND COUNTY
Midland
WILLIAM B. ANGLIN (CIRCA 1850–1879)

The Comanches had been relegated to a reservation in Oklahoma, but trouble broke out again in the summer of 1879 when the federal government granted Chief Black Hawk permission to hunt buffalo in Texas.

Armed with rifles and ammunition graciously furnished by the United States, the chief and twenty-five warriors reverted to his people's old ways and instead began hunting something more precious to them than bison—Texas horseflesh.

A troop of cavalry from Fort Concho began searching for the renegades, but it was a squad from ranger captain June Peak's Company A that found the Indians in present Martin County. Clashing near a reed-lined playa lake that gave the Indians excellent cover, Ranger William Anglin got his horse shot out from under him. Disentangling himself, he managed one pistol shot before another rifle volley killed him. Outnumbered and having already lost one man and two horses, the rangers rode for reinforcements. When cavalry troopers and two rangers returned several days later, they found Anglin's body, wrapped it in a saddle blanket and buried him where he had fallen. Pony tracks led away from the lake in the direction of Oklahoma.

Anglin, the young Virginian who had served his adopted state for three years, proved to be the last ranger killed by Indians in Texas. The deadly

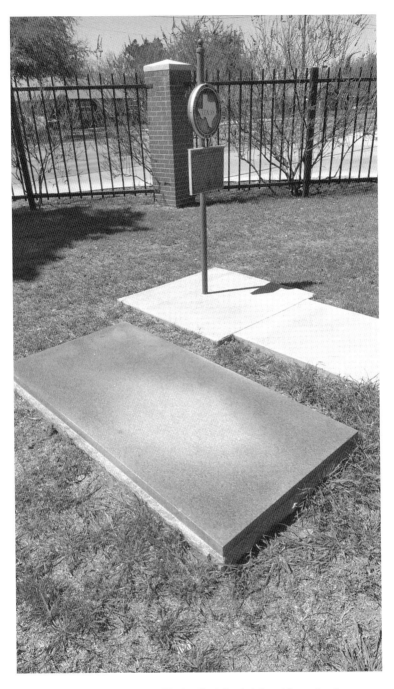

No one knows where Ranger W.B. Anglin is buried, but this marker in Midland's Fairview Cemetery commemorates his death in a fight with Comanches. *Photo by Mike Cox.*

skirmish marked the final fight between the Rangers and their foe of more than half a century.

Visit: A 1967 historical marker just inside the entrance of Midland's Fairview Cemetery, Noble and North Pecos Streets, commemorates the incident. But Anglin's unmarked grave has never been located. The battle is believed to have occurred on the Mabee Ranch in present Martin County, just north of Midland.

Haley Memorial Library and Research Center, 1805 West Indiana Avenue. Houses voluminous library and research papers of noted Texas historian J. Evetts Haley, including transcripts or audio files of his interviews with old-time rangers and material related to ranger Jeff Milton.

NOLAN COUNTY
Sweetwater
A BULLET FOR RANGER WARREN

Coke County rancher Thomas L. Odom, tired of fence cutters wreaking havoc on his ninety-thousand-acre spread, retained a private detective from Louisiana to ferret out the "nippers," as they were called. The bayou country operative in turn hired forty-two-year-old Ben C. Warren to infiltrate the cutters. Warren did his job well, developing information that led to numerous arrest warrants.

When Captain George W. Baylor rounded up the defendants, it displeased them to see that the man they had taken into their confidence now rode as a ranger private.

Ranger Warren, in Sweetwater to testify in the fence-cutting cases, sat talking with Odom near a wood stove in the lobby of the Central Hotel on the night of February 10, 1885, when someone fired a shot through the window. The bullet grazed Odom but hit the ranger full in the face. The state had just lost its star witness.

Nolan County deputies arrested two of the indicted fence cutters for the murder, but neither was ever convicted.

Visit: Long since razed, the frame Central Hotel was built as Sweetwater boomed following the arrival of the railroad in 1881. The old Nolan County

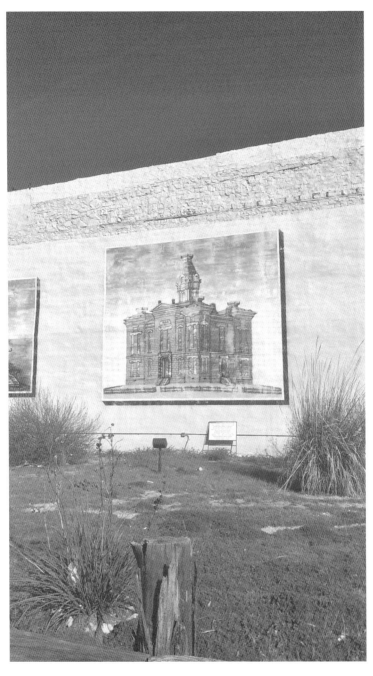

A mural in Sweetwater depicting the old Nolan County Courthouse, where Ranger Ben Warren would have testified if he hadn't been permanently impeached as a state's witness by a bullet. *Photo by Mike Cox.*

Courthouse were the fence cutter trial was held survives only on a mural in downtown Sweetwater. Ranger Warren was buried at the Fort Chadbourne Cemetery near Odom's ranch in present Coke County.

PECOS COUNTY
Fort Stockton
WHO SHOT THE SHERIFF?

Sheriff A.J. Royal was not popular, either among his constituents or the rangers who dealt with him. When he sought reelection in 1894, feelings ran so strong that five rangers came to town to assure honest, violence-free voting. The balloting proceeded without problems, but on November 21, 1894, two weeks after the incumbent lost the election and with three rangers still in town, someone shotgunned the lame duck sheriff as he sat at his courthouse desk. Officers never figured out who did it.

Folklore has it a group of civic leaders drew straws to determine who would kill the former sheriff. Some even speculated the Killer Angel wore a ranger's badge.

> [A.J. Royal was] *a very overbearing and dangerous man when under the influence of liquor…Almost the entire County seems to be against the sheriff.*
> —Sergeant Carl Kirchner to Adjutant General W.H. Mabry,
> *August 10, 1894*

Visit: The killing occurred inside the sheriff's office in the Pecos County courthouse, 400 South Nelson Street, Fort Stockton. Built in 1883, the three-story building, extensively remodeled in later years, remains in use.

GEORGE A. "BUD" FRAZER WAS A SLOW LEARNER

One of the wilder two-man feuds (as opposed to families and political factions pitted against one another) in Texas history unfolded in Reeves and Pecos Counties in the late 1890s.

The two adversaries were former ranger George Alexander Frazer, who at sixteen had served under Captain George W. Baylor at Ysleta and Jim

"Deacon" Miller, a devout Methodist who neither smoked nor drank but who apparently believed he possessed divine exemption from the sixth commandment, the one about not killing people.

A Fort Stockton native, Frazer served two terms as Reeves County sheriff from 1890 to 1894. During that time, Miller worked for him as a deputy. But rather than bonding in a mutual dedication to law and order, for a variety of reasons, they came to loathe each other. On April 12, 1894, six months after getting voted out of office, Frazer confronted Miller in Pecos. Correctly calling him out as a cow thief and murderer, Frazer shot Miller in the arm and then put a well-grouped pattern in Miller's chest. When his enemy went down, Frazer assumed him dead and walked off. Unknown to Frazer, Deacon wore metal body armor under his shirt. The .45 slugs had bruised him badly, but he healed.

Encountering Miller a second time eight months later, Frazer shot him in the arm and leg and put a couple rounds about where his heart should have been beating its last. Apparently, no one had bothered to tell Frazer that Miller wore body armor. Frazer fled.

On September 13, 1896, Miller found Frazer in a Toyah saloon and settled the score with his favorite weapon, a double-barreled shotgun. Miller may or may not have been wearing his bulletproof vest, but his former boss had no such protection.

A jury acquitted Miller, but in consideration of his numerous other killings (a dozen at least), a lynch mob permanently adjudicated his case in Ada, Oklahoma, in 1909.

Visit: Frazer is buried in East Hill Cemetery, one mile south of Fort Stockton. Take U.S. 285 to Parkview and then a half mile east.

Dudley Barker (1874–1952)

Dudley Barker never walked down a sidewalk, only in the middle of the street. And he always sat with his back to a wall.

Born near Round Rock, Barker joined the Rangers on July 1, 1896, and served under Captain Bill McDonald. He established his reputation as a tough lawman when rangers came to San Saba to mitigate a violent feud, but after marrying a local girl, he took up ranching—at least for a while.

Turning back to law enforcement, in 1904, Barker became sheriff of Pecos County. In 1912, in a single gunfight in Fort Stockton, he shot and killed five

Mexican Americans. Other justified homicides occurred as well. After losing a bid for a twelfth term in 1926, he and his wife moved to Alpine. In his fifties, he worked as a ranger again from 1928 to 1933 and also as a state game warden. When not wearing a badge, he did everything from tending bar to selling real estate. He lived a long life and died of natural causes, likely because he never let his guard down.

Visit: As sheriff, the former ranger and his family lived in the old Pecos County Jail across from the courthouse. Barker is buried in Alpine's Elm Grove Cemetery. Annie Riggs Museum, 301 South Main Street. Historic Fort Stockton Museum, Barracks Number 1, Old Fort Stockton.

PRESIDIO COUNTY

BRITE RANCH

Former ranger Sam Neill sat enjoying a cup of coffee about 7:30 a.m. that morning on the Lucas Brite Ranch when he happened to look outside and saw roughly forty horsemen with rifles charging toward the ranch house.

Shouting, *"Mueren los gringos!* [death to the Americans!]," the riders started shooting as they drew closer.

It was Christmas morning, 1917.

Neill grabbed his Winchester and returned fire, dropping one of the attackers from his saddle. Hearing the gunfire, Neill's son Van—ranch foreman—ran in with his rifle and joined in defending his house.

The raiders grabbed a young Mexican ranch hand doing the morning milking and ordered him to go tell the Neills to surrender. The muchacho delivered the message, a demand father and son answered with bullets.

Soon, the raiders turned their attention to the adjacent Busy Bee grocery and post office, looting both. About that time, the mail wagon rolled in, and the bandits promptly killed its two Mexican passengers. Driver Mikey Welch they hanged inside the store, cutting his throat to cease his cursing.

While the fire from the Neills seemed to have lessened the raiders' enthusiasm for storming the ranch house, the attackers knew that sooner or later the men inside would run out of ammunition. Fortunately for the Neills, one of several friends they had invited for a holiday dinner showed

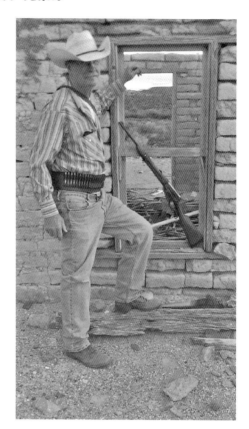

Right: Big Bend rancher Kenny Matthews with a .30-40 rifle popular with rangers in the late nineteenth and early twentieth centuries. *Photo by Mike Cox.*

Below: Rangers used this fortification at the Brite Ranch during the border violence associated with the Mexican Revolution before World War I. *Photo courtesy Marfa Public Library.*

up, saw what was happening and hurried away to call for help. Seeing that, the raiders turned their horses south for Mexico.

It was the tightest place I was ever in.

–Sam Neill

Visit: Still in the same family, the Brite Ranch in western Presidio County remains a working cattle and hunting operation. The old Busy Bee store still stands, with bullet holes from the long-ago raid still visible.

Marfa

JAMES BUCHANAN GILLETT (1856–1937)

Though born in Austin and raised in Lampasas, it was the vast Big Bend country that called to Jim Gillett. Like many rangers, Gillett started out as a cowboy, but the ranger life appealed to him and he joined the Frontier Battalion in 1875.

Gillett did not make a career of the Rangers, but he served longer than most, distinguishing himself first as an Indian fighter and then as a state lawman. He left the force in December 1881 to become assistant city marshal in El Paso. The following summer, city officials appointed him marshal.

In 1885, he returned to cattle ranching, going to work for the Estado Land and Cattle Company before buying his own ranch in 1891. Elected sheriff of Brewster County in 1890 for one two-year term, he continued to ranch. He moved to nearby Jeff Davis County in 1907 and stayed there the rest of his life.

Gillett gave more to the Rangers than his service. In 1921, he wrote and self-published his memoir, *Six Years with the Texas Rangers*, generally regarded as one of the most detailed and readable accounts of nineteenth-century rangering.

A strict teetotaler, Gillett once boasted that "no man will ever kill me drunk." No one ever killed him sober, either. He lived well into the twentieth century, dying of heart failure at Temple's Scott and White Hospital in 1937.

Oh, how I wish I had the power to describe the wonderful country as I saw it then! How happy I am now in my old age that I am a native Texan and saw the grand frontier before it was marred by the hand of man.

–James B. Gillett, Six Years with the Texas Rangers

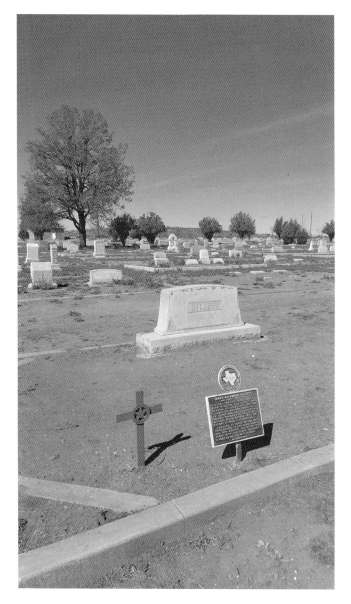

The grave of Ranger-memoirist James B. Gillett, Marfa. *Photo by Mike Cox.*

Visit: Marfa Cemetery, 210 West San Antonio Street (U.S. 90). Marfa and Presidio County Museum, 110 West San Antonio Street. Old Presidio County Jail (1886), 310 Highland Street.

GUNFIGHTS & SITES IN TEXAS RANGER HISTORY

JACK HAYS: TRAIL BLAZER

As a ranger captain, Jack Hays spent most of his time in Central Texas fighting Indians or invading Mexican soldiers. But after the Mexican War, the San Antonio business community commissioned him to map a route from the Alamo City to Chihuahua City, Mexico.

Hays left San Antonio on August 27, 1848, for Enchanted Rock in Gillespie County, where Captain Samuel Highsmith and thirty-seven rangers joined him. They left on September 5, crossing the Devils River (which Hays named) and the Pecos. In the mountainous Big Bend, the trailblazers got lost and at one point went nearly two weeks without food.

Fifty days out of San Antonio, Hays and the rangers reached Presidio, on the Rio Grande. From there, the road to Chihuahua City was better known, so they had essentially accomplished their mission. The men recuperated at the private fort of pioneer Big Bend settler Ben Leaton before returning to San Antonio. The old fort has been restored as Fort Leaton State Historic Site.

Visit: Fort Leaton State Historic Site, 16951 Farm to Market Road 170, Presidio.

Shafter

The Presidio and Cibola Mining Company had three hundred men working its silver mine at Shafter during the last decade of the nineteenth century. With money being made one way, other capitalists—whiskey sellers, gamblers and prostitutes—came to town to make money another way.

Twenty-two-year-old Ranger John R. Gravis and three other local and federal officers constituted the town's ad hoc police force, and they kept busy. Gravis and a Presidio County deputy sheriff had the watch the night of August 4, 1890, when a group of drunk Mexican miners started shooting up the town. As the two officers approached, the pistol-packing drunks opened up on the ranger and his colleague. Gravis fell dead; the deputy went down with an arm wound.

When word reached the Ranger camp at Marfa the next morning, Captain Frank Jones ordered his men to saddle up and made the forty-three-mile ride south to Shafter in less than six hours. The state lawmen rounded up numerous suspects and packed the young ranger's body back to Marfa for shipment by train to his home community of Laredo for burial.

212

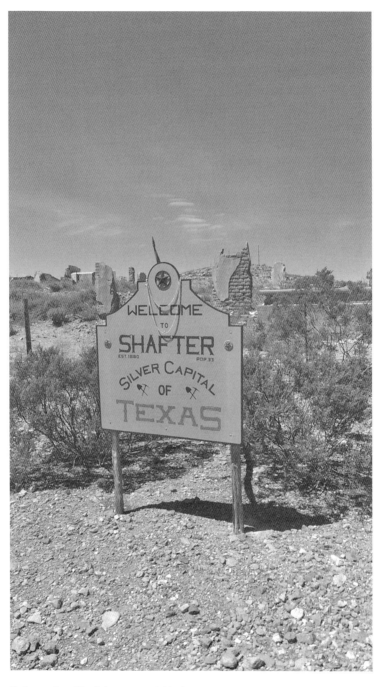

Ruins at the old mining town of Shafter, a once tough town where two rangers died. *Photo by Mike Cox.*

Visit: Production at the mine slowed in the early twentieth century. It closed for good in 1942, and Shafter quickly became a ghost town. While Ranger Gravis lies elsewhere, former ranger and longtime Presidio County lawman Robert Sneed is buried in the Brooks family section of the old Shafter cemetery, just east of town. Like Gravis a half century earlier, Sneed was shot to death in Shafter. A local package store owner was convicted of having killed the lawman on New Year's Day 1940, but the jury saw fit to assess the shooter only a five-year suspended sentence. There's a small museum at the Shafter Cemetery.

Valentine

Even the Mules Got Sick

Former ranger Joe Sitters died hard in a hard country.

The Medina County native joined Frontier Battalion Company D on August 1, 1893, just before he turned thirty and served until October 25, 1896. Later, he worked as a special ranger for the Texas and Southwestern Cattle Raisers Association and after that rode as a U.S. Customs inspector.

Sitters put a lot of men in jail and recovered many head of stolen cattle and horses, but he met his match with a Mexican bandit named Chico Cano, whose gang included his two brothers. The former ranger and other officers tried mightily to catch Cano, but the bandit had friends on both sides of the border and always managed to elude arrest, not to mention a bullet.

Finally, Sitters heard that Cano and his two brothers would be in Texas to attend the wake of a relative who had died. Sitters and several other officers decided to drop by and pay their respects. They got Cano, but the others escaped.

The next day, February 10, 1913, as Sitters and two other officers rode with their prisoner toward the Marfa jail, the rest of Cano's band ambushed them. That left a fellow customs inspector dead and Sitters recovering from a bullet wound to his head. The third lawman also suffered a serious wound. Now it was personal.

Back in the saddle again, figuratively and literally, on May 21, 1915, Sitters, Ranger Eugene Hulen and several other rangers and peace officers rode out of Valentine looking for stolen horses. They correctly figured that Cano would be the one leading the missing remuda toward Mexico.

Three days later, following a trail Sitters should have realized was too easy, they saw horses in a box canyon. Sitters divided the posse, sending most of the men riding up the upper edge of the canyon while he and Hulen entered

the canyon to check the horses. And for the second, and final, time, Sitters rode right into an ambush set by Cano.

Bandits hidden in the rocks above opened fire on the exposed lawmen. Hulen got off only one shot before falling dead. But Sitters, good with a gun and a tough man, lasted about four hours, probably until he ran out of ammunition.

The other lawmen, after trying unsuccessfully to reach their colleagues, rode to a ranch ten miles away to get help. When they returned, they found the mutilated bodies of Sitters and Hulen. Sitters had been shot eleven times, his head smashed with a large rock. The bodies were in such bad shape that the mules carrying them out of the canyon retched.

A Presidio County grand jury indicted Cano for the two murders, but he was never arrested. He died of natural causes on August 28, 1943 at fifty-six. He is buried in Cedillos, Mexico, in a grave now unmarked.

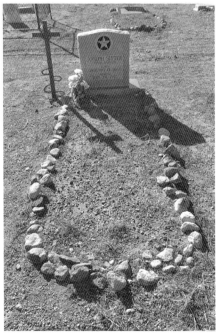

Top: Retired Texas Ranger Joe Davis near where former ranger Joe Sitter and Ranger Eugene Hulen died in an ambush in 1915. *Photo by Mike Cox.*

Right: Valentine, Texas grave of Joe Sitter, a former ranger who died hard in a hard country. *Photo by Mike Cox.*

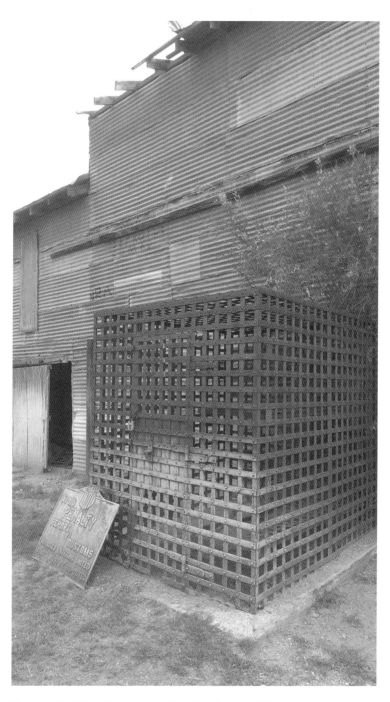

The portable jail at Candelaria in Presidio County held many a ranger's prisoner. *Photo by Mike Cox.*

Visit: The ambush occurred on the present Coal Mine Ranch in Presidio County. The ranch accommodates paid hunters during hunting season but is not open to the public. Sitters is buried in the Valentine Cemetery in Jeff Davis County. Hulen (1876–1915) is buried in Fairview Cemetery, 710 Fair Avenue, Gainesville.

REEVES COUNTY
Toyah
NOT-SO-PEACEFUL PEACE OFFICERS

Sixty-year-old John Morris had already killed two men as a deputy sheriff in Erath County before his election in 1883 as Reeves County's first sheriff.

Sheriffs and Frontier Battalion rangers usually cooperated in the pursuit of law and order, but sometimes county peace officers comported themselves unlawfully and downright disorderly. Morris, for one, drank too much and had an attitude. He didn't much care for ranger captain J.T. Gillespie and his men, stationed at Toyah, and the feeling ran mutual.

On August 18, 1885, Morris took the train from Pecos to Toyah. Alighting drunk from one of the passenger cars, he headed to the Favorite Saloon and proceeded to get drunker. Gillespie sent a sergeant and three rangers to disarm and detain the sheriff until he sobered up, but when the ranger sergeant asked Morris for his gun, the county lawman pulled it and started shooting.

Ranger Thomas P. Nigh fell dead with Morris's second shot (the first missed), and the surviving three state lawmen put five rounds in the sheriff, irrevocably removing him from office.

Visit: Once a bustling division point on the Texas and Pacific Railroad, Toyah today is practically a ghost town. With movie set–like vacant buildings, the town is twenty-two miles southwest of Pecos off Interstate 20. Ranger Nigh reportedly was buried at Toyah, but his grave location is unknown. His only memorial is in cyberspace, where he is listed on the Texas Department of Public Safety's Memorial page at txdps.state.tx.us.

West of the Pecos Museum, 120 East Dot Stafford Street, Pecos. The museum occupies the old Orient Hotel (1904) and the former Number 11 Saloon (1896). Bullet holes from a gunfight in the saloon are still visible. The hotel accommodated many a ranger over the years.

SAN SABA COUNTY

San Saba

"NOTHING LESS THAN A MURDER SOCIETY"

The violence that gripped San Saba County in the 1890s led to more murders than any other of Texas's many bloody feuds. Forty-three homicides have been credited to a wave of vigilantism attributed to what came to be called the San Saba "Mob." One early-day writer called it "nothing less than a murder society."

Four rangers under Sergeant W. John L. Sullivan arrived in San Saba in June 1896 to deal with the trouble. Despite two hung juries, with the help of a fearless prosecutor and a gutsy local newspaper editor, the rangers succeeded in getting the worst member of the lawless crowd prosecuted and sent to prison for life. It took the rangers (others would take part in addition to the original five) and local authorities fourteen months to break up the mob, mostly just by their menacing presence.

The final assertion of Ranger control came when a drunk Mob member with a rifle confronted Ranger Dudley Barker outside the courthouse. Barker pulled his revolver and put five bullets in him. It likely would have been six bullets, but for safety's sake, the ranger always kept the chamber under the hammer empty.

> In the history of the Frontier Battalion since 1874, it has yet to be shown that the Rangers have ever been routed, or withdrawn from their post of duty, and I expect that before very long a different feeling will exist in San Saba and adjoining counties.
> —Adjutant General W.H. Mabry to District Attorney W.C. Linden,
> May 17, 1897

Visit: The courthouse outside of which Ranger Barker killed one Mob member was razed in 1910. A historical marker summarizing the violent period stands outside the "new" 1911 courthouse, East Commerce and South Water Streets. The only surviving building directly connected to the Mob days is the 1884 county jail that held Ranger prisoners at times. The two-story stone lockup continues in use. A 1969 historical marker tells about the structure. San Saba Historical Museum, Mill Pond Park, U.S. 190, half a mile east of courthouse.

WEST TEXAS

TOM GREEN COUNTY
San Angelo
One-Armed Ranger v. the Tenth Cavalry

Like all towns adjacent to frontier military installations, Saint Angela offered Fort Concho's soldiers all the whiskey and women they could pay for.

No matter the town's economic dependence on the post, the citizenry and soldiers had a shaky relationship. In 1881, the garrison served as headquarters of the Tenth Cavalry, a regiment of African American soldiers commanded by white officers. Indians called the black troopers Buffalo Soldiers.

Trouble came in the wee hours of January 31, 1881, when New York–born Tom McCarty, brother of an area sheep rancher, shot and killed Private William Watkins outside one of the town's several saloons. McCarty fled toward the fort, where sentries arrested him. The army kept him overnight in the guardhouse, but in the morning, the sentries turned the prisoner over to Tom Green County sheriff James D. Spears, a former ranger.

This being the second time inside two weeks that an African American soldier had been killed in not-so-saintly Saint Angela, some of the fort's black soldiers began making threats. A handbill circulated that read, in part, "If we do not receive justice and fair play…someone will suffer…It has gone too far, justice or death."

When McCarty's look-alike brother showed up in town, rumor spread that the murder suspect had been released from jail. That night, forty armed troopers charged across the river into town, firing 150 rounds into the Nimitz Hotel and several adjacent businesses. Miraculously, only one person suffered a minor wound. Even so, a mutinous contingent of black soldiers had attacked a Texas town.

An urgent plea went out for rangers. As soon as horseflesh could get them there, twenty-one rangers under Captain Bryan Marsh galloped into town from Colorado City. A hard-drinking ex-rebel, Marsh met with post commander Colonel Benjamin Grierson and threatened to shoot any armed soldiers who tried to cross the Concho into town. When Grierson reminded the ranger that he had more men with guns than Marsh, the captain allowed that he still had enough rangers to shoot anyone who did not follow his orders.

The incident made national headlines, but no further violence occurred. On a change of venue, McCarty later stood trial in Austin for murder, but a jury acquitted him. He later commited suicide in Detroit, Michigan.

Visit: The Nimitz Hotel, at the southeast corner of Concho and Chadbourne Streets, was destroyed by fire in 1893. The killing of Private Watkins occurred outside Charlie Wilson's saloon, located adjacent to the Nimitz. The vacant six-story Town House Hotel (originally the Naylor Hotel) now covers both sites. Fort Concho, abandoned in 1889, is one of the best-preserved former cavalry posts in the West with twenty-three original and restored buildings. Fort Concho National Historic Landmark, 630 South Oaks Street.

VAL VERDE COUNTY
Langtry
JERSEY LILLY SALOON

Judge Roy Bean, the flamboyant so-called Law West of the Pecos, got his title because he served as justice of the peace for the Val Verde County precinct that included Langtry, a rowdy railroad town originally known as Eagle's Nest. With a makeshift office, law library (one book of Texas statutes) and courtroom in his Jersey Lilly Saloon, Bean handled the paperwork when rangers filed criminal charges against those arrested in and around Langtry. The judge famously once fined a dead man for carrying a pistol, the amount due the court being identical to the coin and cash found on the deceased. Seldom sober as a judge, Bean died in 1906.

> *There is the worst collection of roughs, gamblers, robbers and pickpockets…here* [Eagle's Nest] *that I have ever saw, and without the immediate presence of the state* [Rangers] *this class would prove a great detriment towards the completion of the* [rail] *road.*
> —*Ranger report to headquarters, 1882*

Visit: Judge Roy Bean Visitor Center, Langtry. The restored Jersey Lilly stands adjacent to the visitors' center operated by the Texas Department of Transportation. Bean's grave is on the grounds of the Whitehead Memorial Museum, 1308 South Main Street, Del Rio.

WEST TEXAS

FITZIMMONS-MAHER PRIZEFIGHT

Highly hyping the proposed bout, in 1896, a promoter began touting a boxing match in El Paso pitting Robert James Fitzsimmons against heavyweight champion James J. Corbett. Unfortunately for its promoter, prizefighting was illegal in Texas, and the governor sent a trainload of rangers to the City of the Pass to make sure no fists swung there for money. Then Corbett decided to hang up his figurative gloves (fighting was bare knuckle back then) and designated pugilist Peter Maher as his successor. But where to have the fight remained a problem.

Judge Roy Bean, figuring to greatly boost the sale of alcoholic beverages at his Jersey Lilly Saloon, where business had slowed considerably since the heady days of railroad construction that had brought him to Langtry, announced he would host the contest on a sandbar in the Rio Grande. That, technically, would allow the fight to take place in the absence of any state or nation's laws. Just to make sure the match did not occur in the Lone Star State, numerous rangers rode the train carrying the fighters and their fans to Val Verde County.

On February 22, with the rangers enjoying the fisticuffs as well as anyone, the much ballyhooed main event lasted all of ninety-five seconds before Fitzsimmons KO-ed Maher. A 2006 historical marker stands near the site.

Visit: Flooding has long since washed away the sandbar where the international prizefight took place. The historical marker is on Torres Avenue and Texas 25 Loop, Langtry.

NORTH TEXAS

ARCHER COUNTY

STONE HOUSE FIGHT OR BATTLE OF THE KNOBS?

Archer and Wise Counties both claim the same Indian fight, one in which ten rangers died. Only the Alamo with its "Immortal 32" claimed more ranger lives.

While confusion exists about where the fight occurred, the facts are not disputed:

In November 1837, ranger lieutenant A.B. Von Benthuysen led fifteen men in pursuit of a raiding party that had stolen horses. When the rangers encountered the Indians on November 10, one ranger shot without orders and killed an Indian. At that, 150 or so enraged warriors charged the Texans near a geologic formation located either in Archer County (known as the Stone House) or in Wise County (known as the Knobs).

The rangers battled the Indians for ninety minutes, losing four men. Finally, the Indians set fire to the prairie grass hoping to trap the remaining rangers. The lieutenant courageously led his men through the smoke and flames, but in the process, six more rangers died. Left afoot, Von Benthuysen and five other survivors made their escape.

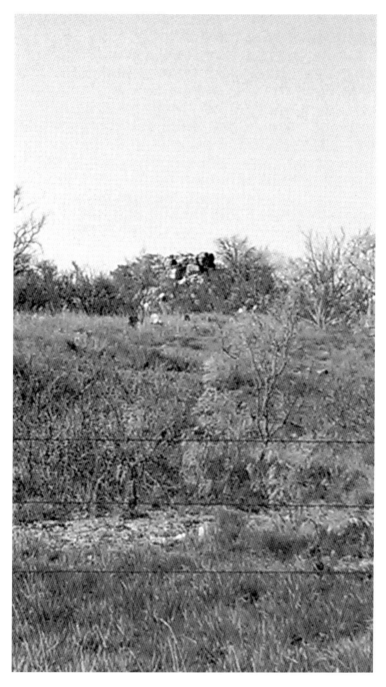

Ten rangers were killed by Indians in a fierce battle believed to have occurred near this geologic formation in Archer County called the Stone House. *Photo by Mike Cox.*

Visit: A historical marker placed in 1970 claiming the fight for Archer County stands ten miles south of Windthorst on State Highway 16. The 1967 marker saying the battle happened in Wise County stands two miles northwest of Decatur on U.S. 287.

ARCHER COUNTY COPPER MINES

Rangers did more than scout for Indians. While trailing Comanches in future Archer County in 1860, ranger captain Sul Ross noticed what looked like copper ore and gathered samples. Analysis proved him correct, and during the Civil War, ore from the area went downstate for use in manufacturing firearm percussion caps. Copper mining continued intermittently in the county through the remainder of the nineteenth century, but no large deposits were ever found, and mining in the area eventually ceased.

Visit: State Highway 25, four and a half miles northwest of Archer City. Archer County Historical Museum, 400 West Pecan Street, Archer City.

ARMSTRONG COUNTY
Goodnight
CHARLES GOODNIGHT, TEXAS RANGER

As a young man, Charles Goodnight rode as a ranger and also served as a scout. But he was much more than that. In fact, some historians credit him with practically inventing the Western cattle industry. While that's a bit broad, he stands as one of Texas's—and the West's—most important historical figures.

Born in Illinois in 1836, Goodnight came to Texas with his family when he was nine. He later rode with a volunteer ranger company in the upper Brazos River valley and at twenty-four worked as a ranger scout. Goodnight put Captain Sul Ross's rangers on the trail that led to the Comanche village on the Pease River where they recaptured Cynthia Ann Parker in 1860. During the Civil War, he signed up with a ranger company operating out of Fort Belknap in Young County.

Goodnight eventually settled in Palo Duro Canyon and soon helped build the famous JA Ranch. Earlier, he had pioneered the trail-driving era in developing the Goodnight-Loving trail with his friend Oliver Loving. Novelist Larry McMurtry used elements of Goodnight's story, particularly his relationship with Loving, in his Pulitzer Prize–winning novel *Lonesome Dove*.

A trailblazer both literally and figuratively, Goodnight did everything from inventing the mobile cowboy kitchen known as the chuckwagon to producing a silent western film using real Indians. He also helped save the American bison from extinction. He died in 1929 at ninety-three.

Visit: Goodnight's 1877 house has been restored, now part of the Charles Goodnight Historical Center and J. Evetts Haley Visitors Center at 4901 County Road 25. Goodnight and wife Mary Ann are buried in the Goodnight Cemetery, still surrounded by prairie. Years ago, some cowboy tied his bandana to the fence around the grave to show his respect, and the tradition has continued. Armstrong County Museum, 120 North Trice Street, Claude. Panhandle Plains Historical Museum, 2503 Fourth Street, Canyon.

COLLIN COUNTY

McKinney

SAM BASS TRAIN ROBBERY SITE

Bandit Sam Bass and gang members Seaborn Barnes, Frank Jackson, "Arkansas" Johnson and Henry Underwood robbed a Texas and Pacific train at McKinney on April 10, 1878. They netted $152 but missed a hidden shipment of $30,000.

Earlier that year, on February 22, at the nearby Allen depot, Bass and his cohorts pulled the first train robbery in Texas history. The gang held up two other trains and a couple stagecoaches—all near Dallas—before heading south to hit a bank in Round Rock. With the rangers on their trail, that proved very bad planning.

Visit: A historical marker placed in 1968 at Heritage Plaza, 200 block of West Main, McKinney, details the McKinney holdup. Allen Heritage Depot Museum, 100 Main Street, Allen. The museum shows a nicely done video documenting Bass's North Texas capers.

COOKE COUNTY
Gainesville
TOM HICKMAN (1886-1962)

Tom Hickman had a big smile, but he frowned on crime. Well, most crime. Like a lot of rangers of his time, he thought state lawmen were better suited for investigating armed robbery and murder than lesser offenses like gambling.

A native of Marysville, a small Cooke County community, Hickman joined the Rangers in 1919. Having risen to captain, in 1926, he and former ranger Stewart Stanley confronted and killed two robbers leaving the Red River National Bank in Clarksville. A year later, the captain coordinated the manhunt for three of the four men who pulled off one of the most famous holdups in Texas history, the Santa Claus bank robbery in Cisco.

Never shy around cameras or in making public appearances, in 1929, the affable lawman agreed to take on a theatrical role in a play produced by the Gainesville Little Theater, *The Bad Man*. Not having to study hard for his role, he portrayed a ranger.

Hickman left the Rangers under a cloud of scandal in 1935, shortly after the creation of the Texas Department of Public Safety. He had been dispatched to Fort Worth to raid a well-known gambling joint, but someone tipped off

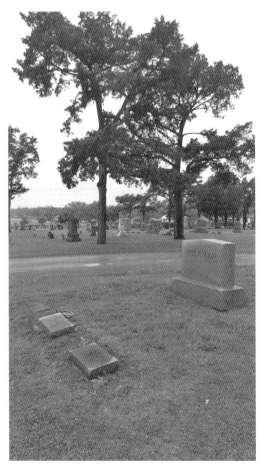

Ranger captain Tom Hickman's grave in Gainesville's Fairview Cemetery. *Photo by Mike Cox.*

the operators. Who dropped the dime was never determined, but Hickman got forced out as head of the Rangers. However, in 1956, Governor Allan Shivers vindicated his name by appointing him to the state's Public Safety Commission, the then three-member policy-setting body for the DPS.

Visit: Hickman is buried in Fairview Cemetery, 710 Fair Avenue. Morton Museum, 210 South Dixon Street, Gainesville.

DALLAS COUNTY
Dallas
JOHN RILEY DUNCAN (1850–1911)

A Dallas police officer before joining the Rangers as an undercover operative, Duncan posed as an itinerant farm hand in Gonzales County and learned that wanted killer John Wesley Hardin had split for Alabama, where he lived under an assumed name. While Ranger John B. Armstrong nabbed Hardin in Florida, the outlaw might have dodged the law even longer, or possibly forever, had it not been for Duncan. In 1990, the National Association for Outlaw and Lawman History (now the Wild West History Association) placed a new marker on Duncan's grave noting that he "Got Wes Hardin." A horseback ranger, Duncan died in a decidedly modern way—an automobile accident.

Visit: Greenwood Cemetery, 3020 Oak Grove Avenue.

STATE FAIR PARK RANGER CABIN

Built at Fair Park as part of the 1936 Texas Centennial, a log replica of a ranger cabin used initially as the headquarters for Company B later became a Department of Public Safety driver's license office. The DPS vacated the building in May 1963, and it was torn down that August.

Visit: Fair Park, 1300 Robert B. Cullum Boulevard.

Old Company B ranger headquarters on the State Fair of Texas grounds in Dallas, since torn down. *Author's collection.*

"One Riot, One Ranger" statue on its way to Dallas's Love Field in 1961. *Photo courtesy Dallas Public Library, History and Archives Division.*

GUNFIGHTS & SITES IN TEXAS RANGER HISTORY

"ONE RIOT, ONE RANGER"

The watchful, twelve-foot-tall bronze ranger statue standing at busy Love Field since 1961 reflects the force's mythology in its simple inscription, "One Riot, One Ranger." The Dallas Historical Commission paid San Antonio sculptress Waldine Tauch $15,683 for the public art piece. Impressive though they are, the four famous words carved beneath the ranger are not based on reality. The apocryphal story is that a worried city mayor (pick a town or occasion) wired the governor for a company of rangers to quell a riot. When the official met the train from Austin, only one lanky state lawman stepped down from a passenger car. "Where are the other rangers?" the startled mayor asked. "You ain't got but one riot, do you?" the ranger supposedly drawled.

Visit: Main terminal, Love Field, 8008 Herb Kelleher Way.

WHERE'S LONE WOLF GONZAULLAS?

One of the state's most-noted ranger captains is missing.

When longtime lawman Manuel T. "Lone Wolf" Gonzaullas died in 1977, a huge crowd of retired and current rangers attended his funeral in Dallas. His remains were cremated and supposedly placed in Big D's sprawling Sparkman-Hillcrest Memorial Park Cemetery, but the cemetery has no record of him.

Born in Spain on July 4, 1891, to a Canadian mother and Spanish father, Gonzaullas lost his parents to the catastrophic 1900 Galveston hurricane. Joining the Rangers in 1920, he served until fired in 1933 by Governor Miriam Ferguson, who wanted her own rangers. Two years later, the newly organized DPS hired Gonzaullas to set up its new crime lab. In 1940, he opted to return to the Rangers. He retired in 1951 as Company B captain.

The best theory on the missing remains is that before the ranger's widow joined him in death on August 15, 1978, she scattered his ashes—somewhere. The couple had no children.

> *In my opinion, Gonzaullas will go down in history as one of the great Rangers of all time.*
>
> *—DPS director Colonel Homer Garrison, 1963*

Captain Manuel "Lone Wolf" Gonzaullas's ashes are missing. *Author's collection.*

Visit: Unknown. The cemetery where he is supposed to be buried is at 7405 W. Northwest Highway.

DONLEY COUNTY
Clarendon
CALVIN ATEN (1868-1939)

What happened on Christmas Day 1889 defined Cal Aten's career as a Frontier Battalion ranger and may have been what caused him to leave the force.

Rangers Aten, John R. Hughes and Bazz Outlaw, along with civilian posse members, tracked two gun-happy outlaws wanted for murder and cattle theft—Will and Alvin Odle—to a cabin near Bull Head Mountain in Edwards County. The brief official report had the pair resisting arrest, but as Aten later wrote to brother (and former ranger) Ira, the killing was nothing but a "plain legal assassination."

Alvin Odle died in Aten's arms.

Whatever impact the killings had on his decision, Aten left the rangers on August 31, 1890. He served for a time as a deputy constable in Round Rock, where he met the woman he would marry. From Central Texas the couple moved to the Panhandle, where he hired on with the Escarbada Division of the XIT Ranch. Later, Aten ranched in Oldham County and then moved to a ranch near Lelia Lake in Donley County. His final law enforcement job came during World War I, when he served as a Loyalty Ranger. He died in 1939.

> *There would have been someone else assassinated if we hadn't got in the first shots.*
>
> —*Cal Aten to Ira Aten, December 12, 1936*

Visit: Citizens Cemetery, one mile south of Clarendon on State Highway 70. Saint's Roost Museum, 610 East Harrington Street.

DENTON COUNTY
Denton
JOHN B. DENTON (1806-1841)

After the shooting stopped and the Indians had fled, Edward Tarrant's order passed from ranger to ranger—gather for roll call. To the elected general's

surprise and relief, every man answered. A dozen or so had been unhorsed, and some stood bareheaded, their hats shot off or otherwise lost, but despite the ferocious fighting, no one had died.

Captain John B. Denton believed the Indians had not gone far and requested permission to take ten men on a scout. What came to be called the Battle of Village Creek had ended, but the day had not. Tarrant gave his assent, warning Denton to be careful.

The captain, a Methodist minister when not rangering, rode out with his men to reconnoiter, soon followed by another ten men and their captain. Riding up Village Creek, the rangers suddenly began taking fire from Indians concealed in the trees along its banks. Denton fell dead from his horse, and two other rangers suffered wounds.

The following day, May 25, 1841, the rangers buried Denton under a tree near a creek about twenty-five miles from the battle site. There he lay for the next fifteen years before some boys discovered an unmarked grave on Olive Creek. Rancher John Chisum recalled hearing about Denton's burial from his father and exhumed the remains. Chisum found someone who had been in the fight, and he identified the remnants of the blanket that Denton had been wrapped in. The rancher put the bones in a box, hoping he could find someone related to Denton so the slain ranger could have a more proper final resting place. Unsuccessful, he reburied the bones on his property. At the turn of the twentieth century, Denton's bones made one more trip—the county Old Settler's Association had him reinterred on the courthouse square.

Visit: The 1896 Denton County Courthouse stands at 110 West Hickory Street. Denton's grave, the only courthouse burial in Texas, lies in an enclosure with a 1901-vintage marker as well as one placed in 1936. Courthouse-on-the-Square Museum, in the courthouse.

ERATH COUNTY

Thurber

CORPORATE PEACEKEEPERS HIT TOWN

The growing labor movement in the late nineteenth century periodically diverted rangers from their more traditional law enforcement duties.

When miners struck the Texas and Pacific Coal Company at Thurber in September 1888, company officials did not seek state help until winter. Captain S.A. McMurry arrived on December 12 and stayed through July 8, 1889. On July 5, 1890, the T&P again requested rangers, and McMurry returned on July 10.

In June 1894, the third time the company asked for rangers, they got Captain Bill McDonald, still recuperating from serious wounds he suffered six months earlier in his shootout with Childress County sheriff John Matthews. The captain met with both labor and management and made it plain he would brook no disorder, and things stayed peaceful.

With the discovery of oil in West Texas, coal mining had played out by 1926, but Thurber continued as a brick-making town until its abandonment in 1937.

Visit: Thurber is seventy miles west of Fort Worth on Interstate 20. Take exit 367. W.K Gordon Center for Industrial History of Texas, 65258 Interstate 20, Mingus.

GRAYSON COUNTY

Sherman

A BAD DAY IN SHERMAN

Rangers did not always succeed in getting their man, quelling a riot or protecting a prisoner.

One of the darker moments in Ranger history took place in Sherman on May 8, 1930. In a case reminiscent of the situation in *To Kill a Mockingbird*, a black man had been arrested for sexually assaulting a white woman in Grayson County.

Fearing a lynching, county officials requested help from the Rangers. When the case came to trial, ranger captain Frank Hamer and some of his men were there. Testimony had just begun when a mob stormed the courthouse. To protect the defendant, the rangers locked him in the county treasurer's vault. But then the townspeople torched the courthouse and the rangers fled for their lives, leaving the prisoner behind. As flames consumed the fifty-four-year-old building, the defendant asphyxiated in the vault.

Not content with having burned down their courthouse and killed the accused rapist, the mob removed his body from the safe, attached a chain

Court House, Sherman, Texas.

A Sherman lynch mob burned down the Grayson County courthouse in 1930 despite the presence of rangers. *Author's collection.*

around its neck and strung it from a nearby tree. For good measure, they started a fire beneath his corpse.

Grayson County has many historical markers, but none address the riot and lynching. A 2001 marker describing the county's various courthouses notes only that the "majestic" 1876 courthouse "served the county until it burned in 1930."

Visit: The present courthouse is at 100 West Houston Street. The historical marker titled "Courthouses of Grayson County" stands at 300 Houston Street.

RED RIVER STANDOFF

In 1931, Oklahoma and Texas had a short-lived armed standoff over a toll bridge spanning the Red River north of Denison. The controversy got settled in court, but when it began, Texas sent a few rangers under Captain Tom Hickman, and Oklahoma dispatched National Guard troops.

Despite all the hardware toted around by both sides, the rangers spent most of their time posing for photographs and target shooting. The incident

got international publicity and supposedly helped embolden Adolf Hitler by supporting his theory that internal strife had weakened the U.S.

The bridge continued in use until 1995. The Texas Department of Transportation donated a segment of the old span to Colbert, Oklahoma, for its city park. A 1998 historical marker explains the unusual incident.

Visit: The marker stands outside the Texas Travel Information Center on U.S. 69/75, 1 mile south of the Red River. Colbert, Oklahoma, is 8 miles northeast of Denison and 3.8 miles east of U.S. 69/77 on Oklahoma 91. The park is at North Timothy and Davidson Streets. Sherman Historical Museum, 301 South Walnut Street, Sherman.

HARDEMAN COUNTY
Quanah
FINDING CYNTHIA ANN

The rangers and cavalrymen rode into a cold north wind, following a trail their guides said would lead to a Comanche village. It was December 19, 1860.

Captain Sul Ross and his rangers hoped to punish warriors who had been killing and stealing in the northwestern counties, but none expected to make history that day. When the armed men topped a rise along the Pease River in present Hardeman County near future Quanah, they saw a small collection of Indian huts and charged. Taken by surprise, the Indians tried to flee, but the rangers and soldiers rode them down and killed several. Someone—accounts vary—had aimed at an Indian wrapped in a buffalo robe when she turned, bared her breasts and held up a baby. "Americano!" she screamed.

Nearly a quarter of a century had passed since that spring morning in 1836 when Indians overwhelmed Fort Parker, killing five settlers and taking one woman and three children captive. All but one of those taken had been accounted for—blonde-haired, blue-eyed Cynthia Ann Parker. Tragic as it had been, the East Texas massacre had virtually been forgotten and plenty of blood spilled since. Even the Parker family, though they had tried hard to find her, had given up hope.

The rangers held their fire and rode closer. It was an Anglo woman, and she had blue eyes.

Left: Quanah Museum visitor and Parker descendant Beverly Waak sights down the barrel of Comanche chief Quanah Parker's rifle. Cynthia Ann Parker was his mother. *Photo by Mike Cox.*

Right: Quanah Parker monument in front of the Hardeman County Courthouse in the town named in honor of the Comanche chief, son of Cynthia Ann Parker.

Returning to Camp Cooper, a military post in what is now Throckmorton County, the rangers turned the woman and her young daughter over to the army. No one knew yet who she was, only that she belonged with her family. But it was too late. Cynthia Ann Parker had just lost the only family and culture that she knew.

Visit: Two historical markers discuss the battle. A 1936 granite marker stands five miles east of Crowell on U.S. 70. The marker notes that the fight occurred four miles to the north. The battle site is on private property. A second marker stands in the Crowell city park.

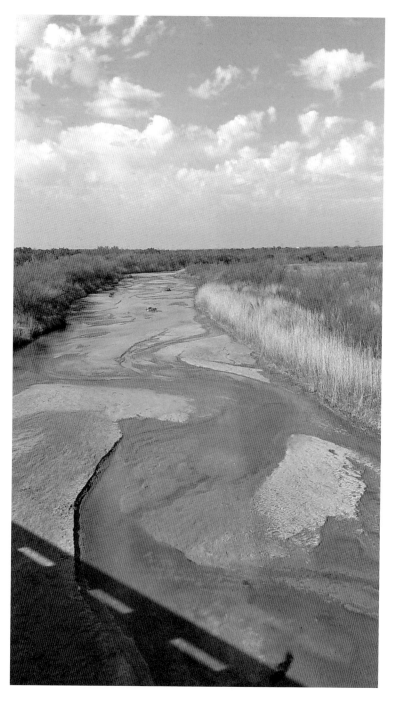

Captain Sul Ross and his rangers rescued Comanche captive Cynthia Ann
Parker along the Pease River in 1860. *Photo by Mike Cox.*

NORTH TEXAS

SHOOTOUT AT THE DEPOT

Captain Bill McDonald relied more on bluster than bullets, but on December 9, 1893, the ranger got into a gunfight in downtown Quanah. His opponent? Childress County sheriff John P. Matthews.

At first, just McDonald and Matthews fired at each other, but two of Matthews's friends soon joined in. When one round tore into the ranger and temporarily paralyzed his right hand, he cocked his six-shooter with his teeth. After the shooting stopped, both officers had life-threatening wounds. Friends took Matthews back to his county, where he lingered until December 30 before dying. The sheriff would have died the day McDonald shot him, but a notebook and two plugs of tobacco stopped two bullets from tearing into his heart. McDonald had a long convalescence but finally recovered. Though tried for murder, a jury acquitted him.

Visit: The shootout started in front of the old First National Bank building in the 100 block of Mercer Street at Third and continued a block to the Fort Worth and Denver Railroad Depot, since razed.

JAMES THOMAS BIRD (1838–1894)

When former Frontier Battalion ranger J.T. Bird died in 1894, his widow assuaged her grief by immersing herself in her love of sculpting. A talented woman who wanted to devote her life to her art but never got a chance, Ella Edgar Bird transformed a large hunk of gypsum into an elegant tombstone for her late husband. When finished chiseling and smoothing, she and a family friend hauled the ornate piece from her home in Paducah and had it placed over Bird's grave. A stone-framed church adorned with a solitary lily and fern wreaths, the monument impressed all who saw it. While Mrs. Bird came to accept that her husband had gone the way of all flesh, over the years, the sculpture she had labored over so arduously slowly melted away, too porous to withstand the elements. Once five feet high, only a few inches of the marker remain.

Visit: Quanah Memorial Park Cemetery, Prairie Street of Farm Road 2640, just north of town.

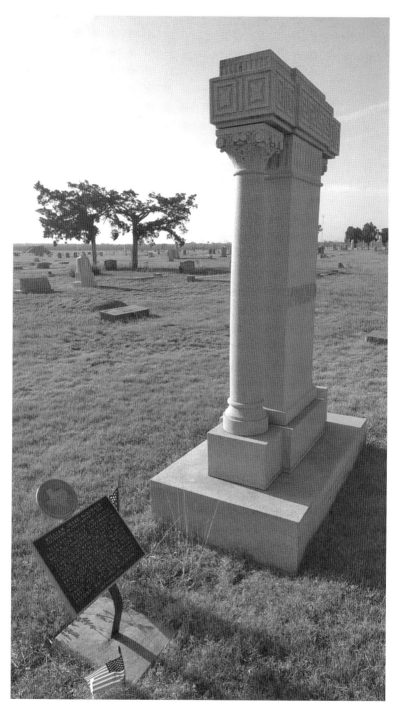

Grave of ranger captain Bill McDonald in Quanah. *Photo courtesy Beverly Waak.*

NORTH TEXAS

CAPTAIN BILL McDONALD'S GRAVE

McDonald left the Rangers in 1907, but he never quit being Captain Bill McDonald. Never opposed to publicity, he clearly enjoyed his reputation and didn't strain himself to correct exaggerations. Flamboyant (and generally effective in his work) as ever, he served as a state treasury agent, a bodyguard for President Woodrow Wilson and finally as a U.S. marshal. The widower married again in late 1914 but died of pneumonia on January 15, 1918. After a well-attended funeral in Fort Worth, he was returned to Quanah for burial.

> *No man in the wrong can stand up against a fellow that's in the right and keep*[s] *on a comin'.*
> —*McDonald's oft-quoted motto, carved in his tombstone*

Visit: Quanah Memorial Park Cemetery. Quanah Museum, 105 Green Street. McDonald sometimes booked prisoners in the 1890-vintage Hardeman County, now a museum, 101 Green Street.

JACK COUNTY

LOST VALLEY FIGHT

Major John B. Jones had been good at fighting Yankees but had much to learn about Indian warfare.

His education began on July 11, 1875, when he and thirty-five rangers found themselves facing more than one hundred well-armed Kiowa warriors bent on revenge.

Earlier that morning, two of Jones's men discovered Indian signs. The rangers took up a trail that led to a rugged expanse in Jack County known as Lost Valley. Unknown to the rangers, in following the Indian's pony tracks, they rode straight into a trap set by Chief Lone Wolf, a savvy headman eager to avenge his son's death at the hands of cavalry troopers the year before.

Suddenly, the warriors swept down on the surprised rangers. Overconfident, Jones rallied his men and ordered a charge. But as the rangers galloped toward the Indians, the Kiowas shot thirteen of their horses out from under them. While seeking cover, Ranger William A. "Billy" Glass collected five bullets and fell dead.

Major John B. Jones and more than thirty rangers came close to a Custer-like massacre at Lost Valley in the summer of 1875. *Photo by Mike Cox.*

Pulling back to a wooded draw, the rangers formed a line and began firing on their attackers. Bravely but foolishly, Jones stood exposed above his men, directing their aim as Indian bullets clipped tree branches just above his head.

As the fight settled into a standoff, each side taking an occasional shot, the summer sun bore down. Thirst overpowering good sense, Ranger Dave Bailey collected everyone's canteen and said he was going to fill them at a nearby water hole. Reluctantly, Jones let Bailey and another ranger go.

That was another mistake on the major's part. Some of the Indians swooped in on the two rangers. One escaped. Bailey did not.

At about four o'clock, Lone Wolf decided he had extracted his pound of flesh and led his warriors away. Jones quickly dispatched a rider to nearby Fort Richardson, and soon, one hundred cavalrymen rode in pursuit of the Indians, but they got away. The rangers lost two men killed, two wounded and nearly half their horses, but it could have been much worse.

> *After killing* [Bailey,] *they scalped him, carving him up like a beef steak and then taking the butt end of their guns and stamping his skull and brains in the ground in sight of the Major and the boys.*
>
> —*Ranger William Callicott*

Visit: A 1970 historical marker stands at a roadside park with a view of Lost Valley twelve miles north of Jacksboro on U.S. 281. Ranger Glass is buried in

a private cemetery on the Mallard Ranch, west of Alvord in Wise County. Take U.S. 287 north of Alvord and turn left on County Road 1590. The cemetery is 0.7 miles west of the intersection of County Road 1590 and County Road 1591. The location of Ranger Bailey's grave has not been determined.

OLDHAM COUNTY

Tascosa

A BULLET SPOILS THE MOOD

Ed King had been a ranger, sort of. He and eight other men under Pat Garrett, the man who killed Billy the Kid, for a time held ranger commissions even though their pay came from the big LS Ranch, not the state treasury. Basically, they rode as hired guns working to prevent cattle rustling.

Regular rangers under Captain G.W. Arrington and the captain himself periodically spent time in the Panhandle town of Tascosa, but with only one small company for the whole top of Texas, they never stayed long.

Garrett left the LS Rangers in 1885, less than a year after their formation, and they were disbanded. King and most of his colleagues stayed in the Panhandle, just plain cowboys except for drinking and carousing excessively. But they were not bulletproof. When King stole another fellow's girl, a bullet in the face (and another in the neck) ended the romance—and him.

While little known today, the March 21, 1886 Tascosa gunfight involving King, some of his pals, a saloon owner and gun-toting cowboys was for a time more famous than Arizona's O.K. Corral shootout. At the conclusion of the "ball," as rangers and cowboys sometimes euphemized gunplay, four men would soon occupy Tascosa's Boot Hill cemetery: King, Jesse Sheets (killed by accident), Frederick Douglas Chilton and Frank Valley. In addition, two participants suffered serious wounds. Three men eventually stood trial for murder, but juries acquitted them.

When the railroad bypassed Tascosa, the once busy community declined and eventually became a ghost town. Amarillo businessman and former pro wrestler Cal Farley purchased the site in 1939 and built it into the nationally known Cal Farley's Boy's Ranch. All that remains

of Tascosa is the stone two-story 1884 Oldham County Courthouse and Boot Hill Cemetery.

Visit: Twenty-two miles north of Vega off U.S. 385 at 134 Dodge City Trail. Old Tascosa Courthouse-Julian Bivins Museum, Boy's Ranch.

PARKER COUNTY
Weatherford
ISAAC PARKER (1793–1883)

Isaac Parker never gave up trying to find his niece Cynthia Ann.

One of elder John Parker's sons, Isaac Parker fought in the Texas Revolution, riding as a ranger under Elisha Clapp. After the war, he became a senator in the Republic of Texas Congress and, following statehood, won election to the state senate. As a member of the legislature, in 1855 he passed the bill creating the county named in his honor.

After rangers recaptured his niece from the Comanches in 1860, Parker took her and her young daughter to his home and did all he could to help her readjust, even sponsoring legislation granting her a pension and land. He moved from Tarrant County to Parker County in 1872 and remained there the rest of his long life. A granite historical marker in his honor was placed in 1936, with a more detailed marker erected in 1986 near his grave.

Visit: From Weatherford, take Farm to Market Road 730 northeast 5 miles, turn south on Ragle Road (at Cedar Fork Church) and continue 1.4 miles to Turner Cemetery, on the east side of the road through a cattle guard. Doss Heritage and Culture Center, 1400 Texas Drive, Weatherford.

SHACKELFORD COUNTY
OLD FORT GRIFFIN

Fort Griffin (garrisoned 1867–81) gave rise to a nearby town of the same name, though it became more notoriously known as "The Flat." Full of

buffalo hunters, gunfighters, gamblers and prostitutes, for a time it was one of the wildest, wooliest places in the Old West. Federal troops lacking civilian law enforcement authority, rangers under Captain George Washington Arrington established a camp there in July 1878. The captain and his men remained about a year before moving farther northwest to bring law and order to the Panhandle.

With the soldiers gone, the buffalo hunted out and the railroad having bypassed the town, the community of Fort Griffin became a ghost town, a collection of crumbling ruins surrounded by large ranches.

> *During this period street duels between the officers and lawless men, especially in the Flat around the fort, was almost a daily occurrence. But the local authorities, aided by Captain Arrington and a company of Texas Rangers, made it a losing game for the vicious characters.*
> —*Edgar Rye,* The Quirt and the Spur *(1909)*

Visit: Fort Griffin State Historic Site, fifteen miles north of Albany at 1701 North U.S. 283.

SOMERVELL COUNTY
Glen Rose
MOONSHINE AND MURDER

Illegal production and sale of alcoholic beverages ranked as Somervell County's top "cash crop" during Prohibition.

But rangers descended on the county on August 25, 1923. By sundown, twenty-seven locals languished in county jail, including the sheriff and county attorney. Twenty-three destroyed stills stood on display outside the courthouse along with stacks of confiscated booze. The cleanup continued most of the week, one bootlegger forever put out of business when he fired on the rangers.

While rangers had definitely disrupted the making and selling of moonshine, adjudication proved more difficult. The state's key witness would be twenty-eight-year-old World War I veteran James Watson, who had collected information as an undercover agent. Of course, for convictions to result, he had to be able to testify. Realizing the

married father of two could be in danger, the rangers stashed him at a boardinghouse for safekeeping.

The former county attorney's trial began on February 20, 1924. That night, someone fired a twelve-gauge shotgun through the window of the boardinghouse where the star witness had been staying and forevermore disqualified his testimony. Rangers quickly rounded up fifteen suspects, including the likely triggerman, but justice proved not only blind, she couldn't hear or talk. Officers charged six men in the undercover lawman's murder, but no witnesses could be found and no convictions would be forthcoming. And as soon as things settled down, moonshining and bootlegging resumed until the so-called Noble Experiment ended.

Visit: Built in 1893 on Bernard Street between Elm and Walnut in Glen Rose, the two-story limestone county courthouse where rangers and the soon-to-be-dead Watson appeared in court for only one day remains in use. The 1884 rock jail where the rangers booked their prisoners was demolished in the early 1930s to make room for a new lockup. Somervell County Museum, Elm and Vernon Streets, Glen Rose.

TARRANT COUNTY
Arlington
MIDDLETON TATE JOHNSON (1810–1866)

Johnson got a county named after himself and is considered the father of Tarrant County, but he proved an embarrassment to his friend, Governor Sam Houston. In 1860, the governor counted on Johnson to deal a heavy blow to the Indians who had been terrorizing northwestern Texas, but his efforts proved futile.

Houston commissioned Johnson to lead a large force of Rangers—a small army compared with usual Ranger numbers—to take on the Indians. Johnson assembled more than seven hundred rangers, but they never found any hostile Indians.

Not that Johnson hadn't proven himself in the past. The fifty-year-old South Carolinian had been in Texas since 1839. He was among the Republic of Texas troops involved in quelling a civil disturbance in Shelby County called the Regular-Moderator War, had ridden with Jack Hays

during the Mexican War and later commanded a ranger company in Tarrant County. But when Houston called on him to bring safety to settlers in Jack, Parker, Palo Pinto and Young Counties, Johnson's force did little more than drill and sit around camp awaiting decisive orders that never came.

Part of the problem was that Johnson had fallen in love with Houston's niece. Rather than devoting his full energy to pursuing Indians, Johnson spent a lot of time away from camp wooing the younger woman, his mind definitely not on rangering.

Houston finally gave up and disbanded the unit. Johnson's courtship led to marriage, but he only got six years with his new wife. He died on May

Middleton Tate Johnson let his love life get in the way of rangering. *Engraving courtesy Tarrant County Junior College.*

15, 1866, in Austin and was buried in the State Cemetery, but three years later, his body was returned to Tarrant County for reburial in his plantation cemetery. A 1936 granite historical marker stands near his final resting place along with another marker placed in 1986.

Visit: Johnson Plantation Cemetery, 1100 block of West Mayfield Street and South Cooper (Farm to Marker Road 157), Arlington.

TOP O' HILL TERRACE

A once flourishing casino midway between Fort Worth and Dallas ended the career of one well-known ranger captain while furthering the reputation of another.

When Beulah Adams Marshall bought land along the Bankhead Highway in the early 1920s, she opened a tearoom popular with socialites. But when Fred and Mary Browning purchased the property in 1926 during Prohibition, they soon offered stronger libations—beer and liquor. They also opened an illegal casino, complete with a secret room for hiding gambling paraphernalia during raids and an escape tunnel for the convenience of staff and prominent Fort Worth–Dallas residents who might find public exposure embarrassing. As if an invisible dome of exclusion from the law covered the place (it was surrounded by a fence with an alarm system and guarded gate), the Top O' Hill also featured a brothel. And only a short distance away, the Arlington Downs racetrack guaranteed a steady customer base.

The Top O' Hill did have its detractors. Particularly outspoken in his condemnation was Dr. J. Frank Norris, pastor of Fort Worth's First Baptist Church, one of the nation's largest congregations. Law enforcement periodically raided the casino, but its operators never seemed taken by surprise. That led to the firing of ranger captain Tom Hickman, who on governor's orders led a raid on the place in 1935 and arrived to find that someone had tipped off the management. Though the DPS never proved it, Hickman was the prime suspect.

In 1947, Captain Manuel T. "Lone Wolf" Gonzaullas and his men had better luck, catching the place in full swing. At the end of the day, what finally put the Top O' Hill at the bottom of the heap was the Baptist church. Dr. Norris used the root of all evil to fight sin, buying the place in 1956 and converting the property into what is now Arlington Baptist College.

> *Top O' Hill Terrace is a blight on Tarrant County. One of these days we are going to own the place!*
>
> *—Reverend J. Frank Norris*

Visit: 3001 West Division Street, Arlington. Tours of the old sin den are available for a small fee. Visit topohillterrace.com.

Fort Worth

Battle of Village Creek

Seeing the line of mounted rangers quietly approaching her people's village, an Indian woman screamed a warning as Edward Tarrant ordered his men to

charge. Galloping toward the creek separating the Texans from the Indians, one of the riders shot the fleeing Indian, not realizing he had killed a female.

In what came to be called the Battle of Village Creek, on May 24, 1841, a force of sixty rangers attacked two large villages made up of Cherokees and several other tribes along Village Creek in what is now Tarrant County. The rangers killed at least twelve Indians, with numerous tribespeople wounded. The Indians killed one ranger, Captain John B. Denton, and two Texans suffered wounds.

The following day, the rangers buried Denton about twenty-five miles from where he had died, but his bones would not permanently rest in peace for sixty years.

> *The Indian yells and firing soon ceased and both parties left the ground. It was not the wish of General Tarrant to take any prisoners. The women and children alone we suffered to escape if they wished, and the men neither asked, gave, nor received any quarter.*
> —*William N. Porter to Secretary of War Branch T. Archer,*
> *June 5, 1841*

Visit: The fight occurred along Village Creek, most of which Lake Arlington later inundated. A 1936 granite historical marker placed near the site was later relocated to the southwest corner of Spur 303 and West Green Oaks Boulevard, Arlington. Just to the west of this marker, at the seventh tee on Lake Arlington Golf Course (1516 Green Oaks), is a marker expanding on the early history of the area.

BIRD'S FORT

Rangers returned to future Tarrant County in the fall of 1841 to build a log blockhouse on the Trinity River, the beginning of what would grow into the western half of the sprawling Dallas–Fort Worth Metroplex.

Major Jonathan Bird and twenty-nine rangers established the fort that October. A few families soon settled about three miles west of the fort, the beginning of Birdville. Following the creation of Tarrant County in 1849, Birdville was the first county seat.

Visit: A historical marker placed in 1936 near the site of the fort was moved in 2003 to River Legacy Park in Arlington, one mile north of the Trinity River.

EDWARD H. TARRANT (1799-1858)

Born in South Carolina, Tarrant spent time in Kentucky, Tennessee and Mississippi before coming to Texas in 1835. Settling in Red River County, he represented that area in the Republic of Texas Congress but resigned in 1837 to campaign against hostile Indians. Elected general in command of a ranger-like unit, he was the ranking officer in the Battle of Village Creek. But two years later, he demonstrated a preference for peace in helping negotiate an Indian treaty at Bird's Fort that cleared the way for settlement between the Red River and the Trinity.

Tarrant lived to see the county he had helped clear of hostile Indians named in his honor in 1849. He later moved to a farm in Ellis County and served in the Texas legislature after statehood. He intended to move to the Fort Belknap area in Young County but had to delay that because of Indian trouble, which led him back to rangering from 1857 to 1858. On a trip from Ellis County to Fort Belknap, Tarrant became ill and died in Parker County on August 2, 1858. Seven months later, his remains were relocated to his property in Ellis County. He was moved a third time on March 3, 1928, this time to Fort Worth.

Visit: Pioneer Rest Cemetery, 620 Samuels Avenue, Fort Worth. A historical marker stands near his grave.

PARKER LOG CABIN

Isaac Parker, whose niece Cynthia Ann had been taken captive by Comanches in their 1836 attack on Fort Parker, built a log cabin at Birdville in the 1850s.

In early January 1861, when word reached Parker that a white woman had been captured in the Pease River fight, he believed she might be his long-lost niece Cynthia Ann. He traveled from Birdville to Camp Cooper, where the Rangers had taken her, and through an interpreter identified her as Cynthia Ann. Parker took the woman and her daughter to his cabin in Birdville, and he and his family cared for her until she moved to Anderson County.

Parker left the Birdville cabin in 1872, settling in Parker County. The cabin stood abandoned until 1929 when it was moved to Shady Oak Farms in Fort Worth. It now is one of several historic structures preserved in Log

Isaac Parker brought his niece to his log cabin in Birdville following her rescue by rangers twenty-four years after Comanches captured her in East Texas. *Author's collection.*

Cabin Village. Still standing at the original site of Parker's cabin are several old trees known as the Parker Oaks.

Visit: The oaks are adjacent to the Parker Cemetery on Cardinal Road, east of Loop 820 in Hurst. Log Cabin Village, 2100 Log Cabin Village Lane, Fort Worth.

JAMES MADISON BROWN (1838-1892)

James Brown served as a ranger from April to November 1875, but his passion for gambling on horses teamed with an otherwise fast lifestyle got him eternally corralled six feet under. He had been a state policeman prior to his time in the Rangers, and was sheriff of Lee County from 1876 to 1884. In that capacity he presided over the hanging of outlaw Bill Longley in 1878. From 1888 to 1892 the former ranger lived in Fort Worth, living the sporting life. Brown's figurative horse came in last on September 6, 1892 at the Garfield Park Race Track in Chicago when a Windy City policeman killed him in a gunfight. The National Association for Outlaw and Lawman History placed a new marker on his grave in 2006.

Visit: Oakwood Cemetery, 701 Grand Avenue.

GUNFIGHTS & SITES IN TEXAS RANGER HISTORY

HELL'S HALF ACRE

When the first locomotive puffed into Cowtown in 1876, the need soon arose for a venue where all the buffalo hunters, cowboys, drummers, freighters, gamblers, outlaws and railroad men descending on the city could let off a little steam of their own. A fourteen-block red-light district with saloons, gambling halls and bordellos grew rapidly.

During its heyday, outlaws like Bat Masterson, Doc Holliday, Wyatt Earp, Longhair Jim Courtright, Luke Short, Butch Cassidy, the Sundance Kid and lesser lights all contributed to the local economy. Rangers were there, too, officially and, boys being boys, unofficially.

Acording to the November 29, 1878 *Fort Worth Democrat*, Hell's Half Acre's denizens included "lewd women of all ages 16 to 40...the most respectable of citizens, the experienced thief...the ordinary murderer, the average cowboy and the ordinary young man about town."

Hell's Half Acre remained a popular Fort Worth destination until the commander of the army's Camp Bowie pressed city officials to shut it down during World War I.

Visit: South end of downtown, along Commerce and Calhoun Streets. The area was cleared in the 1960s to make room for the Tarrant County Convention Center.

U.S. COURTHOUSE

Outlaw Sam Bass is reputed to have spent time and money in the bars and brothels of Hell's Half Acre before a ranger's bullet ended his wild oat sowing. None of those old dives remain, but Bass and the Frontier Battalion still have a Cowtown presence. With federal Depression-era public art money, in 1940, Frank A. Mechau Jr. painted two large Ranger-related works for the fourth-floor courtroom of the U.S. Appeals Court in the 1933-vintage Federal Courthouse. The oils are *The Taking of Sam Bass* and *Texas Rangers in Camp*.

Visit: 501 West Tenth Street. Texas and Southwestern Cattle Raisers Museum, 1005 Congress Avenue, Suite 825.

The Amon Carter Museum, 3501 Camp Bowie Boulevard, has one of the nation's largest collections of Western art, including many works by Frederick Remington and Charles Russell.

WHEELER COUNTY
Mobeetie
LAW COMES TO THE PANHANDLE

Alerted that a party of Pueblo Indians leading a dozen pack animals had been seen riding east across the Panhandle, Captain G.W. Arrington immediately ordered his rangers to mount up.

The lawmen caught up with the Indians near Fort Elliott, a cavalry post adjacent to Mobeetie in present Wheeler County. As Arrington

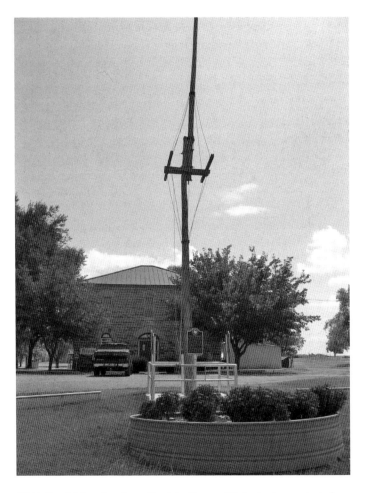

Old jail at Mobeetie, where Captain George W. Arrington protected the Panhandle in the late 1870s. *Photo courtesy Debby Arrington.*

suspected, the New Mexican Indians had been smuggling old rifles intended for trade to the Comanches newly relegated to a reservation in Indian Territory. When the ranking officer at the fort heard what happened, he dispatched a company to take the Indians into federal custody as wards of the government.

Seeing the soldiers riding fast toward him, Arrington had his rangers dismount and rest their Winchesters across their horses—muzzles pointed at the approaching bluecoats. It ended peacefully, but not before harsh words from both sides, followed later by a flurry of official correspondence between Washington and Austin. The ranger buried the contraband weapons and sent the Pueblos back to New Mexico with a warning not to come back. Nothing came of the military's protest.

Arrington's Company C had established Camp Roberts at Blanco Canyon in present Crosby County in the late summer of 1879. Until he left the Rangers in 1882, the captain and his rangers stayed busy in the Panhandle, handling everything from escorting surveying parties to enforcing the law in the area's two settlements—Tascosa and Mobeetie.

Following his state service, Arrington stayed in the Panhandle. He served as Wheeler County sheriff from 1882 to 1890 but also grew wheat and raised cattle on land he purchased in Hemphill County. He died in 1923.

Visit: A historical marker commemorating Arrington stands in front of the former Wheeler County Jail in Old Mobeetie, south of State Highway 152. His grave lies in the Mobeetie Cemetery, two and a half miles south of New Mobeetie on County Road H. The captain's heirs still operate the Arrington Ranch, 9765 County Road 5, Canadian. A two-story frame house Arrington built on the ranch in 1919 still stands, now a bed-and-breakfast.

Mobeetie Old Jail Museum. Arrington officed in the 1886 jail during his last two terms as sheriff. River Valley Pioneer Museum, 118 North Second Street, Canadian. The museum has an exhibit on the Arrington family and ranch.

WICHITA COUNTY

Wichita Falls

TWO BANK ROBBERS GET "SUSPENDED" SENTENCES

Only a historical marker at the entrance of a modern high-rise in downtown Wichita Falls remains as a reminder of what happened there on February

Two bank robbers were lynched near this spot in Wichita Falls after rangers tracked them down and then, as it turned out, left town too soon. *Photo by Mike Cox.*

25, 1896—an incident that proved both the effectiveness and one of the weaknesses of the rangers.

After cowboys Foster Crawford and Elmer "Kid" Lewis robbed the City National Bank and killed a popular teller, Captain Bill McDonald and some of his men tracked down the pair after a local posse had given up. That demonstrated what the rangers generally excelled at. But when the rangers moved on to another task, assuming that the criminal justice process in Wichita County would proceed routinely, the captain soon received word that both suspects had been taken from the county jail and strung up in front of the bank they had robbed. Rangers couldn't be everywhere.

Visit: The marker is at 800 Scott Street. The bank where the robbery occurred stood at the corner of Seventh and Ohio Streets. As the outlaws fled town, someone killed one of their horses. The owner of that horse, which had been stolen, had one of the animal's hooves converted by a taxidermist into a jewelry box for his wife. That unusual item is on display at the Museum of North Texas History, 720 Indiana Avenue.

Burkburnett

Burkburnett became an oil boomtown in 1918-1919, later inspiring the classic 1941 Clark Gable movie *Boomtown*. A legal dispute with Oklahoma over oil drilling rights along the nearby Red River led the governor to send rangers in 1920 to assert state control. The situation remained peaceful, if tense, and was resolved by the U.S. Supreme Court.

Rangers went to Wichita County in 1920 during a dispute with Oklahoma over oil-rich land along the Red River. *Author's collection.*

Visit: A 1966 historical marker off State Highway 267, just west of Interstate 44 in Burkburnett tells the story of the oil boom. Two markers deal with the situation that brought in rangers, one placed in 1977 at the ghost town of Bridgetown on State Highway 240, six miles west of Burkburnett, and one erected in 1981 at the same location discussing Receiver Bridge, a structure built over the river during the time the disputed area was under federal receivership.

SELECTED ADDITIONAL TEXAS RANGER–RELATED HISTORICAL MARKERS

ARCHER COUNTY
Archer City

Camp Cuerton, Civil War Ranger camp four miles east of present Archer City. Named for ranger captain James Jackson "Jack" Cureton (1826–1881). Marker placed in 1963. Courthouse lawn, Center Street.

BANDERA COUNTY
Bandera

HICKS RANCH HOUSE

Stone and cypress house built in 1855 for former ranger Fabian L. Hicks (1828–1899). Marker placed 1965. From Bandera take Farm to Market Road 3240 eight miles southwest to ranch entrance, just before junction with Farm to Market Road 2828.

CAMP MONTEL

Civil War Ranger camp. Marker placed in 1964. Courthouse grounds, 504 Main Street. Camp stood twenty-five miles west and one mile south of Farm to Market Road 470.

POLLY'S CHAPEL

Jose Policarpo Rodriquez (1829–1914) served as a U.S. Army scout before settling in Bandera County near the Privilege Creek community in 1858.

APPENDIX A

During the Civil War, he rode as a ranger in Bandera County to protect the area from Indians. In 1882, having converted to Methodism and become a minister, he built a stone chapel where he preached. Nearby, he also built a school. Marker placed in 1965. State Highway 16 from Bandera eight miles to Privilege Creek Bridge, north on County Road and drive three miles to chapel.

BASTROP COUNTY
Bastrop
OLD JENKINS HOME

Built circa 1836, one of the oldest surviving frame structures in Texas. First home of Sarah Jenkins, whose first husband was killed and scalped by Indians and whose second husband died in the Alamo. Her son John Holmes Jenkins (1822–1890) served as a ranger and also wrote a memoir giving much insight into the early Anglo settlement of Texas. Marker placed 1964. 1710 North Main Street.

WALLACE-HOLME HOUSE

Built circa 1840, house assumed its basic appearance in 1887. One of its early owners was James P. "One Eye" Wallace (1819–1855), a Republic of Texas–era ranger. He lost an eye during an Indian fight in Limestone County and also participated in the Runaway Scrape. Marker placed 1991. 907 Pine Street.

BELL COUNTY
Belton
FORT GRIFFIN

Site of Republic of Texas–era Ranger blockhouse. Marker placed in 1936. Five miles southeast of Belton on Farm to Market Road 436 at Hartrick Bluff Spur.

LITTLE RIVER FORT

Site of Republic of Texas–era Ranger blockhouse. Marker placed in 1969. Two miles north of Belton on Interstate 35, roadside park at Lampasas River bridge.

APPENDIX A

BEXAR COUNTY

San Antonio

OGE HOUSE

First floor built circa 1857. Former ranger Louis Oge (1832–1915), who served with Bigfoot Wallace, moved into the house in 1881 and had noted architect Alfred Giles expand it in neoclassical style. Marker placed 1971. 209 Washington Street.

CAPTAIN LEE HALL (1849–1911)

Frontier Battalion ranger, 1876–80. Marker placed in 1970. Old National Cemetery, between Paso Hondo and Center Streets. Famed short story writer William Sydney Porter (better known as O. Henry) lived for two years on a La Salle County ranch Hall managed after leaving the Rangers. Porter later based several of his short stories on tales he heard from Hall.

BREWSTER COUNTY

Alpine

J.C. BIRD HOUSE

Julius C. Bird (1863–1925), Frontier Battalion ranger. Marker placed in 2013. Front of house, 208 East Lockhart Street.

BRISCOE COUNTY

Silverton

WILLIAM MOTEN VAUGHAN (1841–1928)

Civil War ranger. Marker placed in 1971. Take State Highway 86 one mile east from Silverton, turn south on dirt road for half a mile, then west to Silverton Cemetery.

BROWN COUNTY

Brownwood

ADAMS-SHAW HOUSE

Quarried sandstone house built circa 1876 for former ranger and cattle rancher George H. Adams (1842–1920). Adams had his brand carved into the front stop. Marker placed 1975. 1600 Shaw Drive.

APPENDIX A

CAMP COLLIER

Civil War Ranger camp. Marker placed in 1963. Courthouse grounds, Broadway and Center Streets. Campsite thirteen miles southwest of Brownwood.

WILLIAM OLIVER CONNELL (1816-1882)

Former ranger, Brown County civic leader. Marker placed in 1997. Connell Family Cemetery, three miles southeast of Brownwood on Farm to Market Road 2525, then turn right on county road just before reaching FM 2126.

GREENLEAF FISK (1807-1888)

Republic of Texas ranger, father of Brown County. Marker placed in 1968, U.S. 67/84, two and a half miles west of Brownwood. Buried in Greenleaf Cemetery, Masonic Addition.

CALLAHAN COUNTY

Belle Plain

JEFF MALTBY (1829-1908)

Frontier Battalion ranger captain. Marker placed in 1992. Eight miles south of Baird on U.S. 283, then east one and a half miles on County Road 470 to Belle Plain Cemetery. Road dead-ends at cemetery.

CASTRO COUNTY

Dimmitt

SHOOT-OUT ON JONES STREET

Former Frontier Battalion ranger Ira Aten had a gunfight with Andrew McClelland on December 23, 1891, in the middle of Jones Street. He was acquitted of assault and soon appointed sheriff. Marker placed in 1983. Jones Street, south of courthouse square.

Visit: Castro County Museum, 404 West Halsell Street.

APPENDIX A

CLAY COUNTY
Buffalo Springs

Scene of July 12, 1874 encounter between rangers under Captain. George W. Stevens and Indians. Junction of Farm to Market Road 174 and Farm to Market Road 3077.

COKE COUNTY
Robert Lee

SHELVING ROCK

Ancient camp site on Walnut Creek. Rangers rendezvoused here a few days before the January 8, 1865 Dove Creek fight in what became Irion County. Marker placed 1972. Sixteen miles southwest of Robert Lee on Farm to Market Road 2034.

COLEMAN COUNTY
Coleman

CAMP COLORADO

U.S. Army post; Civil War and Frontier Battalion ranger camp. Marker placed in 1936. State Highway 206, 5.3 miles from Coleman, 6 miles east on Farm to Market Road 2301 and then turn south on dirt road and follow 1.6 miles to marker. Private property.

REVEREND HUGH MARTIN CHILDRESS SR. (1800–1886)

Republic of Texas ranger. Marker placed in 1996. Travel three miles west of Novice on Farm to Market Road 1770, then turn north on County Road 441 and continue one mile to Atoka Cemetery, at left fork of the road.

COLLIN COUNTY
STIFF CHAPEL CEMETERY

Ranger James Stiff, killed in 1847. Marker placed in 2003. Farm to Market Road 2933 north from McKinney 7 miles to County Road 412, east 1.3 miles.

Visit: Collin County Historical Society and Museum, 300 East Virginia Street, McKinney.

APPENDIX A

CORYELL COUNTY
BENJAMIN F. GHOLSON (1842-1932)

Antebellum ranger, active in Texas Ex-Rangers Association. Marker placed in 1967. One mile south of Evant on U.S. 281, turn east on Langford Cove Road. Cemetery one mile from intersection.

CRANE COUNTY
Crane
CHARLES BOOTHE CURRY (1890-1962)

Ranger, 1933–35. Marker placed in 1977. Crane Memorial Gardens Cemetery, south of Crane on U.S. 238.

CROSBY COUNTY
Crosbyton
CAMP ROBERTS

Frontier Battalion camp in Blanco Canyon, 1879–82. Marker placed in 1967. Four miles east of Crosbyton, at U.S. Highway 82/114 and Farm to Market Road 2592.

Museum: Crosby County Pioneer Memorial Museum, 101 West Main Street. Has an exhibit showing artifacts found at the Ranger camp.

DELTA COUNTY
Cooper
LITTLETON RATTAN (1809-1847)

Ranger killed on December 18, 1847, in an Indian fight in Webb County. Marker placed in 2004. West side of Charleston Street at 3288 Farm to Market Road 895.

APPENDIX A

DEWITT COUNTY

Cuero

JAMES F. BLAIR (1826-1909)

Ranger, later DeWitt County sheriff, 1866–69, during Sutton-Taylor feud. Marker placed in 1968. Clinton Cemetery, three miles south from Cuero on U.S. 183, then a quarter of a mile on Clinton Cemetery Road.
Visit: DeWitt County Historical Museum, 312 East Broadway; Chisholm Trail Heritage Museum, 302 North Esplanade, Cuero Heritage Museum, 124 East Church Street.

DeWitt County has thirty historical markers, but not one of them mentions the bloody Sutton-Taylor Feud that blighted the county in the 1870s.

DUVAL COUNTY

Freer

John C. Duval (1816–1897), the county's namesake (along with his two brothers, all Texas pioneers) wrote the first biography of Bigfoot Wallace as well as one of the classics of Texas history, *Early Times in Texas*. His work inspired other writers, including William Sydney Porter (O. Henry) and J. Frank Dobie. A granite historical marker placed in Freer in 1936 honors this early Texas writer, but the Texas State Historical Commission reports that it is missing.

EASTLAND COUNTY

Eastland

CAMP SALMON

Civil War Ranger camp seventeen miles west of present Eastland. Market placed in 1963. North side of courthouse square, Main Street in Eastland.

APPENDIX A

EDWARDS COUNTY
Rocksprings
FORT CLARK-FORT MCKAVETT MILITARY ROAD

Frontier Battalion rangers gathered in April 1877 near Paint Rock on South Llano River, adjacent to military road, prior to surprise Junction cleanup. Marker placed in 1968. U.S. Highway 377, 20.5 miles north of Rocksprings .

Barksdale
CAMP DIXIE

Civil War Ranger camp. State Highway 55, a half mile north of the Nueces.

ELLIS COUNTY
Waxahachie

MCKINNEY-ADAY FARM HOUSE

Built in 1913 by former Frontier Battalion ranger Henry McKinney (1863–1936), the structure is considered a rare example of an early twentieth-century Prairie-style farm home. Marker placed 2013. 130 Cunningham Meadows Road.

FANNIN COUNTY
SITE OF FORT LYDAY

Isaac Lyday built private blockhouse 1836 later used by Rangers. Marker placed in 1983. East from Ladonia on Farm to Market 64 to Farm to Market 904, north four miles.

Visit: Fannin County Museum, 1 North Main, Bonham.

FRIO COUNTY
RANGER CAMP

Frontier Battalion camp, 1876–77. Marker placed in 1936. Three miles southwest of Frio Town, ghost town 16 miles northwest of Pearsall. U.S. 57 west from Pearsall to Farm to Market Road 140, then turn west.

APPENDIX A

GALVESTON COUNTY
JOHN TRUEHART (1801–1874)
Republic of Texas–era ranger. Marker placed in 1986. Evergreen Cemetery, 403rd Street at Avenue K.

GONZALES COUNTY
KING CEMETERY
Grave of Republic of Texas–era ranger Robert Hall (1814–1899). Marker placed in 2012. North side of U.S. 90A, eight and a half miles west of U.S. 183/90A intersection.

GUADALUPE COUNTY
Seguin
KING RANGER CEMETERY
Also known as the King Family Cemetery, dates to 1852, when the infant daughter of former ranger William George King was buried here. King also lies here. Marker placed in 2004. Gonzales Street, between Peach and King.

HAYS COUNTY
San Marcos
JOSEPH W. EARNEST HOUSE
Civil War ranger, 1862–63. Earnest (1844–1920) built house in 1892. Marker placed in 1979 at 833 Belvin Street.

Wimberley
JACOBS WELL CEMETERY, 1853
Graves of Rangers Elisha McCuistion and Foster Massey. Marker placed in 2010. Quarter-mile east of intersection of Farm to Market 2325 and Jacob's Well Road.

APPENDIX A

HEMPHILL COUNTY
Canadian
OLD COUNTY JAIL

Built in 1890, the old Hemphill County Jail is the second-oldest surviving lockup in the Panhandle. Rangers booked many prisoners here during the wild Borger oil boom in 1927–29. Erected 1970. Courthouse square, Main and Fifth Streets.

HIDALGO COUNTY
Progresso
BATTLE OF LA BOLSA

Site of February 4, 1860 fight between Captain John S. "Rip" Ford's rangers and partisans of Juan Cortina. Marker placed in 1991. Four miles east of Progresso, U.S. 281. Battle occurred at La Bolsa bend of the Rio Grande, one mile south of marker.

San Juan
TOM MAYFIELD

Former ranger Tom Mayfield discovered the Plan of San Diego, part of a Germany-Mexico plot on the eve of World War I to wrest the Southwest from the United States and return it to Mexico. Marker placed in 1993. 125 West Fifth Street (Business U.S. 83).

HUDSPETH COUNTY
Crow Springs

Frontier Battalion rangers camped near the springs in the early 1880s. Marker placed in 1974. U.S. 62/180, four and a half miles east of Salt Flats.

Sierra Blanca
AUGUST FRANSAL (1843–1927)

Frontier Battalion ranger, 1881–83. Marker placed in 1968. Sierra Blanca Cemetery, east of Farm to Market 1111, five blocks north of Business Interstate 10, Sierra Blanca.

Appendix A

Irion County
Mertzon

Battle of Dove Creek
Ranger-Kickapoo battle, January 8, 1865. Marker placed in 1936. Dove Creek Ranch, eight miles southeast of Mertzon off County Road 113.

Jack County
James B. Dosher (1820-1901)
Ranger in 1847–48, variously in 1850s, during the Civil War and in 1874. Received Medal of Honor for role as civilian army scout in Bluff Creek Indian fight, October 5, 1870. Marker placed in 1997. Fort Richardson State Park Interpretive Center, 228 Park Road 61, Jacksboro.

G.D. Cross (1855-1941)
Frontier Battalion, 1873–74. Former ranger Cross built concrete picnic table where rangers once camped on Lost Creek. Marker placed in 1969. Sewell Park, beneath bridge, U.S. 281 and Lost Creek, Jacksboro. Old table still in use.

Squaw Mountain Community
Named for nearby mountain where rangers supposedly buried an Indian woman killed in a skirmish, 1875. Marker placed in 1998. Seventeen miles north of Jacksboro on U.S. 281, two miles east on Farm to Market Road 2190.

Visit: Jack County Museum, 241 West Belknap Street, Jacksboro.

Jasper County
Bevilport

Republic of Texas–era cotton-shipping port on the Angelina River, named for former ranger John Bevil. Now a ghost town. Marker placed in 1967. Four miles west of Jasper, junction Farm to Market 2799 and State Highway 63.

Appendix A

Johnson County
Rio Vista

Henry Briden Cabin

Built in 1849 by Henry Briden (1825–1908), who served two years as a ranger and was the county's first settler. The one-room log cabin was moved from its original location on the east bank of Nolan's River to Rio Vista and restored in 1974. Marker placed 1975. First State Bank grounds, State Highway 174.

Meredith Hart House

Two-story frame house built with slave labor in 1856 by former ranger Meredith Hart (1811–1864). Marker placed 1965. Take Farm to Market Road 916 a half-mile east from Rio Vista to private road.

Kenedy County
Sarita

Armstrong Ranch, established by noted Ranger John B. Armstrong, who captured outlaw John Wesley Hardin. Ranch is still operated by the Armstrong family. Marker placed 1983. South of Sarita on U.S. 77. Private property.

Kimble County
Junction

Bear Creek Ranger Camp

Frontier Battalion ranger camp. Marker placed in 1966. Four miles northwest of Junction on Farm to Market 1674. Camp site on private property, three hundred yards east.

Doom of the Outlaws of Pegleg Station

Rangers broke up a stage-robbing gang, killing robber Dick Dublin at this site on January 18, 1878. U.S. 377, nine and a half miles southwest of Junction.

William Walter Taylor (1868-1945)

Ranger, 1917–27. Marker placed in 1967. Junction City Cemetery.

APPENDIX A

LA SALLE COUNTY

Millett

WILLIAM A. WAUGH (1832-1901)

Antebellum ranger, served in Cortina War. Marker placed in 1978. Exit Interstate 35 in Millett, go west on Farm to Market 469 0.2 miles to cemetery on north side of road.

LEON COUNTY

Centerville

FORT BOGGY

Site of Republic of Texas Ranger blockhouse. Marker placed in 1936. Now Fort Boggy State Park, five miles south of Centerville on State Highway 75 South.

LIMESTONE COUNTY

Mexia

ALBERT R. MACE (1872-1938)

Frontier Battalion ranger, 1893, and town tamer who served in Rangers again in 1930. Mexia Municipal Cemetery, U.S. 84.

LIVE OAK COUNTY

Latham

JESSIE ROBINSON (1800-1882)

Republic of Texas ranger, buried in Latham Cemetery. Marker placed in 1973. From George West, take U.S. 281 fourteen and a half miles to County Road 164 Anna Rose Road and turn right. At County Road 107, turn right. Cemetery is south of County Road 107 on unpaved road.

Appendix A

McCulloch County
Brady

Calf Creek Indian Fight
James Coryell, later Republic of Texas ranger, had close brush with Indians along with future Alamo co-commandant James Bowie and other treasure hunters, November 2, 1831. Marker placed in 1936. West of Brady on U.S. 190 for 10.9 miles to Farm to Market 1311. Turn south and drive 3.3 miles to marker.

Camp San Saba
Civil War Ranger camp. Marker placed 1936. In Camp San Saba community, ten miles south of Brady on Farm to Market Road 1955.

Visit: Heart of Texas Museum, 117 North High Street.

McLennan County
Waco

John Silas Edens (1820-1892)
Republic of Texas ranger. Marker placed in 1994. White Rock Cemetery, Ross Road, one mile west of Ross.

Louis Moore (1817-1894)
Republic of Texas ranger. Marker placed in 1989. Moore Cemetery, 2.1 miles north of intersection of Farm to Market Road 3501 and Farm to Market Road 933.

Ross Oak
Ranger Shapley Prince Ross (1811–1889), father of ranger captain Sul Ross, camped beneath this tree in 1839 and bought the land around it in 1849 as Waco was being settled. Marker placed in 1975 at 613 South Ninth Street.

Medina County
Castroville

Charles de Montel Ranch House
Ranger captain, 1862. De Montel (1812–1882) built house 1848–50. Marker placed in 1970. North of Castroville 1.6 miles off De Montel Lane, private road.

Appendix A

Hondo

Battle of Arroyo Hondo

Following the Battle of Salado three days earlier, rangers, regular soldiers and volunteers fought again with General Adrian Wool's retreating invasion force on September 21, 1842. Marker placed in 1992. Six and a half miles north of Hondo on Farm to Market Road 462.

Visit: Medina County Museum, 2208 Eighteenth Street, Hondo.

MILAM COUNTY

Cameron

Boyhood home of former ranger, governor and Texas A&M University president Lawrence Sullivan Ross, built by his father circa 1841. Family later moved to Waco. Marker place 1969. City park, Fourth and Lamar Avenue North.

MITCHELL COUNTY

Colorado City

Y.D. McMurry (1858-1923)

Frontier Battalion ranger captain. Marker placed in 1970. Colorado City Cemetery, east section.

William Marion Green (1854-1930)

Frontier Battalion ranger, later active in the Texas Ex-Rangers Association. Marker placed in 1968. Colorado City Cemetery.

MONTAGUE COUNTY

Nacona

Red River Station

Civil War ranger post. Marker placed in 1963. Six miles west of Nacona on U.S. 82. Camp site nine miles southwest of marker.

Visit: Tales 'N' Trails Museum, 1522 East U.S. 82, Nacona.

APPENDIX A

NUECES COUNTY

Corpus Christi

THOMAS S. PARKER (1817–1886)

Ranger, 1849, first Nueces County sheriff, 1845–47. Marker placed in 1983. Old Bayview Cemetery, Waco and Ramirez Streets.

PALO PINTO COUNTY

SIMPSON CRAWFORD (1824–1908)

Antebellum ranger. Marker placed in 1980. Three miles east of Grafford on State Highway 254. Grave in Crawford Cemetery, one and a half miles north of marker.

ALFRED LANE (1827–1864)

Civil War ranger, brother-in-law of Charles Goodnight. Killed by Indians in Young County on his way home from a cattle drive, July 15, 1864. Marker placed in 2009. Crawford Cemetery, off State Highway 254, two miles east of Crawford.

REEVES COUNTY

Pecos

Long before settlers came to what is now Reeves County, ranger captain John S. "Rip" Ford and Robert S. Neighbors traversed the area leading an expedition in 1849 to map a wagon road from Austin to El Paso. Marker placed in 1966. Roadside Park off U.S. 285, just north of Pecos.

ROBERTSON COUNTY

Wheelock

Community founded in 1833 by Republic of Texas ranger captain E.L.R. Wheelock (1793–1847). Marker placed in 1936. Farm to Market Road 391 and Farm to Market Road 46. Wheelock is buried in the Texas State Cemetery.

APPENDIX A

RUNNELS COUNTY

Ballinger

Former Frontier Battalion ranger William H. Brown killed by Indians. Grave nineteen miles west of Ballinger on Farm to Market Road 158 to County Road 297 and then a quarter mile south.

Winters

RANGER CAMPSITE

Frontier Battalion ranger campsite, 1874. Marker placed in 1970. Sixteen miles northeast of Winters, on Farm to Market Road 381, 0.3 miles north of County Road 89. Marker 0.5 miles east of site.

CAMPSITE WATER WELL

Take Farm to Market Road 1770 east from Winters twelve miles, then north three and a half miles on Farm to Market Road 382. Marker placed in 1980. Well in field half mile east.

RANGER PEAK

Frontier Battalion ranger lookout point. Marker same location as above.

SAN SABA COUNTY

Cherokee

JOHN WILLIAMS (1798-1862)

Antebellum ranger, killed by Indians in 1862, Llano County. Friends and relatives later placed a granite marker on his grave. Hanna Cemetery, Cherokee.

San Saba

CAMP McMILLAN

Civil War ranger camp. Marker placed in 1964. U.S. 190 at county courthouse, San Saba.

APPENDIX A

TAYLOR COUNTY
Buffalo Gap

RANGER-INDIAN FIGHT, 1863
Marker placed in 1968. Old Settlers Reunion Grounds, Vine and West Streets.

FIRST TAYLOR COUNTY JAIL
Frontier Battalion rangers brought their prisoners to this small jail in the two-story stone courthouse built in 1879. Marker placed 1968. 113 North William Street.

Merkel

INDIAN FIGHT
Ranger-Indian fight, January 1, 1871. Marker placed in 1968. Farm to Market 1235, seven miles south of Merkel.

Visit: Merkel Museum, 1501 North Seventh Street.

TRAVIS COUNTY
Austin

MERRELLTOWN CEMTERY
Grave, Republic of Texas ranger Nelson Merrell (1810–1879). Marker placed in 2000. 14901 Burnet Road.

TEXAS STATE CEMETERY
Historical markers/monuments: Willis T. Avery (1809–1889), Jesse Billingsley (1810–1880), Joseph G. Booth (1840–1910), John W. Bracken (1857–1939), Guy M. Bryan (1821–1901), Edward Burleson (1778–1851), James H. Callahan (1814–1856), Walter P. Callaway (1854–1932), John Grumbles (1804–1858), William P. Hardeman (1816–1898), John R. Hughes (1855–1947), Daniel W. Roberts (1841–1935), William R. Scurry (1821–1864), Lamartine P. Sieker (1848–1914), William Tom (1792–1871), William A.A. "Bigfoot" Wallace (1817–1899), Eleazar L.R. Wheelock (1793–1847), John L. Wilbarger (1829–1850), Robert M. Williamson (1808–1859), Thomas C. Wilson (1892–1917).

WAR DEPARTMENT BUILDING
Site of Republic of Texas War Department, tantamount to Texas Ranger headquarters until 1845. A plaque noting original use of the site is at 713 Congress Avenue outside the Paramount Theater. A freestanding wall of

mortared limestone stands between the theater and the Stephen F. Austin Hotel, the only remnant of the old building.

Webberville

DAVID CRAWFORD EDMISTON (1825–1903)

Grave, former ranger. Marker placed in 1989. Joseph J. Manor Cemetery, Webberwood Way and Sandy Brown Lane.

SUTTON COUNTY

Sonora

OLD SUTTON COUNTY JAIL

Completed in 1891, its first prisoner was gambler-gunslinger John Denson, cousin of outlaw John Wesley Hardin. Marker placed in 1975. Courthouse grounds, Water and Main Streets.

Visit: Old Icehouse Ranch Museum, 206 South Water Street.

TERRY COUNTY

Brownfield

MONROE BROWN SAWYER RANCH HOUSE

Frontier Battalion ranger, 1881–82. Built in 1902, one of oldest residences in county. Marker placed in 1970. From Brownfield, take Farm to Market Road 403 south 7.3 miles, turn east on county road and continue 0.25 miles to ranch house.

UVALDE COUNTY
CAMP SABINAL

Initially U.S. Army subpost 1856, later Ranger camp. Marker placed in 1936. One mile west of Sabinal off U.S. 90, west side Sabinal River.

FORT INGE

U.S. Army post, 1849–61, 1866–69, later Ranger camp. Marker placed in 1966. State Highway 140 one and a quarter miles southeast from Uvalde, Fort Inge Historical Park.

APPENDIX A

RANGER-INDIAN FIGHT

Fight between rangers under Captain John Coffee Hays and Comanches, June 24, 1841. Marker placed in 1936. Nine miles south of Utopia on U.S. 187.

PAT GARRETT HOME SITE

Best known for gunning down Billy the Kid in 1881, Patrick F. Garrett (1850–1908) served as captain of a special ranger company, 1884–85. Ranched in Uvalde County, 1891–96. Marker placed in 1970. U.S. 90, at Texas Department of Transportation yard.

VAN ZANDT COUNTY

Wills Point

NEAL MARTIN (1777–1879)

Republic of Texas ranger grave. Marker placed in 1968. State Highway 47 at Stony Point Road, three miles north of Wills Point.

VICTORIA COUNTY

Victoria

WILLIAM ROBERT SMITH (1888–1952)

Ranger, 1927–33. Marker placed in 1972. Memorial Park Cemetery, 300 West Red River Street.

WALKER COUNTY

Huntsville

JAMES S. GILLASPIE (1805–1867)

Republic of Texas–era ranger. Plaques listing all men he served with placed in 1936. Oakwood Cemetery, Ninth Street and Avenue I.

WHARTON COUNTY

Wharton

ROBERT McALPIN WILLIAMSON HOME SITE

Highest-ranking of the pre-Republic era Rangers, Williamson spent his final two years in Wharton living with his father-in-law following the

death of his wife. He died there in 1859. Marker placed in 1936. 101 Burleson Street.

WILLIAMSON COUNTY

Georgetown

WILLIAM CORNELIUS DALRYMPLE (1814–1898)

Republic of Texas–era ranger. Marker placed in 1994. Presbyterian Cemetery, Twentieth and Paige Streets.

Round Rock

KENNEY'S FORT

Site of private fort built in 1839, first structure in future Williamson County. Here on December 31, 1842, a posse of Austin men recovered government documents from rangers trying to take them from the capital city to Washington-on-the-Brazos. Marker placed in 1936. U.S. 79, east from Round Rock two and a half miles.

BARKER HOUSE

Quaried limestone house where future ranger Dudley Barker was born in 1874. Barker returned to the old house in 1940 and scratched his name and birthday on an interior wall. Marker placed in 1998 at 1112 Ledbetter Street.

Taylor

JAMES O. RICE (1815–CIRCA 1870)

Republic of Texas ranger, participated in Manuel Flores fight, May 17, 1839. Marker placed in 1977. Eight miles south of Taylor on Farm to Market 973 at Farm to Market 1660, Rice's Crossing. Rice is buried in the Sneed Family Cemetery, Travis County.

WILSON COUNTY

Stockdale

King-Lorenz House, built in 1898 by Robert and Rachel King Smith was later home to former ranger Wade Lorenz (1896-1930). Marker placed 1984. South Seventh Street, three blocks south of Main Street.

APPENDIX A

WISE COUNTY
Decatur
FLAT ROCK CEMETERY

Frontier Battalion ranger captain George W. Stevens (1831–1893) deeded land for this cemetery on August 28, 1890, and three years later, he was buried there. Marker placed in 1972. Farm to Market 720 to Old Decatur Highway, 7.2 miles from Decatur.

CAPTAIN IRA LONG (1842-1913)

Frontier Battalion ranger captain, 1874–80. Marker placed in 1967. Cemetery off County Road 4226, four miles southwest of Decatur.

Visit: Wise County Museum, 1605 South Trinity Street, Decatur.

WOOD COUNTY
Quitman
HENRY STOUT (1799-1892)

Republic of Texas–era ranger, present when ranger captain John B. Denton was killed in 1841. Marker placed in 1992. Stout Family Cemetery, Farm to Market 2088, nine miles east of Quitman.

YOUNG COUNTY
Graham
A.B. MEDLAN HOME, CIRCA 1855

Brick ranch house built by antebellum ranger A.B. Medlan. Marker placed in 1964. Five miles south of Graham on State Highway 67, turn left on county road and continue five miles. The structure is on private property.

Newcastle
CAMP BELKNAP

Civil War ranger camp. Rangers based here rode out after Comanches following the 1864 Elm Creek raid. Marker placed in 1963. Three miles south of Newcastle on State Highway 251.

TEXAS COUNTIES AND CITIES NAMED FOR RANGERS

Of Texas's 254 counties, 28 are named in honor of Texas Rangers. Two cities, Ranger in Eastland County and Rangerville in Cameron County recognize the Rangers.

BAYLOR
Dr. Henry W. Baylor (1818–1854)

BELL
Governor Peter Hansborough Bell (1810–1898)

BROOKS
Captain James Abijah Brooks (1855–1944)

BURLESON
Edward Burleson (1798–1851)

CALDWELL
Matthew "Old Paint" Caldwell (1798–1842)

CALLAHAN
James Hughes Callahan (1812–1856)

APPENDIX B

COLEMAN
Robert Morris Coleman (circa 1799–1837)

CORYELL
James Coryell (1803–1837)

DEAF SMITH
Erastus "Deaf" Smith (1787–1837)

DENTON
James B. Denton (1806–1841)

DUVAL
John Crittenden Duval (1816–1897), Burr H. Duval (1809–1836) and Thomas Howard Duval (1813–1880)

EASTLAND
William Mosby Eastland (1806–1843)

ERATH
George Bernard Erath (1813–1891)

GILLESPIE
Robert Addison Gillespie (1815–1846)

HARDEMAN
William Polk Hardeman (1816–1898)

HAYS
John Coffee Hays (1817–1883)

KARNES
Henry Wax Karnes (1812–1840)

KERR
James Kerr (1790–1850)

KIMBLE
George C. Kimble (1803–1836)

APPENDIX B

JOHNSON
Middleton Tate Johnson (1810–1866)

MCCULLOCH
Ben McCulloch (1811–1862)

PARKER
Isaac Parker (1793–1883)

ROBERTSON
Sterling Clack Robertson (1785–1842)

SCURRY
William Read Scurry (1821–1864)

SUTTON
John Schuyler Sutton (circa 1822–1862)
William Read Scurry (1821–1864)

WALKER
Samuel H. Walker (1817–1847)

WILLIAMSON
Robert McAlpin "Three-Legged Willie" Williamson (circa 1806–1859)

YOUNG
William C. Young (1812–1862)

SELECTED BIBLIOGRAPHY

Alexander, Bob. *Bad Company and Burnt Powder: Justice and Injustice in the Old Southwest*. Denton: University of North Texas Press, 2014.

———. *Rawhide Ranger, Ira Aten: Enforcing Law on the Texas Frontier*. Denton: University of North Texas Press, 2011.

———. *Riding Lucifer's Line: Ranger Deaths along the Texas-Mexico Border*. Denton: University of North Texas Press, 2013.

———. *Six-Shooters and Shifting Sands: The Wild West Life of Texas Ranger Captain Frank Jones*. Denton: University of North Texas Press, 2015.

———. *Winchester Warriors: Texas Rangers of Company D, 1874–1901*. Denton: University of North Texas Press, 2009.

Baylor, George Wythe. *Into the Far, Wild Country: True Tales of the Old Southwest*. Edited with an introduction by Jerry D. Thompson. El Paso: Texas Western Press, 1996.

Benner, Judith Ann. *Sul Ross: Soldier, Statesman, Educator*. College Station: Texas A&M Press, 1983.

Blackburn, Ed, Jr. *Wanted: Historic County Jails of Texas*. College Station: Texas A&M University Press, 2006.

Bowman, Bob and Doris Bowman. *More Historic Murders of East Texas*. Lufkin: Best of East Texas Publishers, 2004.

"Brazos." *Life of Robert Hall: Indian Fighter and Veteran of Three Great Wars*. Austin: State House Press, 1992. Reprint of 1898 edition.

Brown, Gary. *Singin' a Lonesome Song: Texas Prison Tales*. Plano: Republic of Texas Press, 2001.

SELECTED BIBLIOGRAPHY

Caldwell, Clifford R., and Ron DeLord. *Texas Lawmen, 1835–1899: The Good and the Bad*. Charleston, SC: The History Press, 2011.

————. *Texas Lawmen, More of the Good and Bad, 1900–1940*. Charleston, SC: The History Press, 2012.

Cantrell, Gregg. *Stephen F. Austin: Empresario of Texas*. New Haven: Yale University Press, 1999.

Cool, Paul. *Salt Warriors: Insurgency on the Rio Grande*. College Station: Texas A&M University Press, 2008.

Cox, Mike. *Texas Ranger Tales*. Vol. 1. Plano: Republic of Texas Press, 1997.

————. *Texas Ranger Tales*. Vol. 2. Plano: Republic of Texas Press, 1999.

————. *Time of the Rangers: The Texas Rangers 1900 to Present*. New York: Forge Books, 2009.

————. *Wearing the Cinco Peso: The Texas Rangers, 1821–1900*. New York: Forge Books, 2008.

Cox, Ross J., Sr. *The Texas Rangers and the San Saba Mob*. San Saba, TX: C&S Farm Press, 2005.

Exley, Jo Ella Powell. *Frontier Blood: The Saga of the Parker Family*. College Station: Texas A&M University Press, 2001.

Ford, John Salmon. *Rip Ford's Texas*. Edited by Stephen Oates. Austin: University of Texas Press, 1963.

Francell, Ron. *The Crime Buff's Guide to Outlaw Texas*. Guilford, CT: Globe-Pequot Press, 2010.

Gilliland, Maude T. *Wilson County Texas Rangers, 1837–1977*. Floresville, TX: Privately published, 1977.

Harris, Charles H., III, and Louis R. Sadler. *The Secret War in El Paso: Mexican Revolutionary Intrigue, 1906–1920*. Albuquerque: University of New Mexico Press, 2009.

————. *The Texas Rangers and the Mexican Revolution: The Bloodiest Decade, 1910–1920*. Albuquerque: University of New Mexico Press, 2004.

Harvey, Bill. *Texas Cemeteries*. Austin: University of Texas Press, 2003.

Hutchinson, Mary Foster. *Texian Odyssey: The Life and Times of a Forgotten Patriot of the Republic of Texas, Colonel Eleazar Louis Ripley Wheelock, 1793–1847*. Austin: Sunbelt Eakin, 2003.

Jones, William Moses. *Texas History Carved in Stone*. Houston: Monument Publishing Co., 1958.

Kelsey, Mavis P., Sr., and Donald H. Dyal. *The Courthouses of Texas*. College Station: Texas A&M University Press, 1993, 2007.

Kuykendall, Marshall E. *They Slept Upon Their Rifles: The Story of the Captain Robert H. Kuykendall Family in America and the Entry of the Family with the Anglo*

Settlement into Mexican/Texas in Stephen F. Austin's Colony in 1821. Austin: Nortex Press, 2005.

Lindsey, Ellis, and Gene Riggs. *Barney K. Riggs: The Yuman and Pecos Avenger.* Privately published, 2002.

Melugin, Ron. *Heroes, Scoundrels and Angels: Fairview Cemetery of Gainesville, Texas.* Charleston, SC: The History Press, 2010.

Miller, Rick. *Bloody Bell County: Vignettes of Violence and Mayhem in Central Texas.* Waco: Nortex Press, 2011.

———. *Texas Ranger John B. Jones and the Frontier Battalion, 1874–1881.* Denton: University of North Texas Press, 2012.

Moore, Stephen L. *Eighteen Minutes: The Battle of San Jacinto and the Texas Independence Campaign.* Lanham, MD: Republic of Texas Press, 2004.

———. *Savage Frontier: Rangers, Riflemen and the Indian Wars of Texas.* Vol. 1, 1837–1837. Denton: University of North Texas Press, 2002.

———. *Savage Frontier: Rangers, Riflemen and the Indian Wars of Texas.* Vol. 2, 1838–1839. Denton: University of North Texas Press, 2006.

———. *Savage Frontier: Rangers, Riflemen and the Indian Wars of Texas.* Vol. 3, 1840–1841. Denton: University of North Texas Press, 2007.

———. *Savage Frontier: Rangers, Riflemen and the Indian Wars of Texas.* Vol. 4, 1842–1837. Denton: University of North Texas Press, 2010.

———. *Texas Rising: The Epic True Story of the Lone Star Republic and the Rise of the Texas Rangers, 1836–1846.* New York: William Morrow, 2015.

Noland, Frederick. *Tascosa: Its Life and Gaudy Times.* Lubbock: Texas Tech University Press, 2007.

O'Neal, Bill. *Lampasas: Biography of a Frontier Texas Town.* Waco: Eakin Press, 2012.

Parsons, Chuck, and Donaly E. Brice. *Texas Ranger N.O. Reynolds: The Intrepid.* Denton: University of North Texas Press, 2005, 2014.

Parsons, Chuck, and Marianne E. Hall Little. *Captain L.H. McNelly—Texas Ranger—The Life and Times of a Fighting Man.* Austin: State House Press, 2001.

———. *The Sutton-Taylor Feud: The Deadliest Blood Feud in Texas.* Denton: University of North Texas Press, 2009.

Proctor, Ben. *Just One Riot: Episodes of the Texas Rangers in the 20th Century.* Austin: Eakin Press, 1991.

Roark, Carol, ed. *Fort Worth & Tarrant County: An Historical Guide.* Fort Worth: Texas Christian University Press, 2003.

Rye, Edgar. *The Quirt and Spur.* Lubbock: Texas Tech University Press, 2000. Reprint of 1909 edition.

SELECTED BIBLIOGRAPHY

Schreiner, Charles, III, ed. *A Pictorial History of the Texas Rangers*. Mountain Home: YO Ranch, 1969.

Seldon, Jack K. Return: *The Parker Story*. Palestine, TX: Clacton Press, 2006.

Spellman, Paul N. *Old 300: Gone to Texas*. Privately published: 2014.

Sterling, William Warren. *Trails and Trials of a Texas Ranger*. Norman: University of Oklahoma Press, 1969. Reprint of 1959 edition.

Thompson, Jerry. *Cortina: Defending the Mexican Name in Texas*. College Station: Texas A&M University Press, 2013.

Weiss, Harold, Jr. *Yours to Command: The Life and Legend of Texas Ranger Captain Bill McDonald*. Denton: University of North Texas Press, 2009.

WEBSITES

Find a Grave. www.findagrave.com.

Former Texas Rangers. www.formertexasrangers.org.

Fort Tours. www.forttours.com.

Hornsby Bend. http://www.hornsbybend.com/cemetery.html.

Officer Down Memorial Page. https://www.odmp.org.

Texas Historical Commission. http://atlas.thc.state.tx.us/shell-county.htm.

Texas Ranger Hall of Fame and Museum. www.texasranger.org.

Texas State Cemetery. http://www.cemetery.state.tx.us/.

Texas State Historical Association. https://tshaonline.org/handbook.

INDEX

INDEX

INDEX

INDEX

INDEX

INDEX

INDEX

INDEX

ABOUT THE AUTHOR

An elected member of the prestigious Texas Institute of Letters, Mike Cox is the author of twenty-six nonfiction books. Over a freelance career of more than forty-five years, he also has written hundreds of articles and essays for a wide variety of national and regional publications. His best-selling work has been a two-volume, 250,000-word history of the Texas Rangers published in 2008.

In September 2011, he received the A.C. Greene Award for lifetime achievement. His book *Cowboy Stuntman: From Olympic Gold to the Silver Screen*, the story of Dean Smith, received a Will Rogers Medallion and was a finalist for the Western Writers of America Golden Spur Award in 2014.

A former award-winning newspaper reporter, Cox was a longtime spokesman for the Texas Department of Public Safety and later communications manager for the Texas Department of Transportation. He retired as a spokesman for the Texas Parks and Wildlife Department in early 2015.

When not writing, he spends as much time as he can traveling, fishing, hunting and looking for new stories to tell.

Visit us at
www.historypress.net
..
This title is also available as an e-book